**KUNSTHALL[
MANNHEIM**

**HATJE
CANTZ**

1,5 Grad

Verflechtungen von Leben, Kosmos, Technik

1.5 Degrees
Interdependencies between
Life, the Cosmos, and
Technology

**KUNSTHALLE
MANNHEIM**

Inhalt / Contents

1,5 Grad
Verflechtungen von Leben, Kosmos, Technik

Das mehrteilige Ausstellungsprojekt verfolgt einen vielstimmigen Ansatz. Mitten in der allgegenwärtigen Klimakrise verdeutlicht es Verflechtungen, Zwischenbereiche und Symbiosen zwischen den einst als voneinander getrennt aufgefassten Sphären Mensch und Umwelt. Dazu werden eigens für die Ausstellung produzierte Kunstwerke sowie Leihgaben, die teils erstmalig in Deutschland zu sehen sind, zusammen mit Sammlungsbeständen gezeigt. Gemeinsam verdeutlichen die Werke, wie die rapiden und inzwischen auch im Alltag spürbaren klimatischen Veränderungen alle Lebewesen betreffen. Der Blick des Publikums wird dabei von den kleinsten Bewohnern der Erde – den Insekten – bis zu den größtmöglichen Zusammenhängen gelenkt: auf den Kosmos der Sterne.

Im Wissen, dass ein solch allumfassender Ansatz wohl kaum in einer einzelnen Ausstellung behandelt werden kann, ist *1,5 Grad* in mehrere Fragmente aufgeteilt, die sich auf alle Ebenen des Neubaus der Kunsthalle erstrecken, aber ebenso Eingang in die Ausstellungsräume des Jugendstilgebäudes finden. Dort eröffnet zudem zeitversetzt eine von Thomas Köllhofer kuratierte Grafikausstellung zum Thema Insekten, die ebenfalls in diesem Katalog dokumentiert wird. Zudem finden sich auf dem Gelände der Bundesgartenschau Mannheim 2023, die den inhaltlichen und organisatorischen Anlass für dieses groß angelegte Ausstellungsprojekt bildet, zwei Außenposten der Ausstellung. Sie fügen sich ein in die Umwidmung eines ehemaligen US-amerikanischen Militärareals im Zuge der BUGA 23. Diese besteht nicht nur aus einer temporären Blumenpracht, sondern sammelt Ansätze für nachhaltige urbane Entwicklungen und möchte zu einer grünen Lunge im Stadtgebiet beitragen.

Die beiden dort zu sehenden Installationen von Olaf Holzapfel und Fabian Knecht bilden eine Brücke zur Ausstellung in der Kunsthalle, wo gleich im Atrium eine paradigmatische Installation von Knecht präsentiert wird: eine Vielzahl manipulierter Thermometer, die statt der tatsächlichen Temperatur die ersehnten niedrigeren Werte anzeigen – eine Verbildlichung des Auseinanderklaffens von Wunsch und Wirklichkeit, wie sie unsere derzeitige Situation bestimmt. Von dort tritt man in die großzügigen Ausstellungsräume des Erdgeschosses, in denen die Klimaanlagen nicht erst im Zuge der gegenwärtigen Energiekrise so eingestellt sind, dass sie energiesparend mit deutlich unterschiedlichen Winter- und Sommertemperaturen operieren, da die Kunsthalle Mannheim bereits 2011 eine sukzessive Umstellung auf Passivhausstandard und somit einen ressourcenschonenden Betrieb aller technischen Anlagen umgesetzt hat. Hier sieht man die dystopisch wirkende Filminstallation über unsere Abhängigkeit von fossilen Verbrennungsprozessen von Julian Charrière neben einem deutlich älteren Werk von Jannis Kounellis, das ebenfalls Kohle ins Bild setzt. Installationen von melanie bonajo und Ernesto Neto inspirieren uns im benachbarten Ausstellungsfragment zum umsichtigen Umgang mit unserer Umwelt. Ein anderes Fragment nähert sich durch einen Fokus auf mögliche Lösungsansätze den riesigen Herausforderungen, vor denen wir stehen, so etwa eine frühe Arbeit der Gruppe SUPERFLEX zu dezentralen ökologischen Biogasanlagen oder die utopisch wirkende Forschung von Kyriaki Goni zur Speicherung von großen Datenmengen in der DNA von Pflanzen. So werden mahnende, beeindruckende Werke neben solchen gezeigt, die zu einem emphatischeren Umgang mit den Ökosystemen unserer Meere und Wälder anregen, aber ebenso neben Positionen, die sich mit den utopischen Versprechen technischer Vorgänge auseinandersetzen.

Wir als Kurator*innen einer Ausstellung über die Verflechtungen von Leben, Kosmos und Technik im Zeitalter der dramatischen Klimaveränderungen möchten weder behaupten zu wissen, wie oder ob diese Krise zu lösen wäre, noch aus einer gesicherten Position heraus unserem Publikum eine spezifische Lesart aufzeigen. Vielmehr sollen sich teils widersprüchliche und historisch höchst

unterschiedliche Positionen zu einem kaleidoskopartigen Bild zusammenfügen, das Reflexion, Nachdenklichkeit, Ideen und differenzierte Meinungen hervorruft.

Dazu dienen auch die im ersten Stockwerk präsentierten Werke mit einem ganz anderen Fokus. Hier wird die Aufmerksamkeit auf die gegenseitige Abhängigkeit und Verflechtung aller Lebewesen des Planeten Erde gerichtet; dies geschieht mit Werken, die in den letzten Jahren zum Teil in ganz anderen Zusammenhängen präsentiert wurden, wie zum Beispiel einer Installation von Laure Prouvost, neueren Werken von Anne Duk Hee Jordan und Marianna Simnett sowie historischen Arbeiten wie beispielsweise von Joseph Beuys. Im zweiten Obergeschoss der Kunsthalle sind Werke zu sehen, die Reflexionen über menschliche Veränderungen des Weltalls (von Eva Gentner) und die Tiefen des Ozeans (von Otobong Nkanga) anstoßen. Sie werden neben zwei Werken von Anselm Kiefer gezeigt, die sich als Dauerleihgaben in der Kunsthalle befinden. So werden Bestände der Sammlung konsequent um neue Lesarten erweitert. Dieses Prinzip zieht sich durch weitere Teile der Sammlungspräsentation, wo neue Konstellationen erkennen lassen, wie Künstler*innen nicht erst in diesem Jahrtausend in ihren Werken die oben genannten Verflechtungen verarbeiten. Somit reicht die Ausstellung zurück zur Zeitenwende der Industrialisierung im ausgehenden 19. Jahrhundert, die auch in besonderer Weise die Entwicklung der Industriestadt Mannheim geprägt hat. Die vor Beginn der Industrialisierung herrschenden Temperaturen sind zugleich die Referenzwerte des 2015 im Pariser Klimaabkommen festgehaltenen 1,5-Grad-Ziels.

Welche Rolle Kunst in einem vom Menschen tiefgreifend geprägten Zeitalter – dem Anthropozän – spielen kann, verhandelt Eva Horn in ihrem Essay. Ihre These, dass nicht die Bebilderung der Klimakrise das Anliegen sein kann, sondern dass die Betrachtenden auf die Verstrickungen mit der sie umgebenden Welt aufmerksam werden müssen, korrespondiert mit einem Leitthema der Ausstellung. Ebenso mündet das zweite Essay von Irina Danieli über die Darstellung von Tieren in historischer und zeitgenössischer Kunst in der Überzeugung, dass die lange vorherrschende Trennung von menschlichem und animalischem Leben in vielen zeitgenössischen Kunstwerken einer anderen Haltung gewichen ist: Tiere gehen uns an.

Den beiden Autorinnen gilt, wie auch allen anderen Autor*innen, ausstellenden Künstler*innen und sämtlichen Projektbeteiligten, mein größter Dank. Außerdem bedanke ich mich herzlich bei dem kuratorischen Team von *1,5 Grad* (Anja Heitzer, Sebastian Schneider, Inge Herold, Pia Goebel) sowie bei Thomas Köllhofer, dem Kurator der Ausstellung *Das Insekt*. Die Realisation eines so umfangreichen Projekts wäre nicht möglich ohne die Leiterin der Restaurierung Katrin Radermacher und das Team Ausstellungstechnik, die den Ausstellungsaufbau professionell umgesetzt haben. Für die großzügige finanzielle Förderung des Ausstellungsprojekts möchte ich mich bei der Stiftung Kunsthalle Mannheim sowie den Hector Stiftungen bedanken. Mein Dank gebührt auch der BUGA 23, die als Kooperationspartner von Anbeginn eine ideale Zusammenarbeit ermöglicht hat.

Ich glaube, ich darf für alle Beteiligten sprechen, wenn ich hier meine Hoffnung zum Ausdruck bringe, dass diese Publikation und die Ausstellung einen fruchtbaren Beitrag zur Diskussion über die enormen Herausforderungen leisten mögen, vor der wir alle als Lebewesen dieser Erde stehen. Darüber hinaus möchte ich betonen, dass diese Publikation in Kooperation mit Hatje Cantz ganz bewusst ressourcenschonend hergestellt worden ist. Für diese Initiative möchte ich sowohl dem Verlag als auch Karsten Heller, dem Gestalter dieses Buches, herzlich danken. Mit dem Ausstellungskatalog setzt sich ein Leitgedanke fort, der auch die gesamte Ausstellung prägt. So haben wir die schon seit mehr als einem Jahrzehnt während Bemühungen der Kunsthalle Mannheim, nachhaltig zu arbeiten, um weitere wichtige Schlüsselkomponenten erweitern können. Dabei ist es unsere Haltung gewesen, keine einmaligen, lediglich für dieses Projekt anwendbaren Standards zu erfüllen, sondern im Sinne einer echten Nachhaltigkeit solchen Maßnahmen den Vorzug zu geben, die auch bei zukünftigen Projekten umgesetzt werden können.

Johan Holten

1.5 Degrees Interdependencies between Life, the Cosmos, and Technology

The multipart exhibition project pursues a polyphonic approach. Amidst the omnipresent climate crisis, it visualizes interconnections, in-between areas, and symbioses between the spheres of human beings and the environment that were once regarded as being separate from one another. It thus presents artworks produced specially for the exhibition and includes loans that are in part being shown for the first time in Germany, along with collection holdings. Together, the works illustrate how the rapid changes in the climate, which have meanwhile become palpable in day-to-day life, affect all living creatures. The gaze of viewers is thus guided from the smallest inhabitants of Earth—insects—to the largest possible context: the cosmos of the stars.

In the knowledge that such an all-encompassing approach can barely be dealt with in one single exhibition, *1.5 Degrees* is divided up into several fragments that are spread out on all the levels of the new building of the Kunsthalle, but are also included in the exhibition spaces of the Jugendstil building. An exhibition, curated by Thomas Köllhofer, of drawings and prints on the topic of insects, which is also documented in this catalogue, belatedly opens there as well. In addition, two outposts of the exhibition are situated on the grounds of The German National Garden Show Mannheim 2023 (BUGA 23), which forms the content-related and organizational occasion for this extensive exhibition project. They are incorporated in a rededication of a former American military base as part of the BUGA 23. The garden show not only offers a grand temporary flower display, but also brings together approaches to sustainable urban developments and would like to contribute to creating a green lung in the cityscape.

The two installations by Olaf Holzapfel and Fabian Knecht that can be seen there form a bridge to the exhibition at the Kunsthalle, where a paradigmatic installation by Knecht is presented directly in the atrium: a large number of manipulated thermometers showing the lower values desired instead of the actual temperature—a visualization of the divergence between wish and reality that defines our current situation. From there, one enters the generous exhibition spaces on the ground floor, where the air-conditioning systems are set in such a way that they operate in an energy-saving manner—not least due to the current energy crisis—with considerably different winter and summer temperatures, since the Kunsthalle Mannheim already implemented a conversion to passive-building standards in 2011 and hence a resource-saving operation of all technical systems. Here, one sees a dystopian-seeming film installation by Julian Charrière about our dependence on processes involved in the burning fossil fuels, juxtaposed with a significantly older work by Jannis Kounellis that also focuses on coal. In the adjoining exhibition fragment, installations by melanie bonajo and Ernesto Neto inspire us to treat our environment with care. Another fragment addresses the huge challenges with which we are confronted through a focus on possible approaches to solutions: thus, for instance, an early work by the SUPERFLEX group on decentralized ecological biogas facilities or Kyriaki Goni's utopian-seeming research on the storage of large amounts of data in the DNA of plants. Admonishing and impressive works are thus presented next to ones that encourage a more emphatic approach to the ecosystems of our oceans and forests, but also next to positions that examine the utopian promises of technical processes.

As curators of an exhibition on interdependencies between life, the cosmos, and technology in an age when dramatic changes in the climate are taking place, we neither claim to know how or if these crises might be resolved, nor do we present a particular reading to our audience from one secure position. The intention is instead to bring together possibly contradictory and historically very different positions in order to provide a kaleidoscopic picture that gives

rise to reflection, contemplation, ideas, and differentiated opinions.

The works with a very different focus that are presented on the first floor are also conducive to this. Here, attention is given to the mutual dependency and interconnection of all living creatures on planet Earth; this takes place with works that have in part been presented in very different contexts in the past years, such as an installation by Laure Prouvost, more recent works by Marianna Simnett, and Anne Duk Hee Jordan, and historical works, for example, by Joseph Beuys. On the second floor of the Kunsthalle, one can view works that initiate reflections on human changes to outer space (by Eva Gentner) and the depths of the ocean (by Otobong Nkanga). They are juxtaposed with two works by Anselm Kiefer, which are found at the Kunsthalle as permanent loans. Collection holdings are thus consistently supplemented so as to include new readings. This principle continues through other parts of the collection presentation, where new constellations make it possible to apprehend how artists have processed the abovementioned interdependencies in their works outside of this millennium. The exhibition thus extends back to the turning point of industrialization at the end of the nineteenth century, which also shaped the development of Mannheim as a city of industry in a particular way. The temperatures that prevailed prior to the beginning of industrialization are simultaneously the reference values for the 1.5-degree target stipulated in the Paris Climate Accords of 2015.

In her essay, Eva Horn examines the role that art can play in an age—the Anthropocene—profoundly shaped by human beings. Her thesis that the concern should not be with illustrating the climate crisis, but instead with making viewers aware of their interconnections with the world around them, corresponds to a guiding theme in the exhibition. The second essay, by Irina Danieli, on the depiction of animals in historical and contemporary art, also leads to the conviction that the separation of human and animal life that long prevailed has given way to a different position in many contemporary artworks: animals are important for us.

My heartfelt gratitude goes to the two authors, as well as to all the other authors, exhibiting artists, and all the individuals involved in the project. In addition, I am extraordinarily thankful to the curatorial team of *1.5 Degrees* (Anja Heitzer, Sebastian Schneider, Inge Herold, and Pia Goebel) as well as to Thomas Köllhofer, the curator of the exhibition *The Insect*. The realization of this extensive project would not have been possible without Katrin Radermacher, the head of conservation, and the exhibition technology team, who realized the installation of the exhibition very professionally. I also extend my thanks to the Kunsthalle Mannheim Foundation and the Hector Foundations for their generous financial support for the exhibition project. My gratitude also goes to the BUGA 23, which as a cooperation partner facilitated an ideal collaboration from the very beginning.

I believe that I may speak for all the participants when I express my hope here that this publication and the exhibition succeed in making a productive contribution to the discussion of the huge challenges with which all living creatures on this planet are confronted. I would also like to emphasize that this publication was intentionally produced in cooperation with Hatje Cantz in a resource-saving manner. For this initiative, I would like to express my heartfelt thanks to both the publishing house and Karsten Heller, the designer of this book. The exhibition catalogue incorporates a guiding principle that also shaped the exhibition as a whole. We have thus been able to add another key component to the Kunsthalle Mannheim's efforts over more than one decade to work sustainably. Our aim in doing so is not merely to fulfill standards set for this project just this one time, but instead to give priority to such measures that can also be implemented in connection with future projects—in the sense of true sustainability.

Johan Holten

Ästhetik des Anthropozäns

Eva Horn

Was kann es heißen, eine Ästhetik des Anthropozäns zu skizzieren? Wie kaum ein anderer Begriff ist das Anthropozän im Kunstbetrieb zu einem Schlagwort geworden, das vor allem Aktualität und politische Relevanz signalisieren soll. Wird in Ausstellungen, Seminaren und Diskussionsveranstaltungen eine »Ästhetik des Anthropozäns« beschworen, geht es dabei meist allgemein um die ökologische Krise, Klimawandel, Müll, Artensterben oder Fragen der Koexistenz mit anderen Spezies, mit denen sich Kunst zu befassen habe – und schon haben wir eine Ästhetik. Zugrunde liegen dem vor allem bestimmte Erwartungen an Kunst: Kunst soll das sehr abstrakte Konzept Anthropozän denk- und wahrnehmbar machen, eine Alternative zum Diskurs von Wissenschaft und Politik bieten und so neue Instrumente des Denkens zur Verfügung stellen: »Modernity was a way to differentiate past and future, north and south, progress and regress, radical and conservative. However, at a time of profound ecological mutation, such a compass is running in wild circles without offering much orientation anymore. This is why it is time for a reset.«[1] So heißt es im *Field Book* der von Bruno Latour kuratierten Ausstellung *Reset Modernity!*. Kunst soll nicht nur helfen, die Dinge anders zu sehen, sondern auch mobilisieren.

Dabei handelt es sich um mehr oder minder sinnvolle Erwartungen und Annahmen über Kunst und ihre Wirkungen. Aber dies alles stellt noch lange kein ästhetisches Programm dar. Was man dann de facto zu sehen bekommt, ist Themenkunst, sind lockere Assoziationen oder bemühte Künstlerkommentare, die das, was man immer schon gemacht hat, nun »im Anthropozän« verorten. Viele Romane, Filme oder Kunstwerke, die sich mit Klimawandel beschäftigen (von Climate Fiction bis hin zu bestimmten Formen der Landschaftsfotografie) werden so zu Anthropozän-Kunst erklärt, ohne dass klar ist, was es eigentlich heißen würde, die fundamentale Transformation des Planeten zum Prinzip einer bestimmten Art von Darstellung zu machen. Eine genuine Ästhetik des Anthropozäns muss also über die Rhetorik der politischen Mobilisierung und über bloße Thematisierungen hinausgehen. Sie hat zu fragen, was es eigentlich bedeuten könnte, sich nicht bloß in bestimmten Inhalten und Themen

dem Befund des Anthropozäns, sondern in der Form ästhetischer Darstellung zu stellen.

Welche Form eine solche Darstellung annehmen könnte, zeigt eine Bildlektüre, die Bruno Latour der siebten Vorlesung seines Buches *Kampf um Gaia* voranstellt. Es geht durchaus nicht um ein zeitgenössisches Kunstwerk, sondern um Caspar David Friedrichs Gemälde *Das Große Gehege bei Dresden* (1831/32, Abb. 1).[2] Das Bild zeigt eine Landschaft am flachen Flussufer, mit Uferschlamm und Wasserlachen. Dieser eigentlich flache Ufersaum aber ist seltsam gewölbt. Ähnlich gewölbt ist auch der Himmel: Er zeigt eine konkave Biegung nach oben. Nur die Horizontlinie in einer mittleren Ferne ist gerade und trennt die zwei perspektivisch verzerrten Räume, Himmel und Erde. Der Blickpunkt der Betrachtung ist schwer auszumachen – weder steht sie auf dem Grund, dessen merkwürdige Kurvatur der Vordergrund zeigt, noch steht er in irgendeiner fixierbaren Höhe über dem Grund. Es ist diese seltsame doppelte Krümmung des Raumes, die Latour als Inbegriff einer Erschütterung liest, die das Anthropozän für das Weltverhältnis des Menschen bedeutet.

Schon der Kunsthistoriker Leo Körner hat gezeigt, dass hier die klassische Formkonvention der europäischen Kunstgeschichte, einen Raum perspektivisch durch einen distanzierten, aber fixen Betrachterstandpunkt visuell zu ordnen, aufgehoben oder zumindest verzerrt ist.[3] Latour geht einen Schritt weiter. Diese Konvention, so stellt er fest, war der Ausdruck eines abendländischen, spezifisch »modernen« Verhältnisses zu den Dingen der Natur: Sie werden dem objektivierenden Blick untergeordnet, als hätten sie keine andere Funktion, als diesem Blick präsentiert zu werden.[4] Der Blick rückt die Dinge auf Distanz, ordnet sie und erschafft so eine Welt, die sich den Betrachtenden offenbart, aber aus einer fixen und weltentzogenen Perspektive. Diese Konvention wird in Friedrichs Gemälde durchaus zitiert – vor allem in der Fluchtpunktkonstruktion des Bildes. Aber gerade dadurch wird die Abweichung umso deutlicher. »[D]as ist keine Landschaft, in die man sich beschaulich vertiefen könnte. Nichts, das Halt bietet, es sei denn, man wäre auf dem

Kahn, aber auch dann wäre man noch in Bewegung«.[5] Was Friedrichs Bild präsentiert, ist ein gekrümmter, nichteuklidischer Raum des Bildes und ein ortloser Blick der desorientierten Betrachtenden. Ein Raum, der aussieht, als würde sich in ihm die Kurvatur der Erdoberfläche abbilden, inklusive Wasserpfützen, die nicht gerade sind, sondern ebenfalls gekrümmt.

Diesen seltsam verzerrten, runden Raum versteht Latour nun als Sinnbild eines menschlichen Standpunkts im Raum einer Natur, in der die Natur nicht länger eine fixierbare Form und der Mensch keinen bestimmbaren Ort mehr hat. Im Anthropozän ist Natur nicht mehr als stabile Gegebenheit darzustellen, sondern nichttotalisierbar und nichtobjektivierbar. Die Betrachtenden sind in diesem Raum gefangen, aber auf einer schwankenden Position. »Das Geniale an diesem Gemälde liegt darin, daß es die Instabilität jedes Blickpunkts auf die Welt – von oben, von unten, oder von der Mitte aus – bezeichnet hat. Das Große Gehege, die große Unmöglichkeit, besteht nicht darin, auf ERDEN eingeschlossen zu sein, sie besteht in dem Glauben, diese sei als ein vernünftiges und in sich stimmiges GANZES erfaßbar, wenn man die unterschiedlichen Größenordnungen in einander schachtelt, von den lokalsten bis zu den globalsten [...].«[6]

Latours Lektüre dieses Bildes ist beispielhaft für eine Ästhetik des Anthropozäns. Das Bild Caspar David Friedrichs scheint eine konventionelle Landschaftsdarstellung zu sein, jedoch mit einer winzigen, aber entscheidenden Abweichung in der Form, einer Verzerrung des dargestellten Raumes. Es geht nicht darum, dass hier Natur als Inhalt dargestellt wird, sondern dass durch die Darstellung selbst die Vorstellung einer transparenten und intelligiblen Anordnung von Welt verabschiedet wird. An ihre Stelle tritt eine tiefgreifende Desorientierung, die Betrachtende ebenso umfasst wie das Dargestellte: eine »Beeinträchtigung der Beziehung zur Welt«[7] und ihrer Kategorien von Subjekt und Objekt, Menschlichem und Nichtmenschlichem, Ganzem und Teil, Position der Betrachtenden und Raum der Darstellung. Das Anthropozän ist die fundamentale Erschütterung eines Dualismus, der lange Zeit nicht nur den

Abb. / Fig. 1
Caspar David Friedrich
*Das Große Gehege bei Dresden /
The Great Enclosure near
Dresden*, 1831/32
Öl auf Leinwand / Oil on canvas
73,5 × 103 cm
Staatliche Kunstsammlungen
Dresden, Galerie Neue Meister

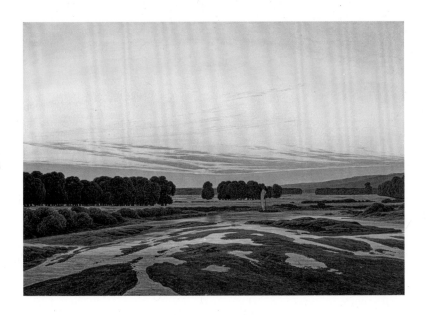

theoretisch-technischen Zugang zur Welt prägte, sondern auch die Konventionen einer Ästhetik, die sich eigentlich als Gegenentwurf dazu verstanden hatte.[8] Diese inkludierte eine Naturästhetik, die die Natur (oder das Nichtmenschliche) als das Unverfügbare, Harmonisch-Schöne oder auch Schrecklich-Erhabene als Gegenpart des Menschlichen gefeiert hatte.

Die Erschütterung traditioneller Erkenntnis- und Betrachtungsformen wird nun aber gerade nicht durch das Sujet des Bildes geleistet, sondern durch die Art und Weise, wie die Welt hier in eine spezifische Form und ein Verhältnis zu den Betrachtenden gebracht wird. Wenn das Anthropozän nicht weniger ist als eine neue Art des In-der-Welt-Seins, so bedeutet dies eine Erschütterung auf zwei Ebenen: erstens als Frage, welche Zugangsweisen und Erkenntnisformen des Nichtmenschlichen wir unter den Bedingungen des Anthropozäns haben; und zweitens als Frage, wie dieses neue Verhältnis zwischen Menschlichem und Nichtmenschlichem zum Gegenstand ästhetischer Darstellung werden kann.

Die neuzeitliche Konstruktion von Natur, deren Erschütterung Latour in Friedrichs Bild erkennt, beruhte auf einem fundamentalen Dualismus von Subjekt und Objekt. Während das (menschliche) Subjekt erkennend, reflektierend, aber auch affektiv bewegt gedacht wird, wurden dem Nichtmenschlichen bestimmte Eigenschaften zu-, aber auch abgesprochen: Die Dinge der Natur werden als stabile Materie verstanden, die bestimmten, für den Menschen grundsätzlich erkennbaren Regeln – den Naturgesetzen – gehorchen, aber keine eigenen Intentionen, Wahrnehmungen oder Bewusstsein haben. Die Natur macht keine Sprünge. Unveränderlich und nach berechenbaren Gesetzen funktionierend, kontinuierlich in Raum und Zeit, lässt sich Natur methodisch beobachten, in Teilaspekte zerlegen, experimentell erschließen und technologisch manipulieren – so die Naturauffassung der Moderne.

Was damit zum Verschwinden gebracht wurde, ist eine Natur, die in vielfältigen, komplexen Verflechtungen besteht, eine Natur, die eben durchaus Sprünge macht und die auch nicht so exakt von Kultur zu separieren ist, wie man glaubte. Eine Natur, die nicht objektiviert und epistemologisch auf Abstand gehalten werden kann und die nicht in Teile zerlegbar ist, ohne wesentliche Zusammenhänge aus den Augen zu verlieren. Erst die Ökologie wird diese Verwobenheit der unterschiedlichsten Akteure in der Natur – und die Verwobenheit menschlicher Lebensformen mit diesen – in den Fokus eines modernen Naturverständnisses stellen. Die Erdsystemwissenschaften gehen noch weiter und beschreiben heute eine Natur der gegenseitigen Abhängigkeiten und Selbstregulationsmechanismen, eine Natur, die unberechenbare *tipping points* und Emergenzeffekte kennt. Spätestens mit dem Klimawandel wird dies allgemeines Wissen.

Der neuzeitliche Dualismus zwischen einer gesetzmäßigen Natur und einem beobachtenden und erkennenden Menschen, zwischen Objekt und Subjekt war die Basis der modernen Naturästhetik.[9] Ein ästhetischer Blick auf Natur wird dabei – dafür steht exemplarisch Kants *Kritik der Urteilskraft*[10] – als Alternative und Ergänzung zur wissenschaftlichen und technischen Herangehensweise verstanden, als Vermittlung zwischen einem theoretisch-wissenschaftlichen Weltzugang und der Sphäre menschlichen Handelns. Ästhetische Erfahrung von Natur, so Kant, liegt nicht im Objekt selbst, sondern in der Haltung des Subjekts, das einen Gegenstand entweder als »schön« oder »erhaben« erfahren kann. Während das

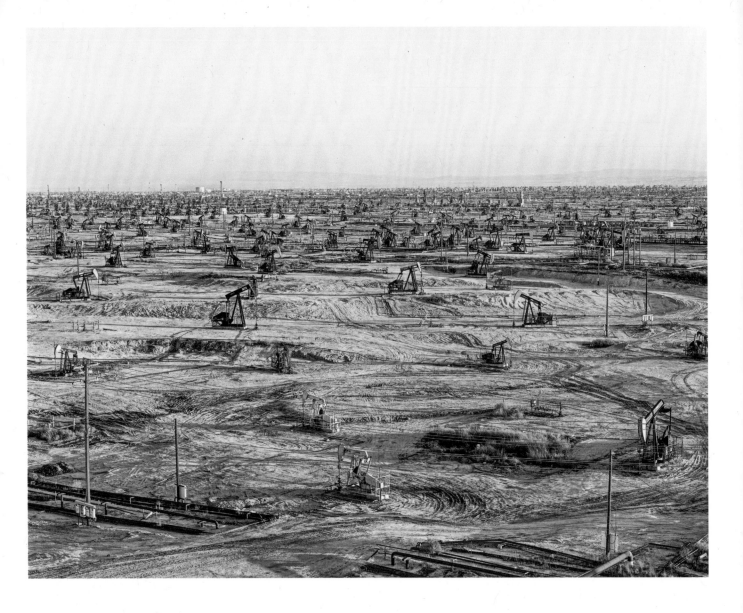

»Naturschöne«, so Kant, »uns eine Technik der Natur entdeckt«, das heißt ihren zweckmäßigen inneren Zusammenhang erkennen lässt, ist die Erfahrung des Erhabenen eine der Überwältigung durch den Gegenstand der Betrachtung.[11] Überwältigt das »mathematisch Erhabene« durch seine »schlechthinnige Größe«,[12] so das »dynamisch Erhabene« durch die Kraft oder Gewalt, die in ihm zum Ausdruck kommt. Das, »was in uns das Gefühl des Erhabenen erregt«, erscheint »der Form nach [...] zweckwidrig für unsere Urtheilskraft, unangemessen unserem Darstellungsvermögen und gleichsam gewaltthätig für unsere Einbildungskraft«.[13] Wahrnehmung, Imagination und Urteilsvermögen geraten an eine Grenze. Typische Gegenstände dieser Erfahrung des Erhabenen sind für Kant vor allem Dinge der Natur – riesige Berge, Unwetter, Eismassen, Gewitter, bedrohliche Felsen, melancholische Einöden oder reißende Ströme. Wichtig ist hierbei jedoch eine Distanzierung der Betrachtenden: durch die Fähigkeit, zugleich vom Gegenstand überwältigt zu werden und diese Erfahrung in Reflexion zu überführen, also zum Beispiel angesichts der Riesenhaftigkeit eines Berges ein Gefühl für die Unendlichkeit des Alls zu bekommen. So werden der sublime Schrecken und die Überwältigung durch die Größe oder Kraft eines Gegenstands bei Kant eingefangen als Selbstvergewisserung des Subjekts.

Natur kann aber nicht nur als schöne oder erhabene, sondern auch als verlorene oder entfremdete Natur in den Blick genommen werden. Ästhetische Darstellung wäre dann entweder der Versuch, dieses Verlorene zu retten oder zurückzugewinnen

14

Abb. / Fig. 2
Edward Burtynsky
*Oil Fields #2, Belridge, California,
USA*, 2003
Digitaler Farb-Chromogendruck /
Digital chromogenic color print
Maße variabel / Dimensions
variable

– etwa in Formen des Nature Writing, aber auch in der modernen Landschaftsmalerei und -fotografie –, oder eine Form, die Verlorenheit und Zerstörtheit der Natur greifbar zu machen. Eine solche negative Ästhetik insistiert gerade auf der Nichtdarstellbarkeit der entfremdeten Natur. In der Ästhetik der Moderne wird so die von Kant beschworene Distanzierung des Subjekts angesichts des Erhabenen fragwürdig. Theodor W. Adorno etwa versteht sie weniger als den Ausweis der Überlegenheit des Menschen über die Natur als seiner Verfallenheit an die Natur: »Weniger wird der Geist, wie Kant es möchte, vor der Natur seiner eigenen Superiorität gewahr als seiner Naturhaftigkeit.«[14] In der Figur des Erhabenen sieht der Philosoph Jean-François Lyotard die Signatur einer postmodernen Ästhetik, die immer auf ein irreduzibles Undarstellbares und Unkommunizierbares verweist: »The sublime *denies itself the solace of good forms*, the consensus of a taste which would make it possible to share collectively the nostalgia for the unattainable, that which searches for new presentations, not in order to enjoy them, but in order to *impart a stronger sense of the unpresentable*«.[15]

Im modernen Erhabenen erscheint so nicht mehr eine Überwältigung durch die Natur, sondern ihre Undarstellbarkeit. An genau diese Diagnose eines Widerstands gegen Darstellung schlechthin schließt eine ästhetische Theorie des Anthropozäns an. Allerdings kann sie sich weder auf die klassische Naturästhetik Kants noch auf Denkfiguren der Entfremdung zurückziehen, sondern muss die Vorstellung von Natur als Anderes und Gegenüber des Menschen selbst infrage stellen. Timothy Morton hat daher vorgeschlagen, den emphatischen Naturbegriff ganz aus einem ästhetischen Programm zu verbannen. Es geht nicht mehr um »Natur«, sondern um »Ökologie« – also keinen unmittelbaren, sondern einen radikal vermittelten oder sogar verstellten Zugang zu Natur.[16]

Muss man den Begriff der Natur also verabschieden? Mir erscheint es sinnvoller, von einer tiefen Transformation auszugehen, die das Nichtmenschliche wie den Menschen betrifft. Eine Ästhetik des Anthropozäns muss sich mit deren fundamentaler Verfremdung auseinandersetzen. Natur kann im Anthropozän nicht mehr als objektivierbare Materie verstanden werden, als etwas, das wahrgenommen wird, aber ohne Wahrnehmung ist, das bearbeitet wird, aber ohne Handlungsmacht ist, etwas, das auf Distanz gerückt werden kann. Die Natur, so Amitav Ghosh, erwidert den Blick, sie ist auf eine unheimliche – das heißt zugleich verdrängte und vertraute – Weise lebendig, bedrohlich, unberechenbar, empfindungsfähig und affektgeladen. Damit wird uns klar, »dass wir uns Elemente unserer Wirkmacht und Bewußtheit mit anderen Wesen und vielleicht sogar mit dem Planeten selbst teilen«.[17] Ghosh fordert »recognition« in einem doppelten Sinne: ein Wiedererkennen von etwas bereits Gewusstem, aber Verdrängtem einerseits, aber auch die Anerkennung des Nichtmenschlichen als eigenwillig, gefährlich, diskontinuierlich und unberechenbar. Verabschiedet man einen Begriff von Natur als das Andere der Kultur, dann ist nicht mehr die Ferne von Mensch und Natur, sondern gerade die unauflösbare Verwobenheit des Menschen mit der Welt (anderen Lebewesen, anderen Lebensformen, Dingen, Technologien) die eigentliche Herausforderung des Anthropozäns: eine Existenz »within the thick of the world, life in a vortex of shared precariousness and unchosen proximities«.[18]

So findet sich der Mensch nicht mehr als Gegenüber, sondern gleichsam im Inneren der Dinge wieder: im Inneren des Klimawandels, inmitten von koexistierenden und symbiotischen Lebensformen, umstellt von Technologien, abhängig von Kapital- und Materialflüssen, die Ökonomien wie Ökologien verändern. In dieses Gewühl der Welt ist der Mensch als Verantwortlicher und Betroffener verwickelt. Die Frage ist, wie er diese wahrnehmen oder – wichtiger noch – darüber reflektieren kann, dass (und warum) er sie eben nicht wahrnimmt. Jede Kunst des Anthropozäns, die sich nicht mit bloßer Thematisierung zufriedengeben will, muss diese Unwahrnehmbarkeit und Unheimlichkeit in ihrer Form ausdrücken. Sie muss etwas sicht-, fühl-, spür- und denkbar machen, was sich phänomenaler Erfahrbarkeit entzieht – und zwar nicht wegen seiner Ferne, sondern wegen seiner Nähe. Anders als in den Ästhetiken der klassischen Moderne

hat die Undarstellbarkeit also nicht mit einem Entzug und einer Unverfügbarkeit der Dinge zu tun. Vielmehr hat sie mit einer unheimlichen, unkontrollierbaren und unüberschaubaren Intimität mit den Dingen zu tun, einer Hyperkomplexität und Überdimensionalität des Nichtmenschlichen, in die menschliche Existenz verstrickt ist. Es ist zu nah, um es objektivieren zu können, zu groß, um es abbilden zu können, zu komplex, um es zu erzählen.

Damit lassen sich drei fundamentale Herausforderungen für eine Ästhetik des Anthropozäns benennen: Eine erste Herausforderung ist Latenz: Prozesse wie Klimawandel oder Artenschwund sind, das ist oft wiederholt worden, schwer als Phänomen beobacht- oder erfahrbar. Was wir davon wissen, wissen wir durch die Vermittlung von Wissenschaft: Messungen, Modellierungen, Prognosen. Die tiefgreifenden ökologischen Veränderungen des Planeten sind zu groß, zu langsam, ortlos und finden zumeist unterhalb der menschlichen Wahrnehmungsschwelle statt. Was bleibt, sind einzelne, katastrophische Ereignisse, die zwar spektakulär und traumatisch sind, aber immer als Ausnahmen erfahren werden. Wie kann man die langsamen und doch drastischen Veränderungen von Lebenswelten und Lebensgrundlagen beobachten, wenn sich im Prozess dieser Veränderung der Maßstab der Beobachtung verschiebt? Wie kann man einen Anstieg von 200 ppm CO_2 spüren, riechen, sehen? 200 ppm CO_2 sind genau das, was uns vom vorindustriellen Zeitalter trennt. Die Frage, die sich für eine Ästhetik des Anthropozäns stellt, ist wie man diese latenten Vorgänge manifest, spürbar, wahrnehmbar, verstehbar machen kann – jenseits der abstrakten Darstellungen, die die Wissenschaft anbietet.

Zweitens stellt Verstrickung respektive *entanglement* eine komplexe Herausforderung dar: Die Erkenntnis der planetarischen Krise des Anthropozäns verschärft eine Diagnose, die die Ökologie schon früh formuliert hat: Alles ist miteinander verflochten. Klimawandel affiziert Wettermuster und Landschaften, Artenschwund verändert Ökosysteme radikal, die Veränderung der Meere lässt nicht nur den Wasserspiegel steigen, sondern verändert auch das Strömungsgefüge der Ozeane. Angesichts dieser planetarischen Verknüpfungen spricht beispielsweise die Klimaforschung mittlerweile von verknüpften Kipppunkten, deren genaue Formen des Ineinandergreifens nur teilweise modellierbar sind.[19] Die andere Seite der Verstrickung sind die komplexen, oft existenziellen Interdepenzbeziehungen des Menschen mit Nichtmenschlichem: Unsere Körper hängen von Symbiosen mit zahlreichen anderen Organismen ab, unsere Ernährung von Mikroorganismen im Boden oder Insekten als Bestäubern, unsere Lebensweisen von Wasserzyklen, Vegetation, Witterungen. Lässt sich der Mensch überhaupt isoliert von diesen Abhängigkeiten denken? Und was ist der menschliche Organismus, wenn er im Grunde als eine »multispecies assemblage« verstanden werden muss?[20] Können wir den Menschen noch als eine separate Spezies denken oder müssen wir ihn nicht eher in Übergängen und Abhängigkeiten von anderen Lebensformen betrachten?

Die dritte Herausforderung ist das Aufeinandertreffen inkompatibler Größenmaßstäbe.[21] Dieser *clash of scales* präsentiert sich auf verschiedenen Ebenen, als Aufeinanderprallen von Zeitskalen (kurze Menschenzeit versus Tiefenzeit der Erdgeschichte, aber auch *deep future* der Erde), von Raumdimensionen (lokale Lebensformen versus planetarische Veränderungen des Erdsystems) und der Anzahl von Handelnden (individuell harmlose Praktiken versus ihre milliardenfache Multiplikation). Die Eingriffe des Menschen in das Erdsystem finden auf Ebenen statt, die entweder zu groß oder zu klein sind: Sie finden zugleich auf planetarischer und molekularer Ebene statt, wie insbesondere die Gaia-Theorie deutlich macht. Jede ästhetische Darstellung der planetarischen Prozesse des Anthropozäns muss sich diesen unverfügbaren und unzugänglichen Größenordnungen stellen und Dinge abbilden, die nicht auf Menschenmaß zu bringen sind. Das bedeutet durchaus nicht, einfach große Kunst zu machen wie Land Art. Es bedeutet eher, die Inkompatibilität unterschiedlicher Blickrichtungen zu behandeln, in denen – je nach Größenordnung der Auflösung oder Darstellung – ganz andere Aspekte sichtbar werden oder auch ganz andere Wirklichkeiten entstehen.

Abb. / Fig. 3
Ackroyd & Harvey
Face to Face (Lauranne), 2012
Durch fotografische Photosynthese in Graskeimlinge eingeprägtes Bild / Image imprinted in seedling grass through the process of photographic photosynthesis, 500 × 375 cm
Installationsansicht / Installation view Domaine de Chamarande

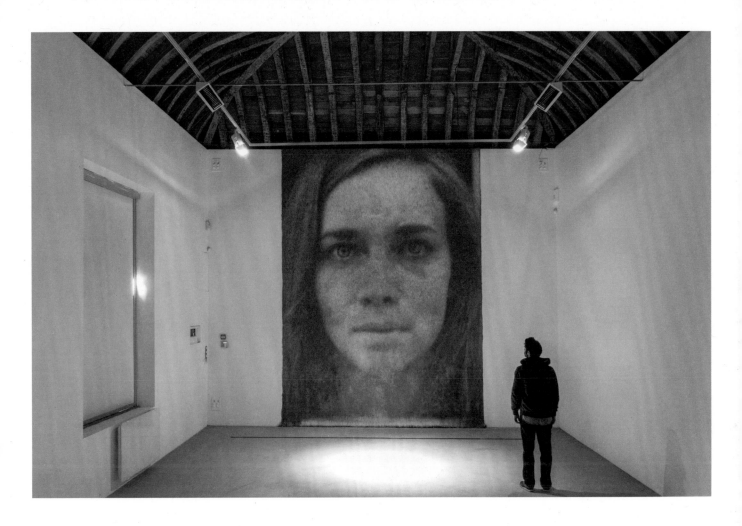

Latenz, Verstrickung und *clash of scales* sind dabei eng zusammenhängende Herausforderungen. Probleme der Darstellbarkeit und Latenz lassen sich auf inkompatible Größenordnungen oder komplexe Verstrickungen zurückführen. Gemeinsam ist diesen drei Herausforderungen, dass sie sich weniger auf der Ebene der Gegenstände stellen, denn als Probleme der Form oder Perspektive. Sie sind in den letzten Jahren oft unter einem vertrauten Begriff diskutiert worden, nämlich dem des Erhabenen.[22] Schon Kants Begriff des »mathematisch Erhabenen« adressiert ausdrücklich eine Konfrontation inkommensurabler Größenordnungen. Erhaben ist, was nicht in Relation zu etwas anderem, »größer als ... x« ist, sondern »schlechthin groß«.[23] Kant geht es dabei darum, an einer überwältigenden Form von Erfahrung – wie Erschrecken, Ehrfurcht oder Entsetzen – zu zeigen, wie der Mensch kraft seines Verstands auch diese noch in ästhetischen Genuss verwandeln kann. Diese Art der ästhetischen Erfahrung setzt jedoch

Distanzierung voraus. Das Erhabene ist ein »Schiffbruch mit Zuschauer«.[24] Jean-Baptiste Fressoz deutet die Affinität des Anthropozän-Konzepts mit dem Erhabenen daher kritisch als den Ausdruck eines Weltverhältnisses, das im Wunsch nach Kontrolle und Distanz besteht. Am »leicht schuldbewußten Vergnügen« in der Erfahrung des Erhabenen, an seiner Affinität zu Gewalt ebenso wie zu technologischer Dominanz zeige sich eine technizistische und apolitische Ideologie: »Es scheint aufregender, die Bewegungen der Menschheit als tellurische Kraft zu denken als die Rückentwicklung eines ökonomischen Systems.«[25]

Ein Beispiel für eine solche Ästhetik des Erhabenen wäre die Perspektive aus großer Ferne, die zeitgenössische Fotografie prägt. Werke wie die düster-schönen Fotografien von Industrielandschaften oder Umweltzerstörung von David Maisel und Edward Burtynsky (Abb. 2) oder auch Aufnahmen der Tempel des Konsums, der Finanzwelt oder des Verkehrs bei Andreas Gursky versuchen gerade durch den Blick

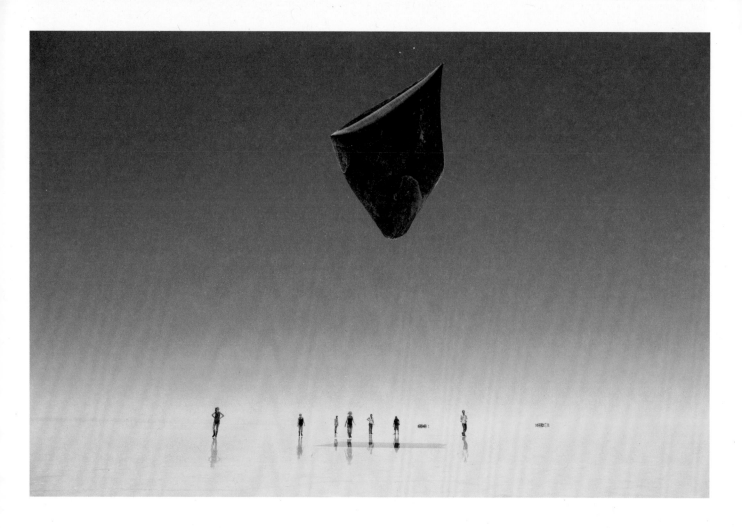

von oben die riesigen Dimensionen heutiger planetarischer Veränderungen sichtbar zu machen.

Die Frage ist, ob aus dem distanzierten Blick notwendig eine technizistische Ideologie spricht. In den genannten Werken scheint es eher darum zu gehen, die Größenordnung ökologischer Zerstörung, massiver Landschaftstransformation oder auch exzessiven Konsums vor Augen zu führen. Dies erscheint weniger als Dominanzgeste denn als Versuch, das »schlechthin große« Ausmaß anthropogener Weltveränderung visuell zu fassen. Die fernen, mal infernalisch zerstörten, mal dämonisch schönen Landschaften, die diese Fotografie zeigt, werden so aus der Latenz ihres Unbeachtet-Seins gehoben. Der nichtmenschliche Blick von oben ist eine Bedingung dieses Manifest-Werdens.

Andere Theorien des Erhabenen im Anthropozän verstehen dieses dagegen als Erfahrung, die statt der Distanzierung der Betrachtenden gerade deren Verstricktheit in das Dargestellte aufruft – oder auch erst herstellt. Das Erhabene wird so zum Schauplatz von Grenzverwischungen zwischen Subjekt und Objekt, Identität und Anderem, Notwendigem und Kontingentem, Vordergrund und Hintergrund. Ein Beispiel für die Unheimlichkeit der Übergänge oder auch Nähe zwischen Menschlichem und Nichtmenschlichen wären die seltsamen Mensch-Tier-Hybride etwa im Werk Kate Clarks oder Patricia Piccininis.

So ist das Erhabene des Anthropozäns etwas ganz anderes als das Kants. Es vermittelt eine Einsicht in eine postnatürliche Natur, in die der Mensch zutiefst involviert ist, ohne sie jedoch zu überblicken, für die er Verantwortung trägt, ohne sie zu kontrollieren, mit der er eine Intimität teilt, ohne sie zu verstehen. »A sublime encounter with climate change«, so Maggie Kainulainen, »is marked by uncanny and unwanted potency, as one finds oneself implicated in the complex web of interactions that will produce some level of global catastrophe«.[26] In dieser Erfahrung der unvorhersehbaren Berührungen und Abhängigkeiten liegt die ökologische Pointe eines Erhabenen im

Abb. / Fig. 4
Tomás Saraceno
*Eclipse of the Aerocene
Explorer,* 2016
Performance Salar de Uyuni,
2016
Foto / Photo: Studio Tomás
Saraceno, 2016

Anthropozän. Die ästhetische Erfahrung ist eine der radikalen Immanenz. Die reflexive Freiheit Kants weicht einer verstörenden Intimität mit einer Welt, die nicht mehr allein Lebenswelt des Menschen ist. Kunst bringt die Welt damit in eine beklemmende Nähe. Dies leisten die massiven Maßstäbe der Fotografie, die ein Außen jenseits zerstörter Landschaften undenkbar machen.

Einer anderen Strategie, die gleichermaßen mit Manifestation des Latenten und Entfremdung des Vertrauten arbeitet, bedienen sich Tara Donovan oder das britische Künstlerduo Ackroyd & Harvey in ihren postnaturalen Installationen (Abb. 3). Virtuos schlagen sie eine Brücke zwischen (vermeintlich) natürlichen und künstlichen Formen, Materialien und Oberflächen. Bei Ackroyd & Harvey, indem sie zum Beispiel lebendiges Gras zum Bildträger von Fotografien machen; bei Donovan, indem sie Formen wie Wolken, Zellmembranen, Schimmel oder Tropfsteinsäulen aus industriellen Materialien wie Plastik, Papier oder Folie herstellt, dies allerdings in riesigen Dimensionen.

Eine andere Möglichkeit, die Unspürbarkeit des Klimawandels sinnlich fühlbar zu machen, sind die künstlichen Atmosphären eines Philippe Rahm oder Olafur Eliasson, die in kleinen, geschlossenen Architekturen die Wirkung von Nebel, Licht, Wasser, Temperatur oder bestimmten Farben auf den menschlichen Körper, aber auch auf menschliche Gemeinschaften experimentell explorieren. Tomás Saracenos *Aerocene*-Projekt dagegen erforscht Klima und Luftströme als planetarisches Transportsystem, das Energie, Materialien und Lasten energieneutral von einem Ort zum anderen bewegt (Abb. 4).

Was diese – experimentellen und stark wissenschaftsbasierten – Projekte gemeinsam haben, ist die Absicht, einen unbeachteten oder nicht wahrgenommenen Hintergrund in den Vordergrund zu bringen. Peter Sloterdijk hat diese Strategie »Explikation« genannt.[27] Explikation kann in der Störung oder Zerstörung dessen bestehen, was sie »explizieren« – also hervortreiben, erklären, rekonstruieren – will: atembare Luft, erwartbares Klima, lebbare Landschaften. So gesehen, ist das Anthropozän selbst eine Art Explikation des Erd-

systems, ein planetarisches Experiment. Als ästhetische Strategie dagegen ist Explikation die Möglichkeit, im Experiment Unwahrnehmbares wahrnehmbar, Verborgenes sichtbar, Vernachlässigtes spürbar zu machen.

Einer Ästhetik des Anthropozäns geht es um Explikation – ein analytisches, häufig experimentelles und hochgradig wissensgestütztes Ausdrücklich-Machen von Prozessen, Gegenständen und Praktiken des Anthropozäns, die latent, zu groß, zu klein oder zu selbstverständlich sind, um wahrgenommen zu werden. Kunst kann diesen Aufmerksamkeit verschaffen, indem sie sie in eine fremde, verzerrende Form bringt. Was dabei hervortritt, ist nicht nur der Hintergrund planetarischer Prozesse, sondern auch das Ausmaß unserer Verstricktheit und Abhängigkeit in sie. Diese Prozesse sind im Begriff, gestört zu werden. Kunst wird sie vielleicht nicht retten, aber sie wird immer neu versuchen, sichtbar zu machen, was da gerade passiert.

1 Bruno Latour u. a. (Hrsg.), *Reset Modernity! Field Book,* Ausst.-Kat. ZKM | Zentrum für Kunst und Medien, Karlsruhe 2016, o.S.

2 Bruno Latour, *Kampf um Gaia. Acht Vorträge über das neue Klimaregime,* Berlin 2017, S. 373–377.

3 Leo Joseph Körner, *Caspar David Friedrich and the Subject of Landscape,* Chicago 1990.

4 Latour 2017 (wie Anm. 2), S. 37.

5 Ebd., S. 375.

6 Ebd., S. 377.

7 Ebd., S. 27.

8 Hartmut Böhme, »Natürlich / Natur«, in: Karlheinz Barck u. a. (Hrsg.), *Ästhetische Grundbegriffe,* Bd. 4, Stuttgart/Weimar 2002, S. 432–498, hier S. 435.

9 Ebd.

10 Immanuel Kant, *Kritik der Urteilskraft,* Akademieausgabe, Bd. 5, Berlin [1790] 1913.

11 Ebd., §23, S. 246.

12 Ebd., §25, S. 248–250.

13 Ebd., §23, S. 245.

14 Theodor W. Adorno, *Ästhetische Theorie,* Gesammelte Schriften, Bd. 7, Frankfurt am Main 1970, S. 410.

15 Jean-François Lyotard, *The Postmodern Condition,* Minneapolis 1984 (zuerst 1979), S. 81 (Hervorhebung d. Verf.).

16 Timothy Morton, *Ecology without Nature. Rethinking Environmental Aesthetics,* Cambridge 2007.

17 Amitav Ghosh, *Die große Verblendung. Der Klimawandel als das Undenkbare,* München 2017, S. 91.

18 Jeffrey J. Cohen, »The Sea Above«, in: ders. und Lowell Duckert (Hrsg.), *Elemental Ecocriticism. Thinking with Earth, Air, Water, and Fire,* Minneapolis 2015, S. 105–133, hier S. 107.

19 Timothy M. Lenton u. a., »Climate tipping points: Too risky to bet against«, in: *Nature,* 575, 7784, November 2019, S. 592–595.

20 Eben Kirksey (Hrsg.), *The Multispecies Salon,* Durham/London 2014.

21 Timothy Clark, *Ecocriticism on the Edge. The Anthropocene as a Threshold Concept,* London/New York 2015.

22 *Sublime. Les tremblements du monde,* hrsg. von Hélène Guénin, Ausst.-Kat. Centre Pompidou-Metz, Metz 2016; Maggie Kainulainen, »Saying Climate Change. Ethics of the Sublime and the Problem of Representation«, in: *Symploke,* 21, 1–2, 2013, S. 109–123; Byron Williston, »The Sublime Anthropocene«, in: *Environmental Philosophy,* 13, 2, 2016, S. 155–174.

23 Kant [1790] 1913 (wie Anm. 10), §25, S. 248.

24 Hans Blumenberg, *Schiffbruch mit Zuschauer. Paradigma einer Daseinsmetapher,* Frankfurt am Main 1979.

25 Jean-Baptiste Fressoz, »L'anthropocène et l'esthétique du sublime«, in: Ausst.-Kat. Metz 2016 (wie Anm. 22), S. 44–49, hier S. 49 (Übersetzung d. Verf.).

26 Kainulainen 2013 (wie Anm. 22), S. 113.

27 Peter Sloterdijk, *Sphären III. Schäume,* Frankfurt am Main 2004, S. 66.

Aesthetics of the Anthropocene

Eva Horn

What might it mean to outline an aesthetics of the Anthropocene? Like barely any other term, the Anthropocene has devolved into a buzzword in the art world that is specifically intended to signal topicality and political relevance. When an "aesthetics of the Anthropocene" is invoked in exhibitions, seminars, and discussion events, it is generally the ecological crisis, climate change, trash, species extinction, or questions regarding coexistence with other species that art is meant to address—as if this in itself made an aesthetics. What underlies this are specific expectations of art: art is supposed to elucidate the abstract concept of the Anthropocene, to offer an alternative to the discourse of science and politics, and thus offer new instruments of thought: "Modernity was a way to differentiate past and future, north and south, progress and regress, radical and conservative. However, at a time of profound ecological mutation, such a compass is running in wild circles without offering much orientation anymore. This is why it is time for a reset."[1] This sentence comes from the *Field Book* for the exhibition *Reset Modernity!* curated by Bruno Latour.

Art should thus not only help us see things differently; it should mobilize us as well.

These are more or less sensible expectations and assumptions regarding art and its effects. But all of this still does not represent an aesthetic program. What people then de facto get to see is thematic art, loose associations, or forced artist commentaries that now situate what has always been done "in the Anthropocene." Many novels, films, or artworks that occupy themselves with climate change (from climate fiction to particular forms of landscape photography) are thus declared to be Anthropocene art, without it being clear what making the fundamental transformation of the planet into a principle of a specific sort of representation would actually denote. A genuine aesthetics of the Anthropocene must therefore go beyond the rhetoric of political mobilization and beyond merely addressing the topic. It has to interrogate what it truly might mean to be confronted with the consequences of the Anthropocene not only in particular contents and themes, but in the form of aesthetic representation.

What form such representation might take is shown by an illustrated lecture that

Bruno Latour appended to the seventh lecture in his book *Facing Gaia*. It is not about a contemporary artwork, but instead Caspar David Friedrich's painting *Das Große Gehege bei Dresden* (The Great Enclosure near Dresden, 1831–32, fig. 1).[2] The picture shows a landscape on a muddy floodplain with pools of water. This actually flat riverbank is, however, strangely warped. The sky is also arched in a similar way: it shows a concave curvature upward. Only the horizon line in the middle distance is straight and separates the two spaces distorted in perspective: the earth and the sky. The vantage point from which it is observed is difficult to identify—it is neither on the ground, whose peculiar curvature shows the foreground, nor is it at some definable height above the ground. It is this strange, doubled curvature of space that Latour reads as an embodiment of the shock that the Anthropocene signifies for people's relationship to the world.

The art historian Leo Körner already showed that the classical formal convention of European art history, according to which space is rendered in perspective by means of a distanced but fixed viewer's viewpoint, is suspended or at least distorted here.[3] Latour goes one step further. This convention, he determines, was the expression of an occidental, specifically "modern" relationship to the things of nature: they are subordinated to an objectifying gaze, as if they have no other function than to become present as this view.[4] The gaze shifts the things into the distance, arranges them, and hence creates the world that is revealed to observers, but from a fixed standpoint pulled away from the world. This convention is clearly cited in Friedrich's painting—its pictorial space is oriented toward a vanishing point. But the deviation becomes that much more notable specifically for this reason. "[T]his is not a landscape that someone might contemplate. It offers no possible stability, except perhaps on the barge, but then one would be in motion."[5] What Friedrich's picture presents is an arched, non-Euclidean pictorial space and the placeless gaze of a disoriented viewer. A space that looks as if the curvature of the surface of Earth is depicted in it, including pools of water that are not straight, but instead curved as well.

Latour now comprehends this strangely distorted, arched space as an allegory for a human point of view in the space of a nature in which nature no longer has a fixed form and human beings no longer have an identifiable location. In the Anthropocene, nature can no longer be depicted as a stable condition, but as something that cannot be totalized, cannot be objectified. Viewers are trapped in this space, but in an unstable position. "What is brilliant about this painting is the way it marks the instability of every point of view, whether it's a matter of seeing the world from above, from below, or from the middle. With the Great Enclosure, the great impossibility is not being imprisoned on Earth, it is believing that Earth can be grasped as a reasonable and coherent Whole, by piling up scales one on top of another, from the most local to the most global."[6]

Latour's reading of this picture is exemplary for an aesthetics of the Anthropocene. Caspar David Friedrich's picture seems to be a conventional landscape picture, but with a tiny though decisive deviation in form, a distortion of the space depicted. It is not about nature being presented as the content here, but instead that as a result of how it is presented even the notion of a transparent and intelligible arrangement of the world is bid farewell. In its place appears a profound disorientation that includes the viewer and what is viewed: a "mutation of the relation to the world,"[7] as well as its categories of subject and object, human and nonhuman, whole and part, position of viewers and space of representation. The Anthropocene represents a fundamental unsettling of a dualism that has shaped not only the theoretical-technical approach to the world for a long time, but also the conventions of an aesthetics that was actually comprehended as an alternative concept of it.[8] This included an aesthetics of nature that celebrated nature (or the nonhuman) as something inaccessible, harmoniously beautiful, or terrifyingly sublime as a counterpart to the human.

The unsettling of traditional forms of cognition and observation is now, however, achieved specifically not by means of the subject of the picture, but as a result of the way in which the world is here brought into

a particular form and relation to viewers. If the Anthropocene is no less than a new way of being-in-the-world, this denotes an unsettling on two levels: first, as a question of what approaches to and forms of recognizing the nonhuman we have under the conditions of the Anthropocene; and second, as a question of how this new relation between the human and the nonhuman can become an object of aesthetic representation.

The modern construction of nature, an unsettling of which Latour discerns in Friedrich's picture, is based on a fundamental dualism of subject and object. While the (human) subject is conceived as cognitive, reflective, but also affectively moved, the nonhuman was ascribed, but also denied, specific characteristics: the things of nature are regarded as stable matter that obeys particular rules that are fundamentally recognizable for human beings—the laws of nature—but have no intentions, perceptions, or consciousness of their own. Nature makes no leaps. By functioning unchangingly and according to predictable laws continuously in space and time, nature can be observed methodically, disassembled into its constituent parts, subjected to experiments, and manipulated by technology—or this was at least the understanding of nature of the modern era.

What was thus made to disappear is a nature consisting of diverse, complex interdependencies, a nature that simply by all means makes leaps, and that cannot be separated from culture as precisely as had been thought. A nature that cannot be kept at a distance in an objectified and epistemological way and that cannot be divided up into its parts without losing sight of essential interconnections. It was ecology that first made this interwovenness of the most diverse protagonists in nature—and the entanglements of human life-forms with them—the focus of a modern understanding of nature. The earth system sciences go even further and today describe a nature of interdependencies and self-regulating mechanisms, a nature of unforeseeable *tipping points* and emergence effects. This became general knowledge at the latest with climate change.

The modern dualism between a nature that follows laws and observing and discerning human beings, between object and subject, was the basis of the modern aesthetics of nature.[9] An aesthetic view of nature—for which Kant's *Critique of the Power of Judgment*[10] stands exemplarily—is thus regarded as an alternative and complement to scientific and technical approaches, as mediation between a theoretical-scientific approach to the world and the sphere of human activity. An aesthetic experience of nature, according to Kant, does not lie in the object itself, but in the attitude of the subject, who can experience an object as being either "beautiful" or "sublime." While the "beauty of nature," according to Kant, "reveals to us a technique of nature"[11] and hence enables its inner purposiveness and coherence to be apprehended, the sublime is the experience of being overwhelmed by the object of contemplation. The "mathematically sublime" overwhelms due to its "absolute scale,"[12] and the "dynamically sublime" as a result of the power or violence that is expressed in it. "What awakens a feeling of the sublime in us" seems "in its form to be contrapurposive for our power of judgment, unsuitable for our faculty of presentation, and as it were doing violence to our imagination."[13] Cognition, imagination, and the power of judgment reach a limit. For Kant, objects that are typical of this experience of the sublime are in particular natural phenomena—huge mountains, severe weather, masses of ice, tempests, towering rocks, desolate wastelands, or raging torrents. What is, however, of importance here is the distancing of the observer: as a result of being simultaneously overwhelmed by an object and translating this experience into reflection, hence, for example, obtaining a feeling for the infiniteness of outer space when confronted with the massive size of a mountain. Sublime horror and being overpowered by the magnitude or power of an object are thus captured in Kant's work as a self-assertion of the subject.

Nature can, however, be regarded not only as beautiful or sublime, but also as a lost or alienated nature. Aesthetic representation would then be either an attempt to rescue or reclaim what has been lost—for instance, in the form of nature writing, or also in modern landscape painting and photography—or a form of making the for-

lornness and destruction of nature palpable. Such a negative aesthetic insists specifically on the nonrepresentability of alienated nature. In the aesthetics of the modern era, the distancing of the subject from the sublime that Kant invokes becomes questionable. Theodor W. Adorno, for example, understands this less as an assertion of man's superiority over nature than of his being a slave to nature: "as Kant thought, spirit in the face of nature becomes aware of its own superiority, it becomes aware of its own natural essence."[14] In the figure of the sublime, the philosopher Jean-François Lyotard sees the signature of a postmodern aesthetics that always points to an irreducibly unrepresentable and uncommunicable quality: the sublime *denies itself the solace of good forms*, the consensus of a taste which would make it possible to share collectively the nostalgia for the unattainable, that which searches for new presentations, not in order to enjoy them, but in order to *impart a stronger sense of the unpresentable*."[15]

In the modern sublime, what thus arises is no longer a being overwhelmed by nature, but an inability to represent it. An aesthetic theory of the Anthropocene is linked to specifically this diagnosis of a resistance to representation as such. This can, however, be traced back to neither Kant's classical aesthetics of nature, nor to figures of thought related to alienation, but must instead call into question the notion of nature as an "other" and counterpart to human beings themselves. Timothy Morton has therefore proposed completely banning the emphatic concept of nature from an aesthetic program. It is no longer about "nature," but about "ecology"—hence not a direct, but instead a radically mediated or even shifted approach to nature.[16]

Does the concept of nature now therefore have to be discarded? It seems more productive to me to speak of a profound transformation affecting both the nonhuman and the human. An aesthetics of the Anthropocene must examine its fundamental alienation. In the Anthropocene, nature can no longer be regarded as objectifiable matter, as something that is recognized but has no cognition, that is processed but has no agency, as something

shifted into the distance. Nature, according to Amitav Ghosh, returns the gaze; it is lively, threatening, unpredictable, sentient, and charged with affect in an uncanny way—thus simultaneously repressed and familiar. It therefore becomes clear to us that "elements of agency are concealed everywhere within our surroundings."[17] Ghosh calls for "recognition" in a twofold sense: a recognizing of something that is already known but repressed on the one hand, and a recognizing of the nonhuman as self-willed, dangerous, discontinuous, and unpredictable on the other. If one bids farewell to a concept of nature as the other of culture, then the true challenge of the Anthropocene is no longer the distance between human beings and nature, but specifically the indissoluble interconnectedness of humans with the world (other living creatures, other life forms, things, technologies): an existence "within the thick of the world, life in a vortex of shared precariousness and unchosen proximities."[18]

Human beings thus no longer find themselves again as a counterpart but, so to say, in the inside of things: inside of climate change, amidst coexisting and symbiotic life forms, surrounded by technologies, dependent on flows of capital and materials that transform economies as well as ecologies. Humans are entangled in this bustle of the world as both the ones responsible and the ones who are affected. The question is how they perceive this or—even more importantly—are able to reflect on the fact that (and why) they do not perceive it. Any art of the Anthropocene that refuses to be satisfied with merely addressing must express this lack of perceptibility and uncanniness in its form. It must make it possible to see, feel, sense, and contemplate something that eludes being experienced phenomenally—and, namely, not because of its distance, but instead due to its closeness. Unlike in the aesthetics of the classical modern era, the lack of representability therefore has nothing to do with withdrawal or an inaccessibility of things. It is instead related to an uncanny, uncontrollable, and unmanageable intimacy with things, to the hypercomplexity and supradimensionality of the nonhuman in which human existence is enmeshed. It is too close to be objectified,

too large to be depicted, and too complex to be recounted.

This thus makes it possible to name three fundamental challenges for an aesthetics of the Anthropocene. A first challenge is latency: processes like climate change or species extinction are, as has frequently been repeated, difficult to observe or experience as phenomena. What we know about them we know through the mediation of science: measurements, modellings, prognoses. The far-reaching ecological changes to the planet are too big, too slow, and placeless, and generally take place below the threshold of human cognition. What remain are individual, catastrophic events, which even though they are spectacular and traumatic, are always experienced as exceptions. How can the slow and nevertheless drastic changes to living environments and the foundations of life be observed when the yardstick of observation is shifting in the process of this change? How can an increase from 200 parts per million CO_2 be sensed, smelled, or seen? 200 parts per million CO_2 are exactly what separates us from the preindustrial age. The question that this raises for an aesthetics of the Anthropocene is how these latent processes can be made manifest, palpable, perceptible, and graspable—beyond the abstract representations offered by science.

Second, entanglement represents a complex challenge: recognizing the planetary crisis of the Anthropocene compounds a diagnosis already formulated by ecology at an early point in time: everything is interconnected. Climate change affects weather patterns and landscapes; species extinction alters ecosystems in a radical way; the transformation of the oceans not only causes water levels to rise, but also alters the structure of currents in the oceans. In light of this planetary interconnectedness, climate research is meanwhile speaking, for instance, of interlinked tipping points, whose precise forms of intertwining can only be modelled in part.[19] The other side of the entanglement are the complex, often existential relations of interdependence between human beings and the nonhuman: our bodies rely on symbioses with numerous other organisms; our nutrition on microorganisms in the soil or insects as pollinators; our ways of life on water cycles, vegetation, and weather conditions. Can human beings think about themselves in isolation from these dependencies at all? And what is the human organism if it basically has to be comprehended as a "multispecies assemblage"?[20] Can we still think about human beings as a separate species or must we not consider them instead in transitions and dependencies on other life-forms?

The third challenge is the coming together of incompatible scales of magnitude.[21] This *clash of scales* is found on various levels, as a clash of time scales (brief human time versus the deep time of geological history, or the *deep future* of the earth), of spatial dimensions (local life-forms versus planetary changes to the Earth system), and of the number of protagonists (individually harmless practices versus their being multiplied millionfold). The interventions of human beings in the Earth system take place on levels that are either too big or too small: they take place on a planetary and molecular level at the same time, as the Gaia theory in particular makes clear. Any aesthetic representation of the planetary processes of the Anthropocene has to surrender to these unavailable and inaccessible magnitudes of scale and depict things that cannot be brought down to a human scale. This, however, certainly does not mean simply making large art like Land Art. It instead means negotiating the incompatibility of different vantage points, in which—depending on the order of magnitude of the dissolution or representation—entirely different aspects become visible or totally different realities emerge.

Latency, entanglement, and a *clash of scales* are thus closely interconnected challenges. Problems of representability and latency can be traced back to incompatible magnitudes of scale or complex entanglements. What these three challenges have in common is that they arise less on the level of objects than as problems of form or perspective. In recent years, they have often been discussed under a familiar term, namely that of the sublime.[22] Kant's concept of the "mathematically sublime" already explicitly addresses a confrontation of incommensurable scales. The sublime is

something that is not in relation to something that is not in relation to something else, to something "greater than . . . x," but instead "absolutely great."[23] Based on an overwhelming form of experience—such as terror, awe, or dread—Kant is hence interested here in showing how human beings can also transform such a form of experience into aesthetic pleasure with the power of their minds. This sort of aesthetic experience, however, requires distancing. The sublime is a "shipwreck with spectators."[24] Jean-Baptiste Fressoz thus interprets the concept of the affinity of the Anthropocene to the sublime rather critically as an expression of a relation to the world that consists of a desire for control and distance. A technicist and apolitical ideology is shown in the "slightly guilty pleasures" of experiencing the sublime, and in its affinity to violence as well as technological dominance: "It seems more exciting to wonder at the dynamism of a humanity as a telluric force than to think about the regression of an economic system."[25]

One example of such an aesthetics of the sublime would be the perspective from a great distance that characterizes contemporary photography. Works like the bleakly beautiful photos of industrial landscapes or environmental destruction by David Maisel and Edward Burtynsky (fig. 2), or Andreas Gursky's pictures of the temples of consumption or the worlds of finance or traffic, attempt to make visible the huge dimensions of the changes taking place on the planet today specifically by means of the view from above.

The question is whether a technicist ideology is necessarily asserted by the distanced gaze. In the works mentioned, the interest seems to be more in showing the magnitude of ecological destruction, the massive transformation of landscapes, or excessive consumption. This appears to be not so much a gesture of dominance as an attempt to capture the "absolutely great" scale of anthropogenic changes to the world visually. The distant, at times infernally destroyed, at times demonically beautiful landscapes that these photographs show are thus lifted out of the latency of their being overlooked. The nonhuman gaze from above is a condition of this becoming-manifest.

Other theories of the sublime in the Anthropocene, by contrast, regard this as an experience that invokes—or also first produces—not a distancing of viewers, but specifically their entanglement with what is presented. The sublime thus becomes a setting for a blurring of boundaries between subject and object, identity and other, the necessary and the contingent, foreground and background. One example of the uncanniness of the transitions or also the closeness of the human and the nonhuman would be the strange human-animal hybrids, for instance, in the work of Kate Clark or Patricia Piccinini.

The sublime of the Anthropocene is thus something very different than the sublime of Kant. It conveys an insight into a postnatural nature in which human beings are deeply involved but have no overall view of it, for which they bear responsibility without controlling it, and with which they share an intimacy without understanding it. "A sublime encounter with climate change," according to Maggie Kainulainen, "is marked by uncanny and unwanted potency, as one finds oneself implicated in the complex web of interactions that will produce some level of global catastrophe."[26] In this experience of the unforeseeable connections and dependencies lies the ecological punchline of a sublime in the Anthropocene. The aesthetic experience is one of radical immanence. Kant's reflexive freedom has given way to a disquieting intimacy with a world that is no longer solely the lifeworld of human beings. Art thus brings the world into an oppressive proximity. This is achieved by the massive dimensions of the photographs, which make an outside beyond destroyed landscapes inconceivable.

Another strategy that also works with manifesting the latent and alienating the familiar is used by Tara Donovan or the British artist duo Ackroyd & Harvey in their postnatural installations (fig. 3). They masterfully span a bridge between (ostensibly) natural and artificial forms, materials, and surfaces: in the work of Ackroyd & Harvey, for instance, by making living grass a picture carrier for photographs; in the work of Donovan by producing forms like clouds, cell membranes, mold, or

stalactite pillars from industrial materials such as plastic, paper, or foil, but with huge dimensions.

Another possibility to make the imperceptibility of climate change perceptible are the artificial atmospheres of Philippe Rahm or Olafur Eliasson, who explore the effect of fog, light, water, temperature, or particular colors on the human body as well as human communities in an experimental way in small, enclosed architectures. Tomás Saraceno's *Aerocene* project, in contrast, examines climate and air currents as a planetary transport system that moves energy, materials, and loads from one location to another in an energy-neutral manner (fig. 4).

What these experimental and intensively science-based projects have in common is the intention to foreground an unnoticed or unperceived background. Peter Sloterdijk has called this strategy "explication."[27] Explication can consist of disrupting or destroying what it wants to "explicate"—hence bring forth, clarify, reconstruct: breathable air, a predictable climate, livable landscapes. When viewed in this way, the Anthropocene itself is a sort of explication of the Earth system, a planetary experiment. As an aesthetic strategy, on the other hand, explication is the possibility—by means of the experiment—to make something that cannot be perceived perceptible, something hidden visible, and something overlooked palpable.

An aesthetics of the Anthropocene is about explication—an analytical, frequently experimental, and very knowledge-based making-explicit of processes, objects, and practices of the Anthropocene, which are latent, too big, too small, or too self-evident to be perceived. Art can attract such attention by being put into an alien, distortive form. What thus emerges is not only the backdrop of planetary processes, but also the extent of our entanglement with and dependency on them. These processes are in the process of being disrupted. Art will perhaps not save them, but it will try again and again anew to make what is currently occurring visible.

1 Bruno Latour et al., eds., *Reset Modernity! Field Book,* exh. cat. ZKM | Zentrum für Kunst und Medien (Karlsruhe: ZKM, 2016), n.p.

2 Bruno Latour, *Facing Gaia: Eight Lectures on the New Climatic Regime,* trans. Catherine Porter (Cambridge, UK and Medford, MA: Polity Press, 2017), pp. 220–23.

3 Leo Joseph Körner, *Caspar David Friedrich and the Subject of Landscape* (London: Reaction Books, 1990).

4 Latour, *Facing Gaia,* p. 17.

5 Ibid., p. 222.

6 Ibid., p. 223.

7 Ibid., p. 7.

8 Hartmut Böhme, "Natürlich / Natur," in *Ästhetische Grundbegriffe,* ed. Karlheinz Barck et al., vol. 4 (Stuttgart and Weimar: Metzler, 2002), pp. 432–98, esp. p. 435.

9 Ibid.

10 Immanuel Kant, *Critique of the Power of Judgment* (1790), trans. Eric Matthews (Cambridge, UK: Cambridge University Press, 2000).

11 Ibid., §23, p. 129.

12 Ibid., §25, pp. 130–32.

13 Ibid., §23, p. 129.

14 Theodor W. Adorno, *Aesthetic Theory,* ed. Gretel Adorno and Rolf Tiedemann, trans. Robert Hullot-Kentor (London et al.: Bloomsbury, 2013), p. 371.

15 Jean-François Lyotard, *The Postmodern Condition,* trans. Geoff Bennington and Brian Massumi (Manchester: Manchester University Press: 1986 [first edition 1979]), p. 81.

16 Ibid. (author's emphasis).

17 Amitav Ghosh, *The Great Derangement: Climate Change and the Unthinkable* (Chicago and London: University of Chicago Press, 2016), p. 65.

18 Jeffrey J. Cohen, "The Sea Above," in *Elemental Ecocriticism: Thinking with Earth, Air, Water, and Fire,* ed. idem. and Lowell Duckert (Minneapolis: University of Minnesota Press, 2015), pp. 105–33, esp. p. 107.

19 Timothy M. Lenton et al., "Climate Tipping Points: Too Risky to Bet Against," *Nature* 575, no. 7784 (November 2019): 592–95.

20 Eben Kirksey, ed., *The Multispecies Salon* (Durham, NC, and London: Duke University Press, 2014).

21 Timothy Clark, *Ecocriticism on the Edge: The Anthropocene as a Threshold Concept* (London and New York: Bloomsbury, 2015).

22 *Sublime: Les tremblements du monde,* ed. Hélène Guénin, exh. cat. Centre Pompidou-Metz (Metz: Centre Pompidou-Metz, 2016); Maggie Kainulainen, "Saying Climate Change: Ethics of the Sublime and the Problem of Representation," *Symploke* 21, nos. 1–2 (2013): 109–23; Byron Williston,

"The Sublime Anthropocene,"
Environmental Philosophy 13, no. 2
(2016): 155–74.

23 Kant, *Critique of the Power of Judgment*,
§25, p. 131.

24 Hans Blumenberg, *Shipwreck with
Spectator: Paradigm of a Metaphor
for Existence* (Cambridge, MA et al.:
MIT Press, 1997).

25 Jean-Baptiste Fressoz, "L'anthropocène
et l'esthétique du sublime," in *Sublime:
Les tremblements du mond*e, pp. 44–49,
esp. p. 49.

26 Kainulainen, "Saying Climate Change,"
p. 113.

27 Peter Sloterdijk, *Spheres: Volume III:
Foams—Plural Spherology*, trans.
Wieland Hoban (South Pasadena, CA:
Semiotext(e), 2016), p. 70.

Eine kleine Geschichte zu Tieren in der Kunst

Irina Danieli

»Ich fürchte, die Thiere betrachten den Menschen als ein Wesen Ihresgleichen, das in höchst gefährlicher Weise den gesunden Thierverstand verloren hat, – als das wahnwitzige Thier, als das lachende Thier, als das weinende Thier, als das unglückselige Thier.«[1]

Wenn heute lebendige Tiere in der Kunst erscheinen, sind Tierschützer*innen nicht weit. So wie es kürzlich am Kunstmuseum Wolfsburg geschehen ist: Damien Hirsts Installation *A Hundred Years* (1990), die zur Sammlung des Museums gehört, wurde für die Ausstellung *Macht! Licht!* aus dem Keller geholt, in welchem sie nach kurzer Zeit wieder verschwand. Nach einer Beschwerde von PETA wurde das Kunstmuseum vom Veterinäramt verwarnt, denn auch Schmeißfliegen fallen unter das Tierschutzgesetz.[2]

In *A Hundred Years* wird geboren, gelebt und gestorben. Die Arbeit besteht aus einem Glaskubus, der mittig durch eine Glasscheibe getrennt wird. Auf der einen Seite schlüpfen Fliegenlarven, auf der anderen befindet sich eine mit Licht ausgestattete elektrische Fliegenfalle, eine

in Viehzuchtbetrieben übliche Gerätschaft. In beiden Hälften des Kubus stehen Schalen mit Nahrung. Die gläserne Trennwand hat zwei faustgroße Öffnungen, die Fliegen können also von einem »Lebensraum« in den anderen fliegen. Die Fliegen, die durch Zufall oder Anziehung des Lichtes in den Todeskubus geraten, verglühen früher oder später in der elektrischen Falle. Theoretisch, wenn die Fliegen in dem Kubus ihres Schlüpfens blieben, wäre es möglich, dass sie ihre volle Lebenserwartung von einigen Wochen erreichen.

Die Arbeit wirft Fragen auf, die in der zeitgenössischen Kunst zunehmend verhandelt werden. Die Fliegenfalle – im Fachjargon Insektenvernichter genannt – verweist auf ihren ursprünglichen Ort: die Viehställe der Massentierhaltung. Dort wird Fleischlicheres, uns Verwandteres getötet.

Die Ästhetik von Hirsts Installation erinnert auch an Todeszellen und das damit verbundene Urteil: Tod auf dem elektrischen Stuhl. Diese Assoziation ist vor allem dem Glaskubus, der Sicht, dem Angesehen- und Ausgestellt-Werden geschuldet. Den Verbrecher*innen und

dem Schlachtvieh geht es gleich, das – im Gegensatz zu den Fliegen – immer schon verurteilt ist. »Tiere schauen uns an«, stellt der Philosoph Jacques Derrida fest, nachdem ihn die Begegnung mit einer Katze ins Unbehagen stürzt. Sie taxiert ihn so mit ihrem Blick, dass er, nackt vor ihr stehend, in einen Teufelskreis der Scham gerät. Er schämt sich vor der Katze und schämt sich für die Scham. Diese vielzitierte Urszene steht für ein radikales Bewusstwerden des eigentlichen Menschseins gegenüber dem fremden Tiersein. Derrida: »Es verfügt über einen ihm eigenen Blickpunkt auf mich. Der Blickpunkt des absolut Anderen [...]«.[3] Können sich Menschen nur in Abgrenzung zu Tieren definieren? Aufgrund der Doppeldeutigkeit des französischen Verbs *regarde* in »L'animal nous regarde«, bedeutet der Satz aber auch »Tiere gehen uns an«. Derrida wiederholt ihn mehrfach in seinem Buch *L'Animal donc je suis,* und auch im Titel liegt ein Spiel mit Doppeldeutigkeiten. Man kann ihn übersetzen mit »Das Tier, das ich also bin« oder mit »Das Tier, dem ich folge«. In einem kleinen Spaziergang durch die abendländische Kunstgeschichte wollen auch wir den Tieren folgen und unseren Blick auf sie richten. Dabei sollen uns besonders die Entwicklungen interessieren, die in der zeitgenössischen Kunst und ihren Verhandlungen des Mensch-Tier-Verhältnisses fortgeführt werden.[4]

Gottheit – Totem – Opfer

Die ersten bekannten bildlichen Zeugnisse von Tieren sind ebenso die ältesten bekannten malerischen Schöpfungen von Menschenhand. Vor circa 30.000 Jahren entstanden die Malereien in der Höhle von Chauvet und etwas Jüngere in den Höhlen von Lascaux und Altamira. Was die Malereien und die dargestellten Tiere – unter anderem Raubkatzen, Bären, Auerochsen, Pferde, Bisons, Rehe und Hirsche – zu bedeuten hatten, ist bis heute nicht geklärt.[5] Vielleicht wurden Tiere auf viel radikalere Weise als das fremde Andere wahrgenommen als in späteren Epochen. Wissen wir, welche Wichtigkeit sie für die Menschen dieser Zeit hatten? Einerseits waren Tiere in der Überzahl

– und die schiere Dominanz dürfte auch Furcht verursacht haben –, andererseits waren Menschen stark von ihnen abhängig. Sollten die oft dargestellten Jagdszenen den Erfolg zukünftiger Jagden erhöhen, indem das als Beute gewünschte Tier auf die Wand gebannt wurde? Wurde mit den Darstellungen eine Art der Geschichtsschreibung betrieben? Vielleicht zeigt sich darin, wie Jessica Ullrich bemerkt, einfach der Ausdruckswille der Menschen und die Bewunderung für ihre tierlichen[6] Verwandten.[7] Diese Schwierigkeit, die Frage, ob die Tiere einen Ding-, Funktions-, Totem- oder Symbolcharakter tragen, wird durch alle Kunstepochen Thema bleiben – auch in den Epochen, aus denen uns schriftliche Zeugnisse erhalten sind. In der Antike werden die Beziehungen konkreter. Es existieren Überlieferungen der Mythologie, Geschichtsschreibung und Fabeln, die uns von den zeitgenössischen Verhältnissen von Menschen und Tieren erzählen. Die antike Sicht auf Tiere ist vor allem durch einen mythisch-religiösen Blick geprägt, doch auch profane Elemente wie ein ganz konkretes Wettbewerbsverhältnis können eine Rolle spielen: Sportliche Aktivitäten wie Wagen- oder Pferderennen sind beliebt, in der römischen Zeit gibt es Gladiatorenkämpfe, in denen Tiere gegeneinander, aber auch Menschen gegen Tiere antreten. Im Mythos existieren neben berühmten Tieren zahlreiche Mischwesen, die ebenfalls Tierattribute tragen, und auch Götter treten als Tiere in Erscheinung. Und dieses ganze Bestiarium bevölkert die sich ausdifferenzierende Kunstproduktion der Antike, in der Frühzeit eher ornamental bis stilisiert, später immer realistischer.

Die Bronzen hellenistischer Zeit sind wegen ihres Materials leider kaum erhalten. Eine schöne Ausnahme ist der *Jockey vom Kap Artemision* (um 150–146 v. u. Z.): Ein feingliedriges Rennpferd scheint gerade im Begriff zu sein, mit Schwung davonzugaloppieren, auf ihm ein kindlicher Reiter, der sich ganz der Bewegung seines Gefährten hingibt und mit diesem zu verschmelzen scheint. Dieser Realismus in der Darstellung wird erst mit der Renaissance wiederkehren. Auch auf philosophischer Ebene wird das Mensch-Tier-Verhältnis diskutiert. Zum Beispiel,

Abb. / Fig. 1
Tizian
*Clarissa Strozzi (1540–1581)
im Alter von zwei Jahren /
Clarissa Strozzi (1540–1581)
at the age of two years,* 1542
Öl auf Leinwand / Oil on canvas
121,7 × 104,6 cm
Gemäldegalerie, Berlin

Symbole um und bewahrt so einen Bilder-
vorrat, zu dem mittelalterliche Schriftsteller
und Künstler später gerne zurückkehren
– wenn dann auch vorwiegend in Tierdar-
stellungen symbolischer und allegorischer
Natur.[9] Dabei entstehen Zuordnungen zu
Tugenden und Lastern, die sich – einmal
festgelegt – nicht mehr ändern. Wie der
Hirsch oder das Lamm für Christus, steht
die Fliege für den Teufel und die Schlange
für die Erbsünde. Die Tiere fungierten als
»Erkenntnisinstrumente«, die den Laien
moralisch belehren und ihm Gottes Heils-
plan vermitteln sollten.[10] Doch so wenig
wie das Laster lassen sich Fantasie und
Tiere dauerhaft in Ketten legen. In mittel-
alterlichen Handschriften finden Tiere sich
zuhauf, tummeln sich frech als Drolerie an
den Seitenrändern oder werden wie im fran-
zösischen *Roman de Renart (Fuchsroman)*
selbst Protagonisten. Wie in der Antike blei-
ben Tierdarstellungen auch fester Bestand-
teil der Bauplastik.

Naturstudien und höfische Tiere

Im Übergang zur Neuzeit ändert sich
der Naturbegriff. Die Natur ist nicht mehr in
erster Linie bedrohlich, sondern wird mehr
und mehr zum Studienobjekt, das man, wenn
man sich genug damit beschäftigt, für seine
Zwecke nutzen kann. Studien von Pflanzen
und Insekten, aber auch von Säugern, Vögeln,
Nagern werden immer beliebter – man denke
an die Präzision von Albrecht Dürers berühm-
tem Aquarell *Feldhase* (1502) oder seiner um
1500 entstandenen Studie zur toten Blauracke.

Mit der höfischen Gesellschaft des
15. und 16. Jahrhunderts entsteht ein neues
Bedürfnis nach Repräsentation, zugleich
werden bestimmte tierliche Begleiter populär.
Zu sehen in Tizians Porträt Karls V. im Bei-
sein seiner Dogge (1533) oder im Porträt der
jungen Clarissa Strozzi in enger Umschlin-
gung ihres Spielgefährten, eines Schoßhunds
(1542, Abb. 1). Gerade im Vergleich der
beiden Bilder erkennt man, wie die Hunde
das Wesen der Besitzer*innen verdeutlichen
und den Repräsentationszweck unterstüt-
zen. Karl V., hochgewachsen stattlich, an
seiner Seite eine ebenso hochgewachsene,
muskulöse Dogge, die ihrem Herrn, wie das

ob man Tiere zu Opferzwecken schlachten
dürfe. Empedokles (495–435 v. u. Z.) for-
dert ein striktes Verbot, wenn wohl auch
vor allem motiviert aus der Reinkarnati-
onsidee. Sollte ein bestimmtes Tier nicht
geschlachtet werden, dann um einen trans-
formierten Menschen darin zu schützen.[8]

Ornament – Symbol – Allegorie

Große Bedeutung für das spätantike
und frühmittelalterliche Mensch-Tier-Ver-
hältnis und für die christliche Ikonografie
hat der *Physiologus*, eine frühchristliche
Naturlehre, die auf das 2. Jahrhundert
u. Z. zurückgeht und zoologisches Wissen,
Fabeln und Deutungen verschiedener Tier-
arten in Bezug auf ihren Platz in der gött-
lichen Ordnung versammelt. Während das
Christentum den kulturellen Reichtum der
Antike minimiert, wandelt es die tierlichen
Charaktere der antiken Fabeln in christliche

Anschmiegen des Hundekopfes zeigt, treu ergeben ist. Die kleine Clarissa, prächtig gekleidet, aber noch mit der Unsicherheit eines Kindes ausgestattet, sucht Halt bei ihrem tierlichen Freund, der seiner Herrin ganz ähnlich, leicht verschreckt, doch hübsch und niedlich verzücken will.

Pathos und Automaten

Mit dem ambivalenten Lebensgefühl des Barock, das zwischen Lebenslust, Ausschweifung und Todesfurcht oszilliert, wird auch das geschlachtete Tier, das bloße Fleisch Thema.[11] Berühmt ist Rembrandt van Rijns Gemälde *Der geschlachtete Ochse* (1655). An einem hölzernen Querträger hängt der wuchtige Leib eines Ochsen; Hufe, Fell und Kopf sind bereits abgenommen. Knochengerüst, Fett- und Sehnenstränge bilden sich aus dem pastosen Farbauftrag heraus. Fleisch und Farbe gehen hier eine haptische Verbindung ein, die auch Ausgangspunkt für zukünftige Künstler*innen sein wird, man denke an Chaim Soutine oder Francis Bacon. Die Motivik steht ganz in der Tradition des Vanitas-Motivs. So wie die Früchte und, mehr noch, das Fleisch verfaulen, verfaulen auch wir. Genauso in Jean-Baptiste Siméon Chardins Gemälde *Der Rochen* (1728, Abb. 2), einer Assemblage aus Fisch, blutigem Rochenfleisch, geöffneten Austern, Trinkbehältnissen und einer wunderschön buckligen Katze, die wild auf die Austern starrt. Das bloße Fleisch der Tiere ist hier als Attribut menschlicher Lust, als Reichtum, als Besitz zu verstehen.

Eine andere Form des Pathos zelebriert Peter Paul Rubens mit seinen blutigen Kämpfen zwischen Menschen und Tieren. Bilder wie *Die Tiger- und Löwenjagd* (um 1616) entstanden in Arbeitsgemeinschaften: Verschiedene Spezialisten wurden für unterschiedliche Aspekte eingesetzt, so die Tierspezialisten Frans Snyders, Adrian van de Velde und Roelant Savery, Letzterer berühmt für seine Insekten. Paulus Potter (1625–1654) hinterließ etwa 200 Gemälde, in deren Zentrum Tiere stehen. Man kann hier, in der holländischen Malerei des 17. Jahrhunderts, einen Vorläufer der im 18. Jahrhundert sich etablierenden Tiermalerei erkennen. Im Barock und Manierismus gab es in den Kunst- und Wunderkammern noch keine klare Trennung von Kunst und Kultur. Zoologische Präparate fanden ihren Platz neben Alabasterarbeiten und antiken Statuetten. René Descartes (1596–1650), der zu dieser Zeit sein mechanistisches Tierbild postuliert,[12] will damit, so Thomas Zaunschirm, nicht in erster Linie Tiere degradieren, sondern die Maschine aufwerten.[13] Das Urbedürfnis des Menschen nach Naturnachahmung bringt menschenähnliche, aber auch tierähnliche Automaten hervor. So stellt Jacques de Vaucanson 1738 an der französischen Akademie der Wissenschaften die Automaten-Ente vor. Sie konnte mit den Flügeln schlagen, schnattern, Wasser trinken und war durch einen künstlichen Verdauungsapparat sogar in der Lage zu defäkieren, was Begeisterung auslöste.

Experiment und Ethik

Der Enthusiasmus für die Naturwissenschaften dauert an, während moralphilosophische Denkbewegungen gegen Ende des 18. Jahrhunderts ihre Spuren hinterlassen. 1789 stellt der Begründer des klassischen Utilitarismus, Jeremy Bentham, den in der Tierethik wohl meistzitierten Satz auf: »Die Frage ist nicht: Können sie denken? oder: Können sie sprechen?, sondern: Können sie leiden?«[14] Ob und wie

Abb. / Fig. 2
Jean-Baptiste Siméon Chardin
La raie / *Der Rochen* / *The Ray*, 1728
Öl auf Leinwand / Oil on canvas
114,5 × 146 cm
Musée du Louvre, Paris

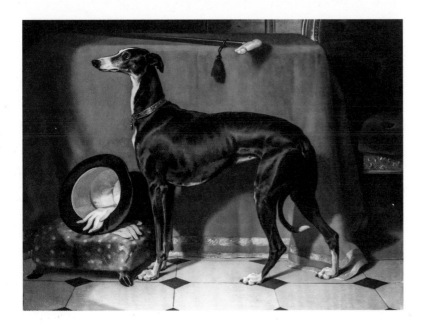

findung frei glaubt, sondern um die Menschen vor Verrohung zu bewahren –, nimmt er Bezug auf diese Drucke von Hogarth.[16]

Das Genre der Tiermalerei – das Tier als Individuum?

Das Genre der Tiermalerei etablierte sich in der holländischen Malerei im 17. Jahrhundert. Allerdings mussten sich Künstler*innen wie Rosa Bonheur (1822–1899) stets gegen das Vorurteil der minderwertigen Malerei wehren. In der Hierarchie der Kunstgattungen war die Tiermalerei das Schlusslicht. Nichtsdestotrotz war sie an den Fürstenhöfen der frühen Neuzeit überaus populär. Dass die »aristokratischen« Tiere enge Beziehungen zu ihren jeweiligen Bezugspersonen eingingen, zeigt sich auch darin, wie menschengleich sie porträtiert wurden. Andererseits wurden aber auch Repräsentationsfunktion und Besitzverhältnis auf die Spitze getrieben. So bekam der Hofmaler von Königin Victoria, Edwin Landseer (1802–1873), den Auftrag, Eos, die Windhündin des Prinzen Albert, zu porträtieren (Abb. 3).[17] Vor dem roten Hintergrund des herabhängenden Tischtuchs kommt das seidig schwarz glänzende Fell des Tieres ideal zur Geltung. Vor seinen Vorderläufen liegen Handschuhe und Hut seines Meisters auf einem mit Rehkitzfell bezogenen Schemel, der wiederum auf die sportlichen Aktivitäten des Prinzen verweist. Die Hündin allein kann ihren Herrn nicht vertreten, doch im Zusammenhang mit dem Arrangement seiner Insignien scheint er dennoch anwesend, ist der eigentliche Porträtierte. Und natürlich orientierte sich Landseer auch an den schon besprochenen Doppelporträts Tizians von Karl V. und Clarissa Strozzi.

George Stubbs (1724–1816), der sich auf Pferde spezialisiert hatte, interessierte sich besonders für deren exakte anatomische Wiedergabe. Dazu sezierte er monatelang Pferde und veröffentlichte seine Erkenntnisse in der vielgerühmten *Anatomy of the Horse*, illustriert mit 18 Kupferstichen.[18] Sein wahrscheinlich bekanntestes Gemälde ist *Whistlejacket* (1762), das in Lebensgröße den gleichnamigen Vollbluthengst in der Levade porträtiert, ohne Reiter

Tiere leiden und insbesondere auch, was das Betrachten des Leidens von Tieren mit dem menschlichen Gegenüber macht, verhandelt das Gemälde *Experiment an einem Vogel* (1768) von Joseph Wright of Derby. Es markiert einen Punkt, der nicht in erster Linie kunsthistorisch eine Schwelle darstellt, sondern vor allem tierethisch. Das Bild rapportiert die fast 100 Jahre zuvor durchgeführten Experimente, die der führende Chemiker der Royal Society, Robert Boyle, an verschiedenen Kleintieren vorgenommen hatte. Er beobachtete das Verhalten von Lebewesen bei reduziertem Luftdruck. Dazu steckte er diverse Kleintiere in eine Pumpe und entzog ihnen in verschiedenen Modi und in unterschiedlichen Graden die Luft, entweder bis sie verendeten oder – durch erneutes Zuführen von Luft – bis zu ihrer vermeintlichen Wiedererweckung.[15] Wright of Derby stellt jenen Moment dar, in dem das Schicksal des Vogels noch nicht entschieden ist.

Die Bildserie *The Four Stages of Cruelty* (1751) von William Hogarth behandelt ebenfalls tierethische Fragen. Vier Drucke erzählen die Geschichte von Tom Nero, der sich vom Tierquäler – zuerst an einem Hund, dann an einem Pferd – zum Mörder entwickelt. Er wird hingerichtet und sein Leichnam zum Sezieren freigegeben. Als sich Immanuel Kant (1724–1804) in seinen Ethikvorlesungen gegen Gewalt an Tieren ausspricht – nicht um der Tiere willen, die er, wie bekannt, von jeglicher Gemütsemp-

und ohne Insignien, die auf die Reitkunst anspielen. Einerseits wird das Pferd geradezu ikonisiert, indem es idealschön vor goldenem Hintergrund formvollendet steigen darf, andererseits folgt die Darstellung dem Naturalismus, der mit Aufklärung und zunehmenden Empirismus einhergeht.

Der Ausdruck der Gemütsbewegungen bei Tieren und Menschen (1872) von Charles Darwin ist ein Wendepunkt in der Debatte des Mensch-Tier-Verhältnisses, denn, wie Darwin feststellen muss, sind Tiere in ihren »Gemütsregungen« den Menschen gar nicht unähnlich.

Ende des 18. Jahrhunderts, mit der Entstehung der zoologischen Gärten, wird ein Nahstudium am lebendigen, exotischen Objekt möglich. In Frankreich nannte man Künstler*innen, die für ihre Zeichenstudien den Zoo aufsuchten, *animaliers*. Höfische Menagerien wurden im Zuge der Revolution der Öffentlichkeit zugänglich gemacht und zur bürgerlichen Einrichtung.

Die berühmteste Tiermalerin war Rosa Bonheur. Sie besuchte regelmäßig die Menagerie im Jardin des Plantes, engagierte sich als Tierschützerin, lebte offen homosexuell und trug Männerkleider. Ganz geprägt von Charles Darwin emotionalisierte Bonheur ihre Tierporträts, um nicht zu sagen: Sie romantisierte sie. Wenn zum Beispiel eine einsame Kuh gegen den Horizont blickt und dabei an Caspar David Friedrichs *Wanderer über dem Nebelmeer* (1818) erinnert; oder wenn sie in ihrem monumentalen *Pferdemarkt* (1855) die Szene voller hochnervöser Pferde – mit wilden Mähnen – derart dramatisiert, dass man in der elektrisierten Atmosphäre einen aufkommenden Sturm zu erkennen meint. Wie sich Pferde wirklich bewegen, konnten die Maler*innen lange nicht erfassen, dies wurde erst durch die Chronofotografie von Eadweard Muybridge (1830–1904) möglich. Mit seiner Fotografie konnte er zeigen, dass galoppierende Pferde jahrhundertelang falsch dargestellt worden waren: Im Galopp halten sie immer entweder mit der Vorder- oder mit der Hinterhand Bodenkontakt, nur im Trab scheinen sie zu fliegen. 1887 wurde der elfbändige Bildband *Animal Locomotion* mit 781 Abbildungen von Tieren in Bewegung publiziert, allein 100 davon zeigen die verschiedenen Gangarten der Pferde. Muybridges Studien über die Fortbewegung von Tieren hatten einen enormen Einfluss auf die Künstler*innen des folgenden Jahrhunderts. Die Fotografie wurde zwar immer mehr zu einer Konkurrentin der Tiermalerei, trotzdem setzte sich letztere bis ins 20. Jahrhundert fort.

Animalismus und Surrealismus

Franz Marc (1880–1916), bekannt für seine bunten Tiere, scheint einer der Ersten, die den Versuch wagten, eine Malerei aus der Perspektive der Tiere zu schaffen.[19] Er wollte das Gefühl, wie sich – nach seiner Vorstellung – das Tier selbst empfindet, auf die Leinwand bringen. Marc sprach sich dafür aus, Tiere und Pflanzen nicht mehr nur noch auf den Menschen zu beziehen. Er selbst nannte diese Herangehensweise »Animalisierung« der Kunst. Er bettete die Tiere derart in die Komposition ein, dass sich ein harmonischer Gesamtzusammenhang ergab, der seinem »Empfinden für den organischen Rhythmus aller Dinge« entsprach.[20]

Im Zuge des Surrealismus und des dazugehörenden Hanges zum Fantastischen werden auch Mischwesen und symbolhafte Tiere wieder populär. Besonders häufig finden sich solche bei Frida Kahlo (1907–1954), meist als porträtierte Begleittiere. Bei der katzenverrückten Leonor Fini (1907–1996) tummeln sich enigmatische Mischwesen und sehr viele Katzen, denen sie sogar ein ganzes Buch widmet, *Miroir des Chats* (1977). Sie erkennt in ihnen ein gleichwertiges Gegenüber. In den Bildschöpfungen von Leonora Carrington (1917–2011) erscheinen viele Formen von Mischwesen. Sie schuf enigmatische, stets ein leichtes Schaudern erzeugende Traumwelten, so bei der *Sphinx* (um 1950), aus deren Armstummeln Federn wachsen – proportional erschreckend, doch dem Eindruck nach voll lebensfähig. Die Chimären der Antike und des Mittelalters kommen als Vertreter*innen des völlig Anderen, Nichtfassbaren zurück.

Tierliche Leiblichkeit in der Malerei

Zwei Maler*innen, die nicht unbedingt als Tiermaler*innen in die Geschichte

Abb. / Fig. 4
Francis Bacon
Figure with Meat, 1954
Öl auf Leinwand / Oil on canvas
129,9 × 121,9 cm
CR 54-14
The Art Institute of Chicago

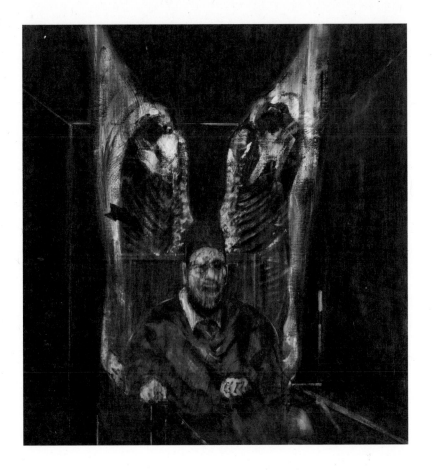

eingegangen sind, sind Francis Bacon (1909–1992) und Maria Lassnig (1919–2014). Ihre Malereien kreisen auf verschiedene Weisen um die Darstellung von Körperlichkeit, oft der eigenen. Und doch tummeln sich bei Bacon wie bei Lassnig verschiedenste Arten Vögel, Hunde, Primaten und eine Vielzahl merkwürdiger Hybridwesen.

So unterschiedlich ihre Malerei auch ist, wenden doch beide sich bemerkenswert ähnlich dem Sujet Tier zu. Es wird zu einem Mittel der Transformation und insbesondere der Reflexion der eigenen Körperlichkeit. Identitätsfragen wie »Wo beginne ich?« oder »Wo verlaufen die Grenzen meines Selbst?« sind für beide relevant, und Tiere scheinen für solche Überlegungen ein geeigneter Gegenstand.

Die eine wie der andere interessieren sich für das Fleisch-Sein, dazu Bacon: »Und selbstverständlich wird man als Maler ständig daran erinnert, dass die Farbe von Fleisch tatsächlich sehr, sehr schön ist. […] Nun, wir sind ja schließlich selbst Fleisch, potenzielle Kadaver. Jedesmal, wenn ich einen Fleischerladen betrete, bin ich in Gedanken überrascht, dass ich nicht dort hänge.«[21] Die Verbindung von Fleisch und Farbe war

schon in den Malereitraktaten des Cinquecento Thema: Malerei als *Incarnazione*, also Fleisch malen, Fleisch werden.[22] Für Aufsehen sorgte Bacons Gemälde *Figur mit Fleisch* (1954, Abb. 4), das auf Rembrandts *Geschlachteten Ochsen* verweist, die Figur zwischen den geschlachteten Kuhhälften ist eine seiner Reminiszenzen an Velázquez' Bildnis von Papst Innozenz X. (um 1650).

Auch Maria Lassnig thematisiert das Fleisch. Ihre Selbstdarstellungen, die Körpergefühlsdarstellungen, die ihren Körper aus einer Innenschau porträtieren, kommen oft fleischfarben daher. Manche dieser Körper scheinen zwischen dem der Künstlerin und einer Hundedarstellung zu oszillieren, bei der durch die nackte Haut das Fleisch leuchtet, das unter dieser liegt. Tiere erscheinen bei Lassnig auch in Form von Doppelporträts. Sie können als Verdopplung, als Verstärkung der Porträtierten gelesen werden, ganz in der Tradition der höfischen Renaissancebilder. In anderen stehen sie in direktem Bezug zu Lassnigs Konzept des Körpergefühls. Dabei verwandeln sich die Tiere formal Lassnigs Darstellungen des menschlichen Körpergefühls an, so als ob die Malerin sich in das Körpergefühl der Tiere hineinversetzte.

Koexistenz: Lebende Tiere

Einen Einschnitt stellt der Einzug lebendiger Tiere in das Kunstgeschehen in den 1960er-Jahren dar.[23] Zaunschirm weist darauf hin, dass just in dem Moment, in dem die Körper der Künstler*innen zum künstlerischen Gestaltungsmittel, zum Material werden, auch das lebendige – oder wie Mona Mönnig differenzieren würde: das »konkrete Tier« – Einzug in die Kunstwelt hält.[24] In seiner Aktion *Coyote, I Like America and America Likes Me* (1974) schließt sich Joseph Beuys drei Tage lang mit einem Kojoten namens Little John in einen New Yorker Galerieraum ein. Beuys steht, sitzt, liegt in dieser Zeit in ritualisierter Abfolge. Dabei kommt es zum Kontakt zwischen dem Kojoten und dem Künstler. Zuerst stachelt Beuys das ängstliche Tier an, seine Wolldecke zu zerfetzen, um im Folgenden sein Zutrauen zu gewinnen. Beuys' Kojote steht als Stellvertreter für die

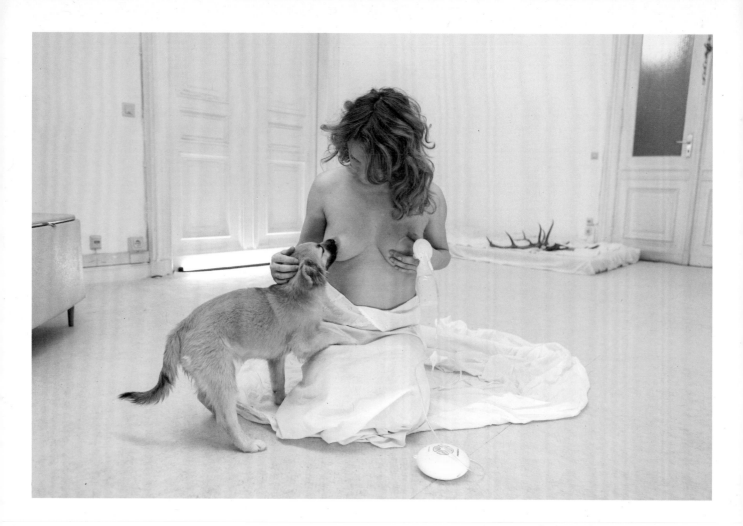

Ureinwohner*innen Amerikas und soll ein Art Verbundenheit mit der Natur verkörpern. Abgesehen davon, dass diese Aktion heute kaum noch so zu lesen wäre, werden Tiere bei Beuys, hier exemplarisch der Kojote, als Symbole eingesetzt und knüpfen an Thematiken des 19. Jahrhunderts, an eine romantische Naturphilosophie an.

In seinem Werk *Untilled* (2013) auf der dOCUMENTA (13) inszeniert Pierre Huyghe Koexistenz im Sinn einer Überwindung des Anthropozentrismus. In der Kasseler Karlsaue legte er einen wilden Garten an, in dem es summt und brummt. Der Kopf einer liegenden weiblichen Plastik wird von einem Bienenvolk ummantelt und der Bienenorganismus wächst und wächst. Irgendwo in dem halb mystischen Gartenidyll leben die weiße Podenco-Hündin Human mit dem pinken Bein und, damals noch ein Welpe, Señor. Eine Namensgebung deutet immer auch in Richtung Anerkennung des Gegenübers als Individuum, und es ist bekannt, dass Tiere mit Namen weniger leicht getötet werden.[25] Soll die Hündin durch ihren Namen für human erklärt werden oder wird, wie Mönnig glaubt, auf die Überrepräsentation des Menschen hingewiesen?[26] Man kommt nicht umhin an, an den Pudel Butz von Arthur Schopenhauer zu denken, der, darf man der Anekdote glauben, von seinem Herrchen »Mensch« betitelt wurde, wenn er unartig war.[27]

Animaux trouvés

Aber nicht nur das lebendige Tier wird als Material gebraucht, auch tote Tiere oder Teile toter Tiere.[28] Betont wird dabei der Zerfall oder die Zusammengesetztheit der Körper, das Maschinenhafte. Berühmt sind die provokativen Arbeiten von Maurizio Cattelan, seine taxidermierten Pferdekörper, die aus den Höhen von Ausstellungsräumen schlaff herunterbaumeln und, Kopf in der Wand, umgekehrte Jagdtrophäen darzustellen scheinen. Wie bei Damien Hirst, in dessen Werk unzählige tote Tiere verarbeitet werden, man denke an

Abb. / Fig. 5
Maja Smrekar
K-9_topology: Hybrid Family,
2016
Performance
Freies Museum Berlin
Foto / Photo: Manuel Vason

seinen in Formaldehyd eingelegten Hai oder an die Kuh mit Kalb in *Mother and Child (Divided)* (1993), scheint der Eindruck – sehr maskulin – auf ein Überwältigungsmoment angelegt, eine Statement-Architektur der bildenden Kunst. Subtiler sind die Arbeiten von Iris Schieferstein und Polly Morgan. Beide führen, im Unterschied zu ihren männlichen Kollegen, ihre taxidermischen Arbeiten selbst aus. Erstere ist vor allem bekannt für ihre Hufschuhe. Sie nimmt Vorder- oder Hinterhufen eines Paarhufers und arbeitet sie zu Schuhen um. Geht es hier um eine Tier-Werdung im Sinne von Gilles Deleuze und Félix Guattari? In *Tausend Plateaus* diskutieren die beiden Philosophen die Idee der Tier-Werdung. Das *Werden* ist bei ihnen nicht Imitation, sondern Verschiebung einer Identität zu einer anderen beziehungsweise die Synthese zweier Identitäten, welche gleichzeitig die Dekonstruktion der ursprünglichen Identitäten impliziert. Das *Werden* (auch Kind-Werden, Frau-Werden, nicht aber Mann-Werden oder Mensch-Werden) lehnt eine Hierarchisierung, eine lineare Struktur der Welt ab. Außerdem denken Deleuze und Guattari den Prozess der Tier-Werdung nicht als durch Abstammung bestimmt, sondern durch Ansteckung.[29]

Schieferstein geht zugleich auch mit der Heuchelei unserer Gesellschaft auf Kollisionskurs. Sie versteht die toten Tierkörper als eine natürliche Ressource von Schönheit. Warum sich nicht davon bedienen, leiten lassen? Ihre Tierkadaver sind zum Teil auf der Straße überfahrene Tiere. 2002 erhielt sie deshalb eine anonyme Anzeige. Tatsächlich dürfen in Deutschland nur solche Tiere taxidermiert werden, die man schießen, halten oder züchten darf. Ein Vogel, der in freier Wildbahn stirbt, darf verwesen, aber nicht verwendet werden.

Morgan verbindet in ihren taxidermischen Skulpturen Tierkadaver so mit Gegenständen, dass sie wie Exponate aus den Wunderkammern des 17. Jahrhunderts wirken. Sie arrangiert Vögel unter einer Glaskuppel, an der ein Kronleuchter hängt, oder lässt seltene Tiere an einem geöffneten, blutroten Herzen speisen. Sie interessiert die Diskrepanz von Lieblichkeit und Vanitas, die Tiere mit ihrer kulturgeschichtlichen Aufgeladenheit dienen ihr als Katalysator.

Tiere als Projektionsfläche oder die Überwindung des Anthropozentrismus

Eine immersive Inszenierung der Gruppe Signa auf den Wiener Festwochen 2016 führt die skurrile Wohngemeinschaft *Canis Humanus* vor.[30] Deren Mitglieder fühlen sich teils als Hunde, teils als deren Besitzer*innen. Die Hunde nehmen vermeintlich hündische Eigenschaften an. In der mehrstündigen Inszenierung lernt man, warum Hunde lieber Hunde sind und Herrchen lieber Herrchen. Man kann zusehen, wie Zuschauer an den perversen Machtspielen teilnehmen, wie Menschen sich Tiere erfinden, um Macht ausüben zu können.

Mit völlig anderer Herangehensweise, in gewissem Sinne aber auch das Tierliche nachahmend, entwickeln Krõõt Juurak und Alex Bailey ihre *Performances for Pets*. Die beiden Künstler*innen performen für Tiere. Sie wollen die Rollen, die seit jeher Menschen und Tieren zugeschrieben werden, umdrehen und verfolgen damit den Ansatz, den Anthropozentrismus zu überwinden. Diesem künstlerischen, wissenschaftlichen und ethischen Ansatz zufolge sollen Tiere nicht mehr begafft werden und Unterhaltung für ihre menschlichen Gegenüber sein, sondern als Individuen erkannt und als diese unterhalten werden. Das Künstlerpaar besucht sein Publikum – Haustiere, Hunde oder Katzen – in seinem gewohnten Umfeld, informiert sich bei seinen Bezugspersonen über charakterliche Eigenheiten und stellt daraufhin ein individuelles Programm für die zu bespielenden Tiere zusammen. Die Haustiere werden zu Rezipient*innen.

Maja Smrekar setzt sich in ihren hybriden Arbeiten dezidiert mit dem Mensch-Tier- und dem Natur-Kultur-Technik-Verhältnis auseinander und bewegt sich dabei an der Schnittstelle von Bioethik, Wissenschaft und Kunst. In *Hybrid Family* (2016, Abb. 5), das aus der vierteiligen Werkreihe *K-9_topology* stammt, werden Fragen nach Mutterschaft, artenübergreifender Verwandtschaft und Instrumentalisierung des weiblichen Körpers (unter anderem über das Thema Stillen) verhandelt. Für die Performance hat sie ihren Körper so manipuliert, dass er Muttermilch produziert. Mit dieser begann sie, einen Hundewelpen zu füttern. Eben-

falls anwesend war der Hund Byron, das Gefährtentier der Künstlerin. Die Dreieckskonstellation lässt an die klassische Kleinfamilie denken, die hier artenübergreifend verstanden wird und so Kerngedanken der Theoretikerin Donna Haraway aufnimmt, die mittlerweile als eine der für den Kunstbetrieb einflussreichsten Personen angesehen wird. »Make kin, not babies« wurde zu ihrem Leitspruch. Verwandtschaft soll nicht mehr über Abstammungsgrade gedacht werden, sondern über aktiv gewähltes Miteinander-Werden. Haraways Denken vereint Wissenschaft, Kunst und Aktivismus. Sie entwickelt ein Verfahren, das sie SF nennt. SF steht für Spekulativen Feminismus, *so far, science fact, science fiction* oder für String-Figuren, Fadenspiele. Mit der Figur des Fadenspiels lässt sich ihr Unterfangen vielleicht am klarsten beschreiben. Wie die Fäden im Geschicklichkeitsspiel – man bildet mit den Fingern die unterschiedlichsten Verflechtungen, öffnet und verdichtet sie, verknüpft sie neu – verhalten sich auch Systeme von Beziehungen und Arten, von Fiktion und Fakten.

Why look at animals?

Dies fragt John Berger in seinem berühmt gewordenen gleichnamigen Essay. Also: Warum sehen wir Tiere an? Weil uns Tiere, um mit Derrida zu sprechen, angehen?

Tiere kommen heute einerseits in völliger Überpräsenz vor, man denke an die Abertausenden TikTok- und Instagram-Videos, anderseits sind sie in unserer Lebenswelt, außer in Form von Heimtieren, nicht wirklich bemerkbar. In Zoos, wie Berger anmerkt, ist eine wirkliche Begegnung mit Tieren nicht möglich. Das als Schauobjekt inszenierte Tier entzieht sich unserem Blick.[31] Der erwiderte Blick der Tiere und somit ihre eigentliche Präsenz sind nach Berger ausgelöscht: »Das ist die letzte Konsequenz ihrer Verdrängung. Dieser Blick zwischen Tier und Mensch, der vielleicht eine der wesentlichsten Rollen in der Entwicklung des Menschen gespielt hat, wurde ausgelöscht.«[32] Die Tierindustrie, insbesondere die der Schlachthöfe, hat sich vollständig aus unserer Wahrnehmungswelt zurückgezogen. Auch Carol J. Adams

argumentiert in *The Sexual Politics of Meat*, dass Tiere als Subjekte durch Zerlegung und Fragmentierung ihrer Körper unkenntlich und als Referenten unsichtbar gemacht werden.[33] Zugleich scheinen wir Tierdarstellungen auf eigentümliche Weise zu übersehen, was auf ein höchst komplexes Verhältnis zwischen den Tieren und uns hindeutet. Mönnig formuliert es so, dass »das tatsächliche Tier von menschlichen Wahrnehmungs- und Sinndimensionen, letztlich: Bildern« so überlagert sei, »dass es schwerfällt, das Tier nicht per se als ein konstruiertes Bild zu verstehen«.[34] Für die bildende Kunst bedeutet dies, dass das Bild des Tieres sich selten bis nie dem eigentlichen Tier gewidmet hat oder widmen konnte. Das Bild des Tieres, auch das des konkreten Tieres ist immer ein besetztes, sei es als Symbol, Metapher oder Idee. Erst in jüngster Zeit gibt es Ansätze in Kunst und Wissenschaft, die menschliche Perspektive zu überwinden. Wie also dem konkreten Tier überhaupt begegnen? Die Ansätze der zeitgenössischen Kunst weisen unter anderem in die Richtung eines heute noch utopisch scheinenden Zusammenlebens. Es ist nicht so, dass Künstler*innen selbst ihre Werke tierethisch verstehen müssen, um derartige Lesarten zu ermöglichen. Wir müssen darüber hinausgehen, Tiere bloß ansehen zu wollen – Tiere gehen uns an.

1 Friedrich Nietzsche, *Die fröhliche Wissenschaft, Kritische Studienausgabe*, hrsg. von Giorgio Colli und Mazzino Montinari, Bd. 3, München u. a. 1988, S. 510.

2 Vgl. Alia Lübben, »Auch Fliegen fühlen. Tierrechtseklat im Kunstmuseum Wolfsburg«, in: *Monopol. Magazin für Kunst und Leben*, 12.7.2022, https://www.monopol-magazin.de/tierrechtseklat-wolfsburger-kunstmuseum-auch-fliegen-fuehlen (10.11.2022).

3 Jacques Derrida, *Das Tier, das ich also bin*, Wien 2010 (zuerst Paris 2006), S. 30.

4 Einen schönen Ritt durch die Kunstgeschichte in Bezug auf das Sujet Tier findet man bei Jessica Ullrich, »Tiere und Bildende Kunst«, in: Roland Borgards (Hrsg.), *Tiere. Ein kulturwissenschaftliches Handbuch*, Stuttgart 2016, S. 195–215. Beispiele, auf die sie zurückgreift, finden sich teilweise auch in dieser Darstellung; hier sollen aber neben dem kunsthistorischen Überblick auch philosophische und kulturgeschichtliche Positionen in Verbindung mit der Darstellungsgeschichte gebracht werden.

5 In den einzelnen Höhlen kommt eine Gattung jeweils prominent vor. In *La Pasiega* werden überwiegend Hirsche und Rehe dargestellt, in *Les Combarelles* Pferde und in *Font-de-Gaumes* Bisons, vgl. Max Raphael, *Prähistorische Höhlenmalerei. Aufsätze. Briefe*, hrsg. von Werner E. Drewes, Köln 1993, S. 16.

6 Im Fachjargon der Human Animal Studies wird statt dem pejorativ anklingenden »tierisch« (analog zu »kindisch« oder »weibisch«) das sachliche Adjektiv »tierlich« (analog zu »kindlich« oder »weiblich«) verwendet, vgl. Arianna Ferrari und Klaus Petrus (Hrsg.), *Lexikon der Mensch-Tier-Beziehungen*, Bielefeld 2015, S. 11.

7 Nach Max Raphael können die Tiere in der prähistorischen Höhlenmalerei mindestens vier verschiedene Bedeutungen annehmen: 1. Tiere stehen für sich selbst, z. B. als Gegenstand, der getötet werden muss. 2. Tiere haben eine magische Funktion und sollen dabei helfen ideologische Wunschvorstellungen zu realisieren. 3. Tiere haben eine totemistische Bedeutung. 4. Tiere werden Symbole verwendet, vgl. Raphael 1993 (wie Anm. 5), S. 120; siehe auch Ullrich 2016 (wie Anm. 4), S. 195.

8 Vgl. Christoph Horn, »Geschichte der Tierethik. Antike«, in: Johann S. Ach und Dagmar Borchers (Hrsg.), *Tierethik. Grundlagen – Kontexte – Perspektiven*, Stuttgart 2018, S. 3–9, hier S. 3.

9 Der *Physiologus* blieb auch eine Verbindung, so schwach sie auch sein mag, mit der alten Wissenschaft und diente als Kern, um den im Laufe der Zeit die objektiveren Hüllen der Alten wieder zusammengesetzt wurden, so Francis Klingender in seinem Opus Magnum *Animals in Art and Thought. To the End of Middle Ages*, hrsg. von Evelyn Antal und John P. Harthan, London 1971, S. 94.

10 Ullrich 2016 (wie Anm. 4), S. 195.

11 Ebd., S. 197.

12 Er wendet sich gegen das gestaffelte Seelenvermögen des Aristoteles und argumentiert für einen strengen Substanzdualismus: Körper und Seele sind getrennt zu denken. Und weil allein der Mensch Geist besitzen kann, rücken Tiere in die Nähe von Maschinen, vgl. René Descartes, *Von der Methode des richtigen Vernunftgebrauchs und der wissenschaftlichen Forschung*, Hamburg 1960, S. 91ff.

13 Vgl. Thomas Zaunschirm, »Im Zoo der Kunst I. Seit wann und warum gibt es lebende Tiere in der bildenden Kunst?«, in: *Kunstforum International*, 32, 174, Januar – März 2005, S. 36–103, S. 54.

14 Jeremy Bentham, *An Introduction to the Principles of Morals and Legislation*, Oxford 1789, Kap. 17 (Übersetzung d. Verf.).

15 Robert Boyle versuchte die Anstrengungen für die Tiere zu minimieren, indem er den einzelnen Tieren Pausen zugestand oder das Maß des Luftentzugs regulierte. Er war der Überzeugung, dass das Zufügen grundloser Schmerzen nicht mit den biblischen Geboten vereinbar war, vgl. Linda Johnson, »Animal Experimentation in 18th-Century Art. Joseph Wright of Derby. An Experiment on a Bird in an Air Pump«, in: *Journal of Animal Ethics*, 6, 2, 2016, S. 164–176, hier S. 166.

16 Immanuel Kant, »Von den Pflichten gegen Thiere und Geister«, in: Kants gesammelte Schriften, Akademieausgabe, Bd. 27/2/2, Abt. 4 (= Vorlesungen über die Moralphilosophie, hrsg. von Akademie der Wissenschaften zu Göttingen), Berlin 1979, S. 1573.

17 Kirsten Claudia Voigt, »Fährten, Gefährten«, in: Lothar Schirmer und dies. (Hrsg.), *Gemalte Tiere. Ein Bilder- und Lesebuch mit 61 Meisterwerken aus sieben Jahrhunderten*, München 2021, S. 11–17, hier S. 13.

18 Alina Christin Meiwes, *Die Tiermalerin Rosa Bonheur. Künstlerische Strategien und kunsthistorische Einordnung im Kontext der Vermittlung*, Baden-Baden 2020, S. 58.

19 Ullrich 2016 (wie Anm. 4), S. 201.

20 Annegret Hoberg, »Eine neue Mission in der Kunst – Murnau, München und der Blaue Reiter«, in: *Das Geistige in der Kunst. Vom Blauen Reiter zum Abstrakten Expressionismus*, hrsg. von Volker Rattemeyer u. a., Ausst.-Kat. Museum Wiesbaden, Wiesbaden 2010, S. 33.

21 David Sylvester, *Gespräche mit Francis Bacon*, Berlin 1983, S. 46.

[22] Vgl. Christiane Kurse, »Fleisch werden. Fleisch malen. Malerei als Incarnazione. Mediale Verfahren des Bildwerdens im Libro dell'Arte von Cennino Cennini«, in: *Zeitschrift für Kunstgeschichte,* 63, 3, 2000, S. 305–325.

[23] Dazu gibt es auch schon einige kunsthistorische Auseinandersetzungen: Annalena Roters, *Mit Tieren denken. Zur Ästhetik von lebenden Tieren in der zeitgenössischen Kunst,* Berlin 2022; Jessica Ullrich, »Achtung lebende Tiere! Ästhetik und Ethik in der zeitgenössischen Kunst«, in: Stephanie Waldow (Hrsg.), *Von armen Schweinen und bunten Vögeln. Tierethik im kulturgeschichtlichen Kontext,* Paderborn 2015, S. 217–240; Thomas Zaunschirm, »Im Zoo der Kunst II.«, in: *Kunstforum International,* 32, 175, April – Mai 2005, S. 36–125.

[24] Mona Mönnig, *Das übersehene Tier,* Bielefeld 2018, S. 228.

[25] Wie und warum Tiere zu ihren Namen kamen, liest man bei Thomas Macho nach: »Tiere als Individuen. Eigennamen und Portraits von Tieren«, in: *Menschen und Tiere. Grundlagen und Herausforderungen der Human-Animal Studies,* hrsg. von Friedrich Jaeger, Essen 2020, S. 237–249.

[26] Mönnig 2018 (wie Anm. 23), S. 232.

[27] Volker Spierling, *Arthur Schopenhauer zur Einführung,* Hamburg 2002, S. 12.

[28] Eine ausführliche Auseinandersetzung von Taxidermie in der Kunst findet sich bei Petra Lange-Berndt, *Animal in Art. Präparierte Tiere in der Kunst 1850– 2000,* München 2009.

[29] Vgl. Gilles Deleuze und Félix Guattari, *Tausend Plateaus. Kapitalismus und Schizophrenie II,* Berlin 1993.

[30] Uraufführung bei den Wiener Festwochen in Kooperation mit dem Volkstheater. Konzept: Signa Köstler, Inszenierung: Signa Köstler und Arthur Köstler, Co-Regie: Ilil Land-Boss, Ausstattung und Kostüme: Signa Köstler, Olivia Schröder und Yulia Yanez, Audiovisuelle Medien: Arthur Köstler und Martin Heise, Dramaturgie: Heike Müller-Merten, Service-Performance-Installation Mai 2016, Faßziehergasse 5A, 1070 Wien.

[31] Vgl. John Berger, »Warum sehen wir Tiere an?«, in: ders., *Das Leben der Bilder oder die Kunst des Sehens,* Berlin 1980, S. 12–35, hier S. 30.

[32] Vgl. ebd., S. 35.

[33] Carol J. Adams, *The Sexual Politics Of Meat. A Feminist-Vegetarian Critical Theory,* London/New York 1990.

[34] Mönnig 2015 (wie Anm. 23), S. 36.

A Brief History of Animals in Art

Irina Danieli

"I fear that animals see a being like them who in a most dangerous way has lost his animal common sense—as the insane animal, the laughing animal, the weeping animal, miserable animal."[1]

If living animals appear in art today, the animal rights activists are bound to show up, as happened recently at the Kunstmuseum Wolfsburg: for the exhibition *Power! Light!*, Damien Hirst's installation *A Hundred Years* (1990), which is part of the museum's collection, was fetched from the cellar, into which it disappeared again a short time later. After a complaint from People for the Ethical Treatment of Animals (PETA), the Kunstmuseum was reprimanded, since blowflies are also covered by the German Animal Welfare Act.[2]

In *A Hundred Years*, flies are born, live, and die. The work consists of a glass cube that is divided in the middle by a sheet of glass. Fly larvae hatch on one side, and on the other is an electric flytrap equipped with light, a device commonly used in animal breeding facilities. Bowls of food stand in both halves of the cube. The glass dividing wall has two fist-sized openings, thus enabling the flies to move from one "living space" to the other. The flies that end up in the death cube, by chance or attracted by the light, are burnt up sooner or later by the electrical trap. Theoretically, if the flies remain in part of the cube in which they hatched, it would be possible for them to achieve their total lifespan of a few weeks.

The work raises questions that are increasingly being addressed in contemporary art. The flytrap—called an insect killer in technical jargon—refers to its original location: the livestock stalls of factory farms. Flesh, of that which coexists with humankind, is killed there.

The aesthetics of Hirst's installation can also call to mind death row cells and the sentence connected with them: death by electric chair. This association arises in particular due to the glass cube, the view, the being seen and exhibited. What criminals and animals for slaughter have in common is that—in contrast to the flies—they have already been sentenced. "Animals look at us," the philosopher Jacques Derrida observed after being unsettled by an encounter with a cat. It assessed him with its gaze in such a way that he, standing

naked in front of it, entered into a vicious cycle of shame. He was ashamed before the cat and was ashamed of his shame. This oft-cited scene represents a radical becoming-conscious of one's own personal humanity vis-à-vis animality. Derrida: "It has its point of view regarding me. The point of view of the absolute other."[3] Can human beings only define themselves based on their distinction from animals? As a result of the dual meaning of the French verb *regarde* in "L'animal nous regarde," the sentence can, however, also mean that "animals are our concern." Derrida repeats it several time in his book *L'Animal donc je suis,* and the title also involves a play with dual meanings. It can be translated as "The Animal That Therefore I Am," or as "The Animal That I Am Following After." In a brief stroll through occidental art history, we would also like to follow after animals and look at them. In doing so, we should be particularly interested in the developments that are being propelled forward in contemporary art and its negotiations of the relation between human and animal.[4]

Divinity—Totem—Sacrificial Offering

The earliest known pictorial testimonies to animals are also the oldest known pictorial creations by the human hand. The paintings in the cave of Chauvet-Pont-d'Arc were produced roughly 30,000 years ago, and those in the caves of Lascaux and Altamira slightly more recently. What the paintings and the animals depicted in them—including predatory cats, bears, aurochs, horses, bison, roes, and stags—are intended to signify has hitherto not been clarified.[5] Perhaps animals were perceived as alien in a much more radical way than in later epochs. Do we know what significance they had for the people of this time? On the one hand, animals were in the majority—and their sheer dominance may also have caused fear—and on the other, people were heavily dependent on them. Were the frequently depicted hunting scenes supposed to increase the success of future hunts by binding the animal desired as prey to the wall? Was a sort

of writing of history engaged in with the pictures? Perhaps what is shown by this, as Jessica Ullrich has observed, is simply people's desire to express themselves and their appreciation of their animal cohabitants.[6] This difficulty, the question of whether animals have the character of a thing, function, totem, or symbol, would remain a theme through all art epochs—also in the epochs from which written testimonies have been preserved for us. The relations became more concrete in antiquity. Mythology, historiography, and fables that tell us of the contemporary relations between human beings and animals have been handed down to us. The view of animals in antiquity is shaped in particular by a mythical-religious gaze, but profane elements like a very concrete competitive relationship might also have played a role: sporting activities like chariot or horse races were popular, and in Roman times there were gladiator fights in which animals fought against each other, as well as humans against animals. In myths, besides famous animals, there are also numerous hybrid creatures with animal attributes, and gods also appear as animals. And this entire bestiary populated the differentiating art production of antiquity, in the early period in a more ornamental to stylized manner, and later increasingly more realistically.

The bronzes of the Hellenistic period have, unfortunately, barely been preserved due to the material with which they were made. But one beautiful exception is the Jockey from Artemision (ca. 150–146 BCE): a slender racehorse appears to be in the process of galloping away with momentum, and seated on it is a child rider who follows the movement of his companion and seems to merge with it. This realism in pictures would first return with the Renaissance.

The human-animal relation is also discussed on a philosophical level: for instance, whether animals may be slaughtered for sacrificial purposes. Empedocles (495–435 BCE) called for a strict ban, even if perhaps motivated specifically by the idea of reincarnation. If a particular animal were not slaughtered, then this was done in order to protect a human inside it undergoing transformation.[7]

Ornament—Symbol—Allegory

Physiologus, an early Christian text on nature that dates from the second century CE and brings together zoological knowledge, fables, and interpretations of various types of animals with reference to their place in the divine order, had great significance for the human-animal relation of late antiquity and the early Middle Ages, as well as for Christian iconography. Though Christianity minimized the cultural wealth of antiquity, it transformed the animal characters of the fables of antiquity into Christian symbols and thus enshrined a stock of images to which medieval authors and artists later frequently returned—even though also predominantly in depictions of animals with a symbolic and allegorical nature.[8] It gave rise to attributions of virtues and vices that—once defined—did not undergo any further changes. Just as the stag or the lamb stands for Christ, the fly represents the devil and the snake original sin. The animals served as "instruments of cognition" that provided laypeople with moral teachings and were supposed to communicate God's divine plan.[9] But fantasy and animals can be put permanently in chains just as little as vices. In medieval manuscripts, animals are found in great numbers, frolic insolently as drolleries in the side margins, or become protagonists themselves, as in the French *Le Roman de Renart* (Reynard the Fox). As in ancient times, depictions also remained a fixed element in architectural sculpture.

Nature Studies and Courtly Animals

The concept of nature changed in the transition to the modern era. Nature was no longer first and foremost threatening, but increasingly became an object of study that could be used for one's own purposes when engaged with sufficiently. Studies on plants and insects, but also on mammals, birds, and rodents became ever-more popular—simply think of the precision of Albrecht Dürer's renowned watercolor *Feldhase* (Young Hare, 1502) or his study of dead European rollers produced around 1500.

With the courtly society of the fifteenth and sixteenth centuries, a new need for representation emerged, while particular animal companions became popular at the same time, as can be seen in Titian's portrait of Charles V in the company of his mastiff (1533) or in the portrait of the young Clarissa Strozzi petting her playfellow, a lapdog (1542, fig. 1). How the dogs visualize the character of their owners and support the representative objective can be recognized particularly when one compares the two pictures. Carl V, is tall and stately, and at his side is an equally tall, muscular mastiff that is devoted to its owner, as is shown by its snuggling head. The small Clarissa, magnificently dressed, but still revealing the uncertainty of a child, seeks stability in her animal friend, which, quite similarly to its owner, is slightly frightened, but charms her with its prettiness and sweetness.

Pathos and Automatons

With the Baroque's ambivalent attitude toward life, which oscillated between a zest for life, debauchery, and fear of death, the slaughtered animal, mere meat, also became a topic.[10] Rembrandt van Rijn's painting *Slaughtered Ox* (1655) is well known. The massive body of an ox hangs from a wooden crossbeam; the hooves, fur, and head have already been removed. The skeleton, seams of fat, and tendons are formed from the paste-like application of the paint. Here, flesh and paint enter into a haptic relationship that would also be a starting point for future artists such as Chaim Soutine or Francis Bacon. The motifs follow very much in the tradition of the vanitas motif. Just as fruits and, even more so, flesh rot, we decay as well: like in Jean-Baptiste-Siméon Chardin's *La raie* (The Ray, 1728, fig. 2), an assemblage of fish, bloody ray meat, opened oysters, drinking vessels, and a cat with a wonderfully arched back that is eyeing the oysters. The mere meat of the animals here can be understood as an attribute of human desire, wealth, and ownership.

Peter Paul Rubens celebrated a different form of pathos with his bloody battle between human beings and animals. Pictures like *The Tiger Hunt* (ca. 1616) were produced in working communities: various specialists were responsible for different aspects, hence the animal experts Frans Snyders, Adrian van de Velde, and Roelant Savery, the latter of whom is famous for his insects. Paulus Potter (1625–1654) left behind roughly 200 paintings with animals as their focus. Here, in the Dutch painting of the seventeenth century, it is possible to recognize a precursor to the animal painting that became established in the eighteenth century. In the Baroque and Mannerism, there was still no clear separation between art and culture in chambers of art and curiosities. Zoological specimens found their place next to alabaster works and ancient statues. What René Descartes (1596–1650), who at this time postulated his mechanistic image of animals,[11] thus wanted, according to Thomas Zaunschirm, was not first and foremost to degrade animals, but to valorize the machine.[12] People's elemental need to imitate nature brought forth automatons similar to human beings, but also similar to animals. Jacques de Vaucanson thus presented a duck automaton to the French Academy of Sciences in 1738. It was able to flap its wings, quack, and drink water, and thanks to an artificial digestion apparatus, could even defecate, a feature that delighted viewers.

Experiments and Ethics

The enthusiasm for the natural sciences persisted, while moral-philosophical trains of thought also left behind their traces toward the end of the eighteenth century. In 1789, Jeremy Bentham, the founder of classical utilitarianism, deployed the perhaps most frequently cited statement in animal ethics: "The question is not Can they think? or Can they talk? but Can they suffer?"[13] Whether and how animals suffer and, in particular, what observing the suffering of animals does to their human counterpart is addressed in the painting *An Experiment on a Bird* (1768) by Joseph Wright of Derby (1734–1797). It marks a point that represents not first and foremost a threshold in art history, but especially in animal ethics as well. The picture reports on the experiments conducted on various small animals almost one hundred years before by Robert Boyle, the leading chemist of the Royal Society. He observed how living creatures reacted when air pressure was reduced. To do so, he put diverse small animals in a pump and deprived them of air in a variety of modes and to various extents, either until they perished or until their alleged reawakening—owing to a renewed supply of air.[14] Wright of Derby depicted the moment at which the fate of the bird has not yet been decided.

The picture series *The Four Stages of Cruelty* (1751) by William Hogarth (1697–1764) also deals with questions involving animal ethics. Four plates recount the story of Tom Nero, who developed from an abuser of animals—first a dog, then a horse—into a murderer. He was executed and his corpse released for dissection. When Immanuel Kant (1724–1804) spoke out against violence to animals—not for the sake of the animals, which, as is well known, he believed did not feel emotions, but in order to protect people from brutalization—he made reference to these pictures by Hogarth.[15]

The Genre of Animal Painting— The Animal as Individual?

The genre of animal painting already became established in Dutch painting in the seventeenth century. Artists such as Rosa Bonheur (1822–1899), however, always had to defend themselves against the prejudice that it was inferior painting. In the hierarchy of art genres, animal painting was the dimmest light. It was nevertheless very popular at the courts of the early modern era. The fact that "aristocratic" animals entered into close relationships with their respective companions is also shown in their being portrayed like people. On the other hand, representative function and ownership status were also taken to an extreme. Edwin Landseer (1802–1873), the court painter of Queen

Victoria, was commissioned to portray Eos, Prince Albert's grayhound (fig. 3).[16] Against the red backdrop of the tablecloth, the animal's silky black, glossy fur comes into its own in an ideal manner. In front of its forelegs, its master's gloves and hat lie on a footstool upholstered with the skin of a fawn, which in turn makes reference to the prince's sporting activities. It is not possible for the dog alone to represent its master, but combined with the arrangement of his insignia, Prince Albert nevertheless seems to be present and is the true subject of the portrait. And Landseer naturally also oriented himself toward the previously discussed double portraits of Charles V and Clarissa Strozzi by Titian.

George Stubbs (1724–1816), who specialized in horses, was interested in particular in reproducing their anatomy in an accurate way. To this end, he dissected horses for months and published his insights in the famous work *Anatomy of the Horse*, which is illustrated with eighteen copperplate engravings.[17] His most well-known painting is probably *Whistlejacket* (1762), which depicts the thoroughbred stallion of the same name rearing up, without a rider or insignia alluding to equestrianism. On the one hand, the horse is made virtually into an icon by having it rear up flawlessly in an ideally beautiful manner against a golden backdrop. On the other, the picture adheres to the naturalism that emerged with the Enlightenment and growing empiricism.

Charles Darwin's *The Expression of the Emotions in Man and Animals* (1872) is a turning point in the debate on the relationship between humans and animals, since, as Darwin was compelled to determine, animals are not at all unsimilar to people in their "emotions."

With the creation of zoological gardens at the end of the eighteenth century, close study of the exotic living object became possible. In France, artists who visited the zoo for their drawing studies were called *animaliers*. Court menageries were made accessible to the public in the course of the revolution and became bourgeois institutions.

The most famous painter of animals was Rosa Bonheur. She regularly visited the menagerie in the Jardin des Plantes, was active as protector of animals, lived openly as a lesbian, and wore men's clothing. Bonheur, who was very much influenced by Charles Darwin, emotionalized her animal portraits—that is to say, she romanticized them when, for instance, a solitary cow looks at the horizon and thus calls to mind Caspar David Friedrich's *Wanderer über dem Nebelmeer* (Wanderer above the Sea of Fog, 1818); or when in her monumental *Marché aux chevaux* (The Horse Fair, 1855) she dramatized the scene filled with very nervous horses—with wild manes—in such a way that one thinks one can recognize an impending storm in the electrified atmosphere. How horses really move, however, was something that painters were unable to comprehend for a long time; this first became possible as a result of the chronophotography of Eadweard Muybridge (1830–1904). With his photographs, he was able to show that galloping horses had been depicted incorrectly for centuries: when galloping, they always retain contact with the ground with either their fore- or hindlegs, and only seem to fly when trotting. The eleven-volume photo book *Animal Locomotion* was published in 1887, with 781 illustrations of animals in motion, 100 of them alone showing the various gaits of horses. Muybridge's studies on animal locomotion had a huge influence on the artists of the century that followed. Even though photography competed increasingly with animal painting, such painting nonetheless continued into the twentieth century.

Animalism and Surrealism

Franz Marc (1880–1916), who is known for his colorful animals, seems to have been one of the first to try painting from the perspective of animals.[18] He wanted to capture how—in his imagination—the animal perceives itself on canvas. Marc advocated for no longer relating animals and plants solely to human beings. He himself called this approach an "animalizing" of art and embedded animals in compositions in such a way that a harmonious

overall context that corresponded to his "sensibility for the organic rhythm of all things"[19] resulted.

In the course of Surrealism and the corresponding penchant for the fantastical, hybrid creatures and symbolic animals also became popular once again. They are found with particular frequency in the work of Frida Kahlo (1907–1954), generally portrayed as companion animals. In the work of the cat fanatic Leonor Fini (1907–1996), enigmatic hybrid creatures and a large number of cats frolic about, to which she even dedicated an entire book, *Miroir des Chats* (Mirror of Cats, 1977). She recognized them as equals. Many forms of hybrid creatures also appear in the pictorial creations of Leonora Carrington (1917–2011). She created enigmatic dreamworlds that always caused a slight shiver, as in the work *Sphinx* (ca. 1950), from whose stumps of arms feathers grow—terrifying in their proportions, but totally viable in effect. The chimeras of antiquity and the Middle Ages thus returned as representatives of the totally other, the incomprehensible.

Animal Corporeality in Painting

Two painters who have not necessarily gone down in history as painters of animals are Francis Bacon (1909–1992) and Maria Lassnig (1919–2014). Their painting revolves around the rendering of corporeality, often their own, in various ways. And yet diverse species of birds, dogs, and primates, and a wide range of hybrid creatures nonetheless romp around in the work of both Bacon and Lassnig.

As different as their painting is, they both turned to the subject of animals in a notably similar way. They became a means of transformation and, in particular, of reflecting on their own corporeality. Questions regarding identity such as "Where do I begin?" or "Where do the boundaries of myself lie?" were relevant to both of them, and animals seemed to be apt objects for such considerations.

Both of them were interested in being meat, as Bacon stated: "And, of course, one has got to remember as a painter that there is this great beauty of the colour of meat. . . . Well, of course, we are meat ourselves, potential carcasses. If I go into a butcher's shop, I always think it's surprising that I wasn't hanging there instead of the animal."[20] The connection between flesh and paint was already a topic in treatises on painting of the Cinquecento: painting as *incarnazione*, or painting meat, becoming meat.[21] A stir was caused by Bacon's painting *Figure with Meat* (1954, fig. 4), which makes reference to Rembrandt's *Slaughtered Ox*, while the figure between the halves of the slaughtered cow is one of his reminiscences on Velázquez's portrait of Pope Innocence X (ca. 1650).

Maria Lassnig also made meat a topic. Her self-portraits, renderings of physical sensations that portray her body from an inner perspective, frequently include meat tones. Some of these bodies seem to oscillate between that of the artist and a picture of dogs, in which the flesh beneath shines through the naked skin. Animals also appear in Lassnig's work in the form of double portraits. They can be read as a doubling, as an intensification of what is portrayed, following very much in the tradition of courtly Renaissance pictures. In others, they have a direct relationship to her concept of physical sensation. The animals are adapted to the form of Lassnig's pictures of human body sensations, thus as if the painter empathized with the physical sensations of animals.

Coexistence: Living Animals

The appearance of living animals on the art scene in the 1960s represents a turning point.[22] Zaunschirm has pointed out that at the same moment when the bodies of artists became an artistic tool, became material, living animals—or as Mona Mönnig would differentiate: the "concrete animal"—also entered the modern art world.[23] In his action *Coyote, I Like America and America Likes Me* (1974), Joseph Beuys locked himself inside a gallery space in New York City for three days along with a coyote called Little John. During this time, Beuys stood, sat, and layed down in a ritualized

sequence. The coyote and the artist came into contact in the process. Beuys first spurred the fearful animal to shred his wool blanket, in order to thus gain its trust. Beuys's coyote served as a representative for the Indigenous peoples of America and was supposed to embody a sort of solidarity with nature. Apart from the fact that this action would hardly be read in this way today, animals, here exemplarily a coyote, were used in Beuys's work as symbols and are linked to themes of the nineteenth century, to a romantic natural philosophy.

In his work *Untilled* (2013) at Documenta 13, Pierre Huyghe staged coexistence in the sense of an overcoming of anthropocentrism. In Karlsaue Park in Kassel, he planted a wild garden filled with buzzing and droning. The head of a reclining female sculpture was obscured by a colony of bees, and the bee hive grew and grew. Somewhere in the semimystical garden idyll lived Human, a white female Podenco dog with one leg painted pink, and Señor, who was still a puppy at the time. Assigning names always also points toward recognizing one's counterpart as an individual, and it is known that animals with names are killed with more difficulty.[24] Is the dog declared to be human by its being given a name, or, as Mönnig believes, is reference being made to the overrepresentation of human beings?[25] It is difficult to avoid thinking about Arthur Schopenhauer's poodle Butz, which, if one believes the anecdote, was called "mensch" (man) by its master when it was naughty.[26]

Animaux trouvés

But not only did living animals come to be used as material; dead animals or parts of dead animals did as well.[27] What is thus underscored is the dissolution of the body or the aspect of its being assembled, a machine-like quality. Maurizio Cattelan has created provocative works that are well known: his preserved horse heads, which dangle down loosely from the heights of exhibition spaces and, head in the wall, conversely seem to represent

hunting trophies. As in Damien Hirst's work, in which countless dead animals have been incorporated—his shark preserved in formaldehyde or the cow with calf in *Mother and Child (Divided)* (1993) come to mind—the emphasis seems to be put (in a very masculine way) on a moment of being overwhelmed, on statement architecture in visual art. The works of Iris Schieferstein and Polly Morgan are more subtle. In contrast to their male colleagues, they both do their taxidermic work themselves. The former is known in particular for her hoofed shoes. She takes the front or hind hooves of a cloven-hoofed animal and transforms them into shoes. Is this about becoming-animal in the sense of Gilles Deleuze and Félix Guattari? In *A Thousand Plateaus*, the two philosophers discuss the idea of becoming-animal. For them, the *becoming* is not imitation, but rather the shifting of identity toward an "other" and/or a synthesis of two identities, which simultaneously implies the deconstruction of the original identities. *Becoming* (also becoming-child, becoming-woman, but not becoming-man, or becoming-human) rejects hierarchization, a linear structure of the world. Moreover, Deleuze and Guattari regard the process of becoming-animal as being determined not by ancestry, but by contagion.[28]

Schieferstein is simultaneously also on a collision course with the hypocrisy of our society. She regards dead animal bodies as a natural resource of beauty. Why not make use of it, be guided by it? Her animal cadavers are in part animals that were run over on the street. In 2002, she thus received an anonymous notification stating that in Germany solely animals that have been shot, reared, or bred may actually be preserved. A bird that dies in the wild may decay but may not be used.

In her taxidermic sculptures, Morgan combines animal cadavers with objects that seem like exhibits from the chambers of curiosities of the seventeenth century. She arranges birds under a glass dome from which a chandelier hangs, or has rare animals feed on an opened-up, blood-red heart. She is interested in the discrepancy between loveliness and vanitas; the animals with their cultural-historical charging serve as a catalyzer for her.

Animals as Projection Surface, or Overcoming Anthropocentrism

An immersive staging by the Signa group at the Vienna Festival in 2016 presented the bizarre, shared accommodation *Canis Humanus*.[29] Its members feel in part like dogs, and in part like their owners. The dogs take on supposedly doglike characteristics. In the several-hour staging, one learns why dogs are good dogs and masters are good masters. One can observe members of the audience participating in the perverse power games and people inventing animals for themselves in order to be able to wield power.

Krōōt Juurak and Alex Bailey developed their *Performances for Pets* with an entirely different approach but in a certain sense also imitated animal characteristics. The two artists perform for animals. They want to reverse the roles that have always been ascribed to humans and animals, and thus take a step toward overcoming anthropocentrism. According to this artistic, scientific, and ethical approach, animals should no longer be gawked at and provide entertainment for their human counterparts, but instead be perceived as individuals and entertained as such. The artist duo visits its audience—house pets, dogs, or cats—in its familiar surroundings, obtains information about character traits from their human companions, and then puts together an individual program for the animals to be entertained. The house pets become recipients.

In her hybrid works, Maja Smrekar resolutely examines human-animal and nature-culture-technology relations and is thus active at the interface between bioethics, science, and art. *Hybrid Family* (2016, fig. 5), which comes from the four-part series of works *K-9_topology*, deals with questions regarding motherhood, interspecies relationships, and the instrumentalization of the female body (et al. via the topic of breastfeeding). For her performance, she manipulated her body so that it produced mother's milk. She then began feeding a puppy. Also present was the dog Byron, the artist's companion animal. The triangular constellation calls to mind the classic nuclear family, which is understood here from an interspecies perspective and hence takes up the central idea of the theorist Donna Haraway, who is regarded by some as one of the individuals most influential for the art world. "Make kin, not babies" has become her motto. Kinship should not be thought of based on degree of ancestry, but rather as based on an actively chosen coming-together. Haraway's considerations bring together science, art, and activism. She has developed a process that she calls "SF," standing for speculative feminism, *so far, science fact, science fiction*, or for string figures, cat's cradle. Her undertaking can perhaps be described most clearly using the figure of cat's cradle. Systems of relationships and species, fiction and facts, also behave like the strings in the game of dexterity—with one's fingers, one forms diverse interconnections, opens them up, and compresses them, interweaves them anew.

Why Look at Animals?

John Berger asks this question in his now-famous essay of the same name. Hence: Why do we look at animals? Because, to use Derrida's words, they concern us?

Today, there is a great presence of animals on the one hand—just think of the countless TikTok and Instagram videos in which they appear—and on the other they are not really noticeable in our lifeworld, apart from in the form of pet animals. In zoos, as Berger notes, a real encounter with animals is not possible. The animal staged as an exhibition object is marginalized.[30] According to Berger, the look returned by animals and thus their actual presence has been eradicated: "Therein lies the ultimate consequence of their marginalisation. That look between animal and man, which may have played a crucial role in the development of human society . . . has been extinguished."[31] The animal industry, particularly that of slaughterhouses, has receded from our world of cognition entirely. In *The Sexual Politics of Meat*, Carol J. Adams also argues that animals as subjects have been made unrecognizable and invisible as referents as a

result of the dissection and fragmentation of their bodies.[32] At the same time, we seem to overlook depictions of animals in a strange way, a fact that points to a highly complex relationship between us and animals. Mönnig formulates this as follows: that "the real animal" has become overlaid with "dimensions of human cognition and senses, ultimately: pictures" to such an extent "that it is hard not to regard the animal as such as a constructed picture."[33] For visual art, this means that the picture of an animal has rarely if ever been or could be dedicated to the real animal. The picture of an animal, also that of a specific animal, is always a picture that has been appropriated, be it as a symbol, metaphor, or idea. Only very recently have there been approaches in art and science that transcend the human perspective. How, therefore, can the concrete animal be encountered at all? The approaches of contemporary art point, among other things, toward a still utopian-seeming coexistence. It is not the case that artists themselves must comprehend their works from the perspective of animal ethics so as to facilitate such readings. We must go beyond merely wanting to look at animals—animals concern us.

1 Friedrich Nietzsche, *The Gay Science,* ed. Bernhard Williams, trans. Josefine Nauckhoff (Cambridge, UK: Cambridge University Press, 2005), p. 145.

2 See Alia Lübben, "Auch Fliegen fühlen: Tierrechtseklat im Kunstmuseum Wolfsburg," *Monopol: Magazin für Kunst und Leben* (July 12, 2022), https://www.monopol-magazin.de/tierrechtseklat-wolfsburger-kunstmuseum-auch-fliegen-fuehlen (all URLs here accessed in December 2022).

3 Jacques Derrida, "The Animal That Therefore I Am (More to Follow)," trans. David Wills, *Critical Inquiry* 28, no. 2 (Winter 2002): 369–418, esp. 380.

4 A wonderful journey through art history in connection with the subject of animals is found in Jessica Ullrich's text "Tiere und Bildende Kunst," in *Tiere: Ein kulturwissenschaftliches Handbuch*, ed. Roland Borgards (Stuttgart: J. B. Metzler, 2016), pp. 195–215. Examples that she examines are in part also found in this essay; but besides the overview of art history, the presentation of history is also meant to be connected with philosophical and cultural-historical positions.

5 In the individual caves, one respective species appears prominently. In La Pasiega, primarily stags and does are depicted; in Les Combarelles, horses; and in Font-de-Gaume, bison; see Max Raphael, *Prehistoric Cave Paintings*, trans. Norbert Guterman (New York: Pantheon Book, 1946), p. 4.

6 According to Max Raphael, four different meanings can be ascribed to animals in prehistoric cave paintings: animals represent themselves, for instance, as an object that has to be killed; animals have a magical function and should thus assist in making ideological wishful thinking a reality; animals have a totemic significance.; animals are employed as symbols; see idem., *Prehistoric Cave Paintings*, p. 46; see also Ullrich, "Tiere und Bildende Kunst," p. 195.

7 See Christoph Horn, "Geschichte der Tierethik: Antike," in *Tierethik. Grundlagen – Kontexte – Perspektiven*, ed. Johann S. Ach and Dagmar Borchers (Stuttgart: J. B. Metzler, 2018), pp. 3–9, esp. p. 3.

8 The *Physiologus* also remained a link, as weak as it might also be, to the old science and served as a core around which the more objective shells of the old were once again assembled over the course of time, according to Francis Klingender in his magnum opus *Animals in Art and Thought: To the End of Middle Ages*, ed. Evelyn Antal and John P. Harthan (London: Routledge, 1971), p. 94.

9 Ullrich, "Tiere und Bildende Kunst," p. 195.

10 Ibid., p. 197.

11 He rejects Aristotle's differentiated abilities of souls and argues for a strict dualism of substance: body and soul should be considered separately. And because solely human beings can have a spirit, animals are shifted in the direction of machines; see René Descartes, *Discourse on the Method of Rightly Conducting One's Reason and of Seeking Truth in the Sciences* (Project Gutenberg), https://tinyurl.com/mtzkn322.

12 See Thomas Zaunschirm, "Im Zoo der Kunst I: Seit wann und warum gibt es lebende Tiere in der bildenden Kunst?," *Kunstforum International* 32, no. 174 (January–March 2005): 36–103, esp. 54.

13 Jeremy Bentham, *An Introduction to the Principles of Morals and Legislation* (London: T. Payne and Son, 1789), chap. 17 (emphasis by the author).

14 Robert Boyle attempted to minimize the exertions of animals by giving individual animals breaks or regulating the prevalence of drafts. He was convinced that inflicting pain without cause could not be reconciled with the biblical commandments; see Linda Johnson, "Animal Experimentation in 18th-Century Art: Joseph Wright of Derby: An Experiment on a Bird in an Air Pump," *Journal of Animal Ethics* 6, no. 2 (2016): 164–76, esp. 166.

15 Immanuel Kant, "Von den Pflichten gegen Thiere und Geister," in *Kants gesammelte Schriften*, Akademieausgabe, vol. 27/2/2, para. 4 (Lectures on moral philosophy, published by Akademie der Wissenschaften zu Göttingen) (Berlin, 1979), p. 1573.

16 Kirsten Claudia Voigt, "Fährten, Gefährten," in *Gemalte Tiere: Ein Bilder- und Lesebuch mit 61 Meisterwerken aus sieben Jahrhunderten*, ed. Lothar Schirmer and idem. (Munich: Schirmer/ Mosel, 2021), pp. 11–17, esp. p. 13.

17 Alina Christin Meiwes, *Die Tiermalerin Rosa Bonheur: Künstlerische Strategien und kunsthistorische Einordnung im Kontext der Vermittlung* (Baden-Baden: Tectum Verlag, 2020), p. 58.

18 Ullrich, "Tiere und Bildende Kunst," p. 201.

19 Annegret Hoberg, "Eine neue Mission in der Kunst – Murnau, München und der Blaue Reiter," in *Das Geistige in der Kunst: Vom Blauen Reiter zum Abstrakten Expressionismus*, ed. Volker Rattemeyer et al., exh. cat. Museum Wiesbaden (Wiesbaden: Museum Wiesbaden, 2010), p. 33.

20 David Sylvester, *Interviews with Francis Bacon* (London: Thames & Hudson, 1975), p. 46.

21 See Christiane Kurse, "Fleisch werden. Fleisch malen. Malerei als Incarnazione: Mediale Verfahren des Bildwerdens im Libro dell'Arte von Cennino Cennini," *Zeitschrift für Kunstgeschichte* 63, no. 3 (2000): 305–25.

22 There are already various art-historical examinations of this: Annalena Roters, *Mit Tieren denken: Zur Ästhetik von lebenden Tieren in der zeitgenössischen Kunst* (Berlin: Neofelis, 2022); Jessica Ullrich, "Achtung lebende Tiere! Ästhetik und Ethik in der zeitgenössischen Kunst," in *Von armen Schweinen und bunten Vögeln: Tierethik im kulturgeschichtlichen Kontext*, ed. Stephanie Waldow (Paderborn: Wilhelm Fink, 2015), pp. 217–40; Thomas Zaunschirm, "Im Zoo der Kunst II," *Kunstforum International* 32, no. 175 (April–May 2005): 36–125.

23 Mona Mönnig, *Das übersehene Tier* (Bielefeld: transcript Verlag, 2018), p. 228.

24 How and why animals received their names is addressed in the work of Thomas Macho: "Tiere als Individuen: Eigennamen und Portraits von Tieren," in *Menschen und Tiere: Grundlagen und Herausforderungen der Human-Animal Studies*, ed. Friedrich Jaeger (Stuttgart: J. B. Metzler, 2020), pp. 237–49.

25 Mönnig, *Das übersehene Tier*, p. 232.

26 Volker Spierling, *Arthur Schopenhauer zur Einführung* (Hamburg: Junius Verlag, 2002), p. 12.

27 An in-depth examination of taxidermy in art is found in the book by Petra Lange-Berndt, *Animal Art: Präparierte Tiere in der Kunst 1850–2000* (Munich: Schreiber Verlag, 2009).

28 See Gilles Deleuze and Félix Guattari, *A Thousand Plateaus: Capitalism and Schizophrenia II* (Minneapolis: University of Minnesota Press, 1993).

29 Premiere at the Vienna Festival in cooperation with the Volkstheater. Concept: Signa Köstler; staging: Signa Köstler and Arthur Köstler; codirector: Ilil Land-Boss; props and costumes: Signa Köstler, Olivia Schröder, and Yulia Yanez; audiovisual media: Arthur Köstler and Martin Heise; dramaturgy: Heike Müller-Merten; service-performance-installation May 2016, Faßziehergasse 5A, 1070 Vienna.

30 John Berger, "Why Look at Animals?," in idem. *Ways of Seeing* (London: Penguin Books, 2009), pp. 3–30, esp. p. 25.

31 Ibid., p. 35.

32 Carol J. Adams, *The Sexual Politics Of Meat: A Feminist-Vegetarian Critical Theory* (London and New York: Bloomsbury, 1990).

33 Mönnig, *Das übersehene Tier*, p. 36.

1,5 Grad

1

Aktivismus / Activism

Aktivismus

Sebastian Schneider

Im Dezember 2015 einigten sich 197 Staaten auf der UN-Klimakonferenz in Paris, den globalen Temperaturanstieg auf 1,5 Grad Celsius zu begrenzen – ein hehres Ziel, das nach heutigem Stand von keinem der großen Industrieländer erreicht wird. Es ist diese politische Wirkungslosigkeit im Kampf gegen den Klimawandel, die seitdem eine Vielzahl neuer Protestbewegungen hervorgebracht hat. Dabei kommt auch der Gegenwartskunst eine aktive Rolle zu. Viele Künstler*innen begreifen ihr Schaffen als Möglichkeit, um konkret auf Missstände und Benachteiligungen hinzuweisen oder um Handlungsalternativen zu formulieren. Ihre Arbeiten zielen auf Intervention und Mitbestimmung. Gerade in Staaten mit restriktiver Gesetzgebung wird Kunst zu einem Vehikel, um jenseits etablierter (und sanktionierter) Formen des Protests Ungerechtigkeiten anzuprangern.

Beispielhaft für eine solche künstlerische Praxis steht Emerson Pontes. Der Künstler, Biologe und Pädagoge wurde im Amazonasgebiet im Norden Brasiliens geboren. Er versteht seine interdisziplinäre Arbeit als Form des Protests gegen die Umweltzerstörung in den von indigenen Bevölkerungsgruppen bewohnten Gebieten Brasiliens. Der Vorstellung einer dem Menschen untergeordneten Umwelt setzt Pontes ein Konzept gegenseitiger Abhängigkeit entgegen. Um diesem Gedanken nachzugehen, hat Pontes das Alter Ego Uýra Sodoma kreiert, die wie ein Hybrid aus Mensch und Pflanze erscheint und in deren Rolle der Künstler indigenes ökologisches Wissen an Jugendliche aus dem Amazonasgebiet vermittelt. Gleichzeitig entstehen Fotografien, die Uýra Sodoma im Regenwald oder in verdreckten Industrielandschaften zeigen – durch kunstvolle Verkleidung scheint sie mit ihren Kulissen zu verschmelzen. Als Uýra Sodoma überwindet Pontes die Grenzen von Mensch und Natur,

aber auch von Mann und Frau. Diese in Fotografien gebannten performativen Akte zielen in ihrer Intention und Wirkung auf nachhaltige Veränderung im Sinne einer planetarischen Sorgearbeit.

Die Themen Fürsorge, Mensch-Umwelt-Beziehungen und Geschlechtsidentität stehen auch im Zentrum des Videos *Night Soil – Nocturnal Gardening* von melanie bonajo. Darin werden vier Frauen vorgestellt, die alternative Methoden der Landnutzung und Tierhaltung erproben. Die Porträts bieten Einblicke in solidarische Lebensformen, die von einem veränderten Verhältnis zur Natur, einem anderen Gemeinschaftssinn, aber auch einem alternativen Umgang mit dem eigenen Körper und vorgegebenen Geschlechterrollen erzählen. Gerade jetzt, wo uns die Klimakrise dazu herausfordert, unseren Lebensstandard und unsere Konsummuster zu hinterfragen, zeigt das Video, dass es möglich ist, sich dem kapitalistischen Streben nach Wachstum, Gewinnmaximierung und Individualisierung radikal zu widersetzen.

Somit stellt sich auch die Frage, wie wir Gemeinschaft denken und welche Rolle wir dem Kollektiv zuschreiben. Diesem Thema widmen sich die Zwillingsschwestern Margaret und Christine Wertheim in ihrer künstlerischen Arbeit. Mit ihren raumgreifenden gehäkelten Korallenriffen verweisen sie auf ein Ökosystem, das symbolisch für die zerstörerischen Folgen der Erderwärmung steht. Die Werke sind das Ergebnis eines gemeinsamen Herstellungsprozesses, bei dem die Schwestern Interessierte im Vorfeld einer Ausstellung dazu einladen, selbst Bestandteile des Riffes zu häkeln. Auffällig ist hierbei, dass sich vor allem Frauen dazu bereit erklären, die eigene Autor*innenschaft zugunsten eines gemeinsamen Projekts zurückzustellen.[1] Die Biologin und Feministin Donna Haraway verweist auf die Korallenriffe von Margaret und Christine Wertheim als Beispiel für ihre These, dass sich Lebewesen nie nur aus sich selbst heraus entwickeln, sondern immer in ein erweitertes Netz von Bezügen eingebettet sind.[2] Damit hinterfragt Haraway die darwinistische Entwicklungslogik, die die individuellen Fähigkeiten des Einzelnen als Grundvoraussetzung für das eigene Überleben setzt. Ihre Forderung, den Menschen in einem Netzwerk von unlösbaren Bezügen und Abhängigkeiten zu denken, wird von Künstler*innen wie Pontes, bonajo sowie Margaret und Christine Wertheim aufgegriffen und kann als Impuls verstanden werden, um der Klimakrise zu begegnen.

Auch Guadalupe Miles und Tita Salina richten ihren Blick auf die Bedeutung von Gemeinschaften, allerdings verwenden sie dabei dokumentarische Mittel. Die Fotografien von Miles entstanden über einen Zeitraum von mehreren Jahren, in denen sie immer wieder zu

Mitgliedern der Wichí und der Chorote, zwei indigenen Volksgruppen im Norden Argentiniens, zurückkehrte. So entwickelte sich eine tiefe Verbundenheit, die es Miles ermöglichte Bilder aufzunehmen, in denen die normalerweise übliche Hierarchie zwischen Fotograf*in und Fotografierten obsolet zu sein scheint. Besonders eindrücklich zeigt sich diese Umkehr der Kräfteverhältnisse bei den Porträts. Sie sind in engem Austausch mit den dargestellten Personen entstanden und vermitteln diese Nähe durch eine fast schon spürbare Unmittelbarkeit. Gleichzeitig dokumentiert Miles mit ihren Fotografien den besonderen Bezug der Wichí und der Chorote zur Natur, die durch Umweltverschmutzung stark bedroht wird. Vor allem der Fluss spielt als Nahrungsquelle, aber auch als Spielplatz für Kinder eine zentrale Rolle. Miles' Fotografien rufen ins Bewusstsein, dass indigene und marginalisierte Gruppen besonders stark von den Folgen des Klimawandels betroffen sind.

Diese Thematik greift auch Tita Salina mit ihrer Videoinstallation *1001st Island – The Most Sustainable Island in Archipelago* auf. Sie entstand zusammen mit Fischer*innen aus Jakarta, die stark unter der massiven Verschmutzung der lokalen Gewässer leiden. Ebenfalls sieht sich die Küstenstadt mit der realen Gefahr konfrontiert, von Wassermassen des im Zuge der Erderwärmung steigenden Meeresspiegels überspült zu werden. Die Regierung plant deshalb, künstliche Inseln als Schutzwall in der Bucht von Jakarta zu errichten. Vier dieser Inseln existieren bereits jetzt – allerdings sind sie seit Jahren unvollendet und unbewohnbar. Mehr noch: Die Fischer*innen berichten, dass sich die Fangzahlen durch die künstlichen Inseln drastisch verschlechtert haben. Gemeinsam mit einer Gruppe von lokalen Fischer*innen hat Salina das Meer von Plastikmüll gereinigt. Aus dem gewonnenen Müll fertigte sie eine Insel, mit der sie sich auf dem Meer aussetzen ließ. Salina fügt den angeblichen 1000 Inseln des Archipels in der Bucht von Jakarta eine weitere hinzu, die sinnbildlich für das Problem der Landgewinnung und den Umgang mit Müll steht. Eine weitere Realisierung findet das Projekt nun in Mannheim, wo eine neue Insel aus vor Ort gesammeltem Müll entstehen wird.

Ernesto Neto eröffnet mit seiner Installation *O Be Vi de Só e Té, Agradê* einen Raum der Begegnung und der Gemeinschaft, der dazu anregt, über die hier angestoßenen Themen zu reflektieren. Der Künstler erschafft aus textilen Materialien begehbare Installationen, die zum Verweilen einladen. Dabei kommen auch Muscheln, Gewürze oder Kräuter zum Einsatz, die mit ihren Gerüchen die immersive Qualität der Arbeiten verstärken. Neto füllt diese Materialien in Stoffe und gehäkelte Kokons und schafft so dreidimensionale,

organisch anmutende Gebilde. Wie Pilze, die aus dem Boden schießen, oder Tropfen, die vom Himmel fallen, bevölkern sie den Ausstellungsraum. Die Vertikale bildet eine formale Konstante im Werk des brasilianischen Künstlers. Hier materialisiert sie Netos poetischen Gedanken, dass sich Himmel und Erde in Form von Pflanzen stetig zu küssen versuchen. Das damit einhergehende Postulat, uns selbst und die uns umgebende Umwelt achtsamer wahrzunehmen, kann für sämtliche in diesem Fragment vereinten Künstler*innen geltend gemacht werden.

[1] Vgl. Ann-Katrin Günzel, »Margaret und Christine Wertheim. Vom Wert und Wandel der Korallen«, in: *Kunstforum International,* 49, 281, Juni 2022, S. 226–237, hier S. 230.

[2] Vgl. Donna J. Haraway, *Unruhig bleiben. Die Verwandtschaft der Arten im Chthuluzän,* Frankfurt am Main/New York 2018, S. 110–112.

Activism

Sebastian Schneider

At the UN Climate Conference in Paris in December 2015, 197 nations agreed to limit the global temperature rise to 1.5 degrees Celsius—a noble objective that from today's perspective will not be achieved by any major industrial nation. This political ineffectiveness in the struggle against climate change has since then spawned a wide variety of new protest movements. Contemporary art also plays an active role in them since many artists see their work as an opportunity to point to specific grievances and inequalities or to formulate alternatives for action. Their works aim at intervention and codetermination. Particularly in countries with restrictive legislation, art thus becomes a vehicle for denouncing inequalities that goes beyond established (and sanctioned) forms of protest.

Such social artistic practice is represented exemplarily by Emerson Pontes, an artist, biologist, and educator who was born in the Amazon region in North Brazil. He regards his interdisciplinary work as a form of protest against the destruction of the environment in areas of Brazil inhabited by Indigenous groups. Pontes counters the notion of an environment subordinate to people with a concept of mutual dependence. To address this idea, Pontes created the alter ego Uýra Sodoma, who looks like a hybrid of a human being and a plant and in whose role the artist imparts Indigenous ecological knowledge to young people from the Amazon region. Photographs showing Uýra Sodoma in the rain forest or in filthy industrial landscapes—in which they seem to blend into their backdrops by means of elaborate costumes—are also created. As Uýra Sodoma, Pontes pushes the boundaries between human beings and nature, but also between men and women. The intention and effect of these performative actions captured in photographs aim at sustainable change in the sense of planetary care work.

The themes of care, gender identity, and relationships between humans and nature are also central to melanie bonajo's video *Night Soil—Nocturnal Gardening*. It presents four women that examine alternative methods of land use and animal farming. The portraits provide insights into solitary ways of life that tell of a different relationship to nature, a different sense of community, and an alternative approach to dealing with one's own body and prescribed gender roles. Particularly today, when the climate crisis challenges us to question our living standards and patterns of consumption, the video shows that it is possible to take a radical stand against the capitalist striving for growth, profit maximization, and individualization.

This also raises the question of how we think about community and what role we ascribe to the collective. The twin sisters Margaret and Christine Wertheim have dedicated themselves to this topic in their artistic work. With their large, crocheted coral reefs, they make reference to an ecosystem that stands symbolically for the destructive consequences of global warming. The works are the result of a joint production process in which the sisters invite interested individuals to crochet components of the reefs prior to an exhibition. What is striking about this is that women in particular declare their willingness to subordinate their own authorship for the benefit of a joint project.[1] The biologist and feminist Donna Haraway makes reference to Margaret and Christine Wertheim's coral reefs as an example of her theory that living beings never develop exclusively on their own, but are instead always embedded in an extended network of relationships.[2] Haraway thus questions the Darwinist logic of development, which posits the particular abilities of individuals as a prerequisite for their survival. Her call to think about people within a network of indissoluble relationships and dependencies has been taken up by artists like Pontes, bonajo, and Margaret and Christine Wertheim, and can be regarded as an impulse for facing up to the climate crisis.

Guadalupe Miles and Tita Salina also focus on the significance of communities, but make use of documentary means in doing so. Miles's photographs were produced over a time period of several years, during which she returned again and again to members of the Wichí and Chorote, Indigenous population groups in northern Argentina. This gave rise to a close bond that enabled Miles to take pictures in

which the normally standard hierarchy between photographer and photographed seems to be obsolete. The portraits show this inversion of power relationships in a particularly impressive way. They were created in close exchange with the individuals depicted and convey this closeness through an almost palpable immediacy. With her photographs, Miles documents the Wichí's and Chorote's special relationship to nature, which is severely threatened by environmental pollution. The river in particular plays a central role as a source of food, as well as place for children to play. Miles's photographs promote awareness of the fact that Indigenous and marginalized groups are affected to a particularly great extent by the consequences of climate change.

 Tita Salina also takes up this complex of topics with her video installation *1001st Island—The Most Sustainable Island in Archipelago*. It was produced in cooperation with fishers from Jakarta, who are suffering severely as a result of the massive pollution of local bodies of water. The coastal city also finds itself confronted with the real danger of being flooded by masses of water due to rising sea levels caused by global warming. The government therefore has plans to construct artificial islands in the Bay of Jakarta as a protective barrier. Four such islands already exist today—but have been unfinished and uninhabitable for years. Moreover, the fishers report that catch figures have worsened drastically as a result of the artificial islands. In cooperation with a group of local fishers, Salina removed plastic garbage from the sea, and from the waste obtained created an island with which she exposed herself to the sea. In the Bay of Jakarta, Salina thus added another island—which symbolically represents the problem of land reclamation and how waste is handled—to the 1,000 alleged islands of the archipelago. Another realization of the project is now taking place in Mannheim, where a new island will be created from rubbish collected locally.

 With his installation *O Be Vi de Só e Té, Agradê*, Ernesto Neto opens up a space for encounters and community that encourages visitors to reflect on the issues addressed here. Using textile materials, the artist creates walk-through installations that invite people to spend time in them. Seashells, spices, or herbs that intensify the immersive quality of the works with their aromas are also incorporated. Neto fills these materials in textiles and crocheted cocoons and thus creates three-dimensional, organic-seeming forms. They populate the exhibition space like mushrooms springing up from the ground, or drops falling from the sky.

The vertical is a formal constant in the work of the Brazilian artist. Neto's poetic idea that heaven and earth are constantly striving to kiss each other in the form of plants is materialized here. The concomitant postulate that we ourselves as well as the environment surrounding us should be perceived more attentively can be invoked for all of the artists brought together in this fragment.

1 See Ann-Katrin Günzel, "Margaret und Christine Wertheim: Vom Wert und Wandel der Korallen," *Kunstforum International* 49, 281 (June 2022): 226–27, here p. 230.

2 See Donna J. Haraway, *Staying with the Trouble: Making Kin in the Chthulucene* (Durham, NC: Duke University Press, 2016), pp. 76–81.

Emerson Pontes / Uýra Sodoma
Séries Uýra, Elementar Amazônia, 2017–2020
Farbfotografie / Color photography
Maße variabel / Dimensions variable

Fotos / Photos: Matheus Belém, Lisa Hermes,
Lúcio Silva, Keila Serruya

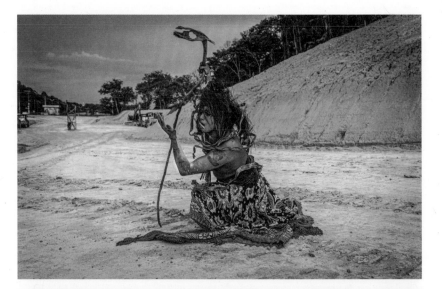

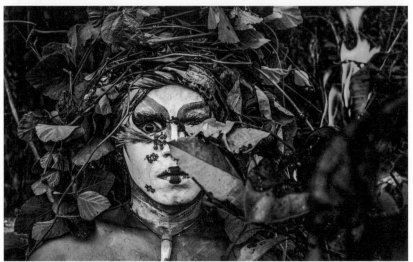

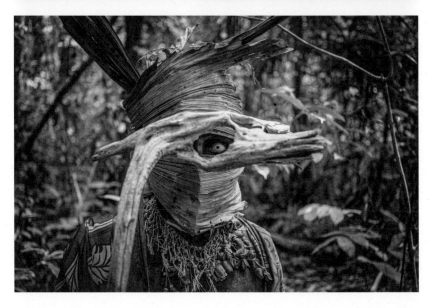

EMERSON PONTES

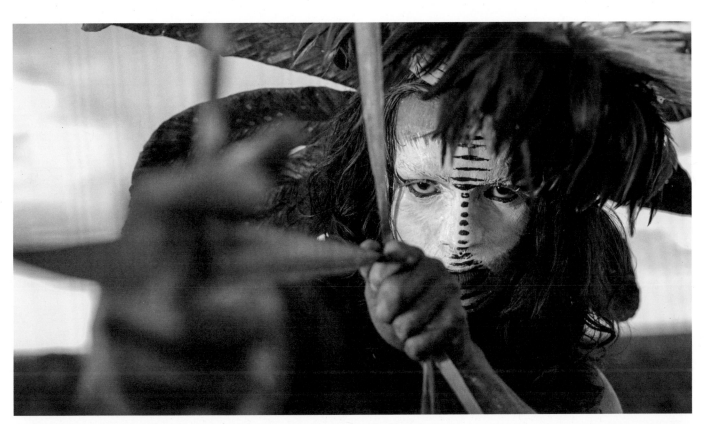

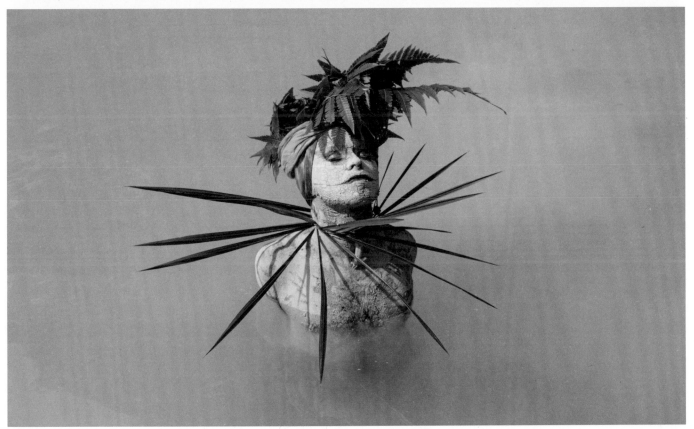

melanie bonajo
Night Soil – Nocturnal Gardening, 2016
HD-Video (Farbe, Ton / Color, sound)
49:47 min
Video still

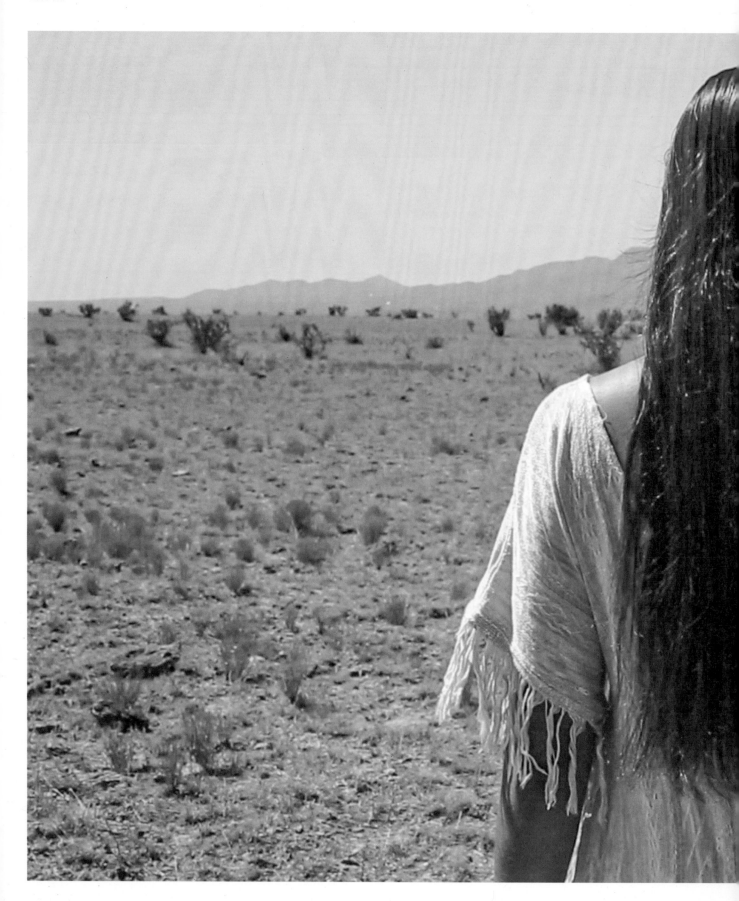

1,5 Grad

MELANIE BONAJO

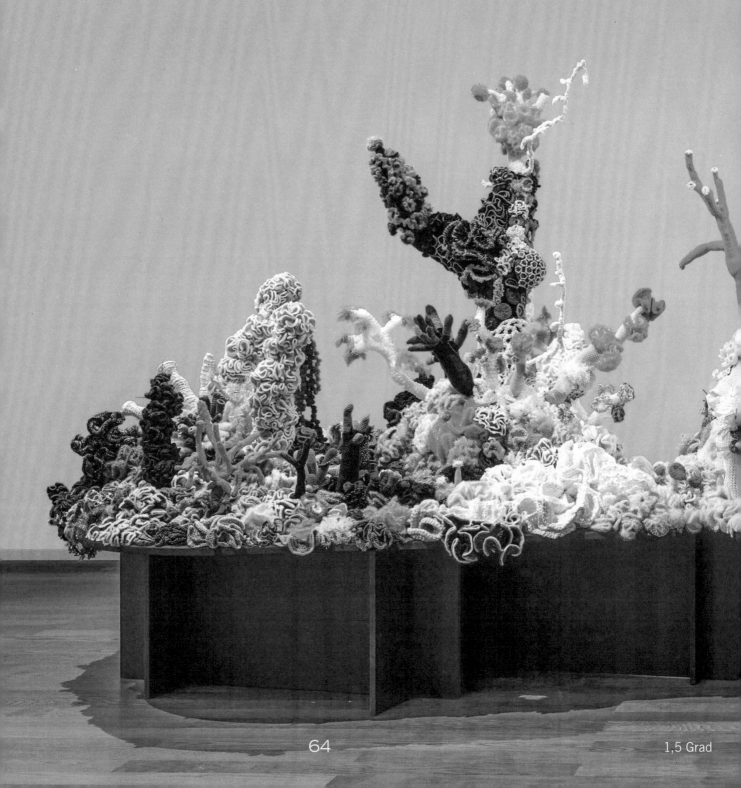

1,5 Grad

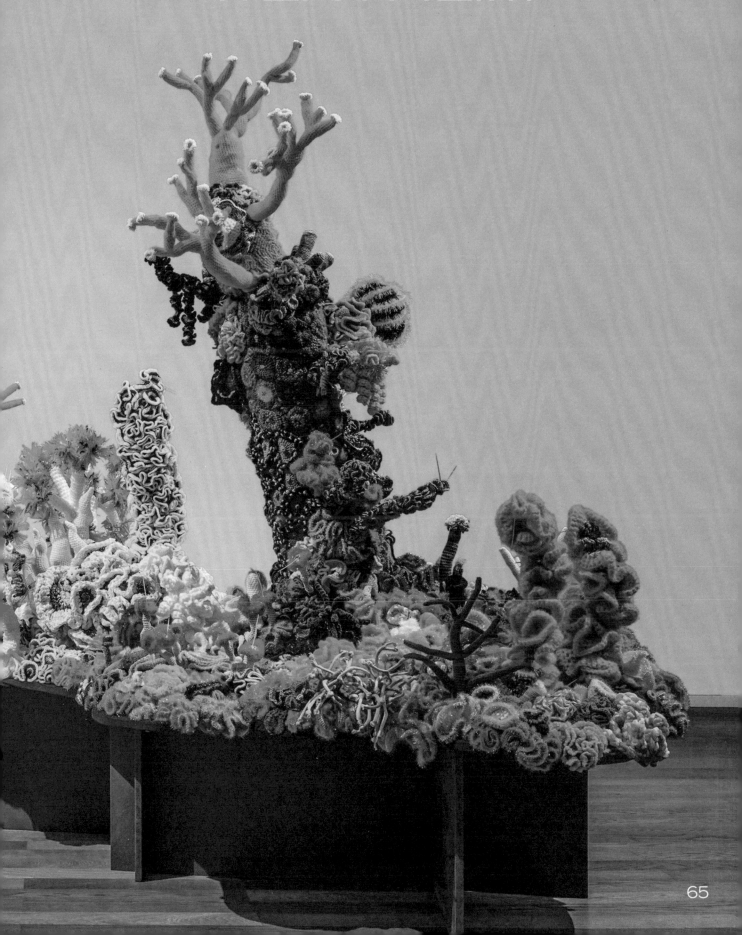

Guadalupe Miles
Ohne Titel / Untitled (aus der Serie / from the series *Chaco*), 2001–2005
Farbfotografie / Color photography
je / each 110 × 110 cm

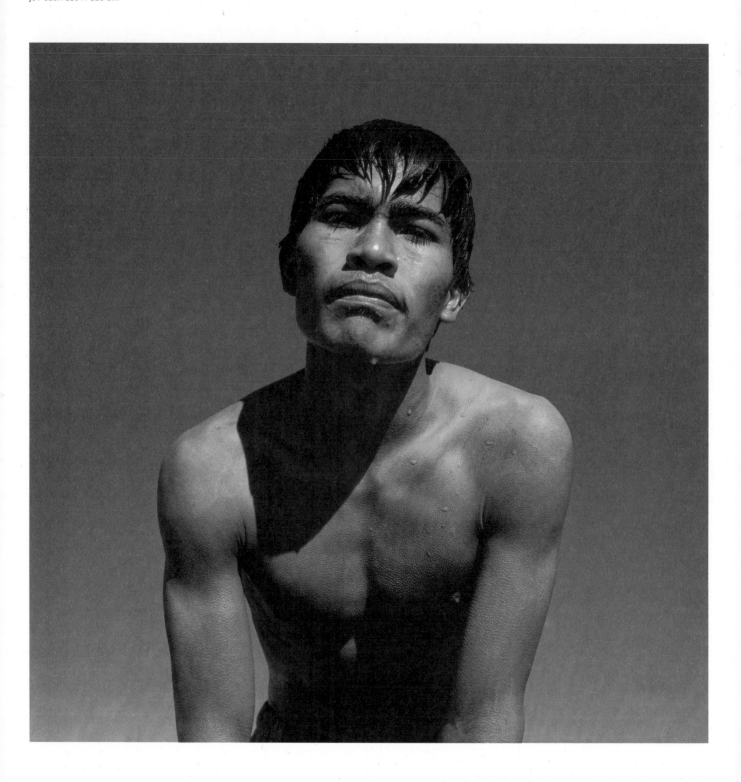

GUADALUPE MILES

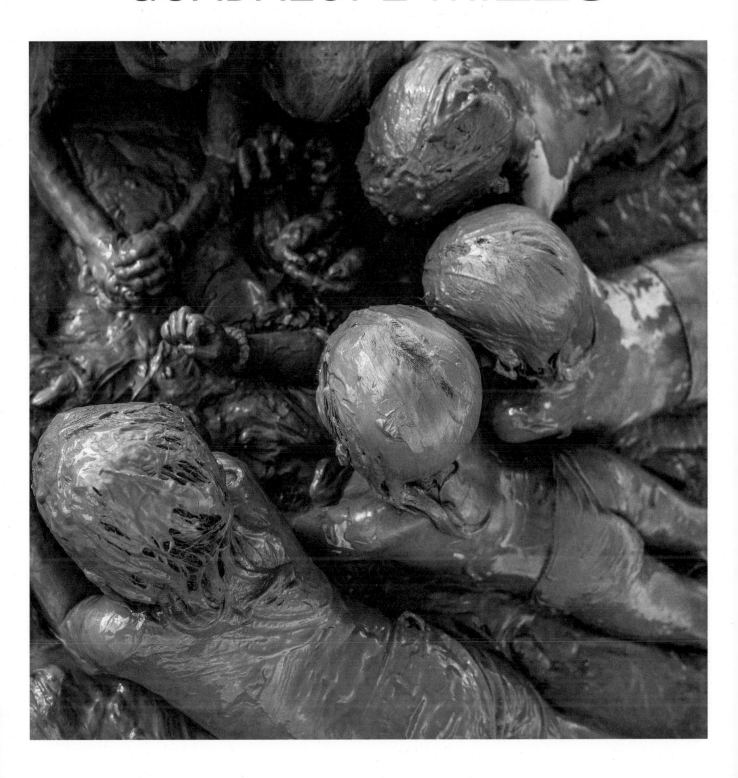

Tita Salina
1001st Island – The Most Sustainable Island in Archipelago, 2015/16
Performance Sharjah Art Foundation 2016
Foto / Photo: Alfredo Rubio

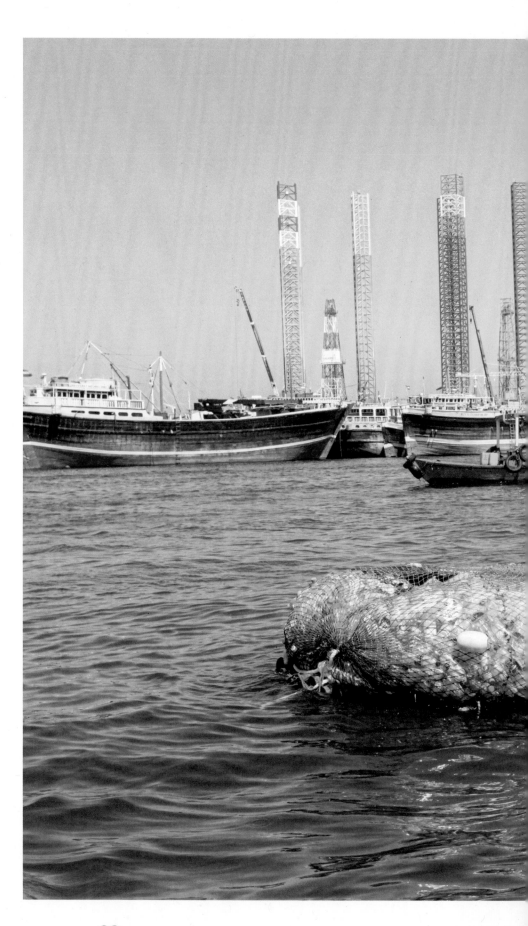

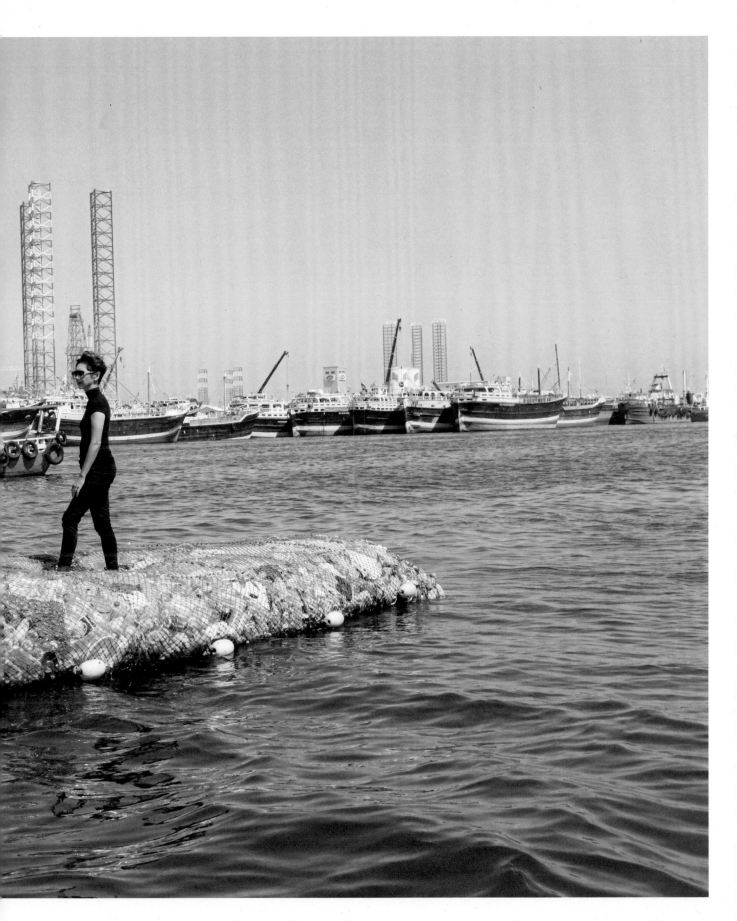

Ernesto Neto
O Be Vi de Só e Té, Agradê, 2021
Terrakotta, Baumwolle, Sand, Nüsse, Stampfer, Kräuter / Terracotta, cotton, sand, nuts, stamps, herbs
Maße variabel / Dimensions variable
Installationsansicht / Installation view Fortes D'Aloia & Gabriel, Rio de Janeiro

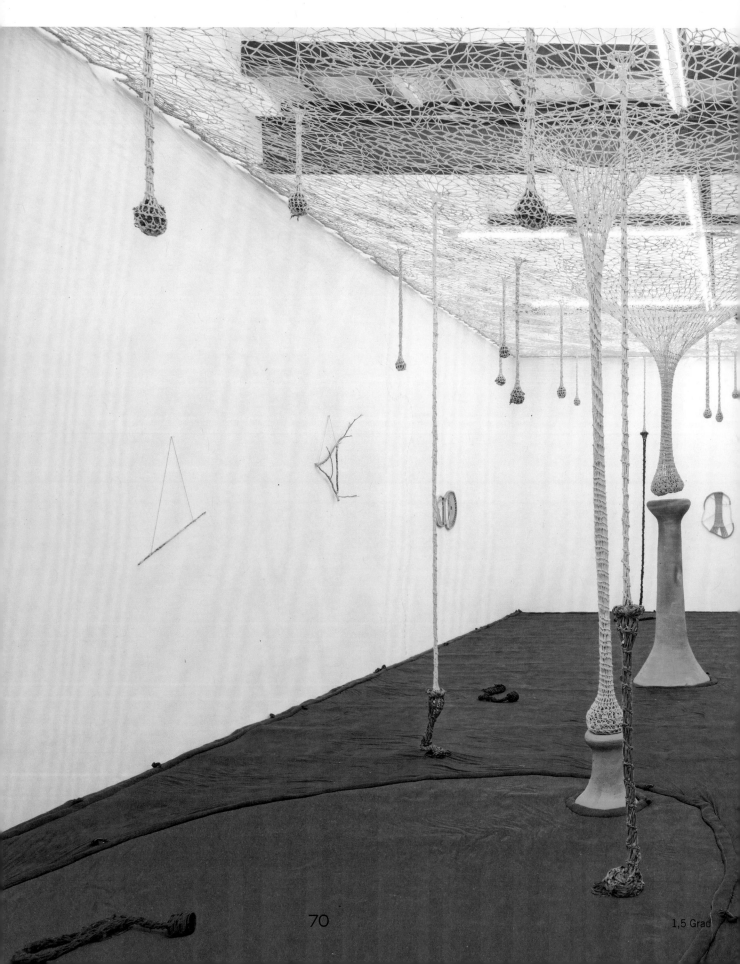

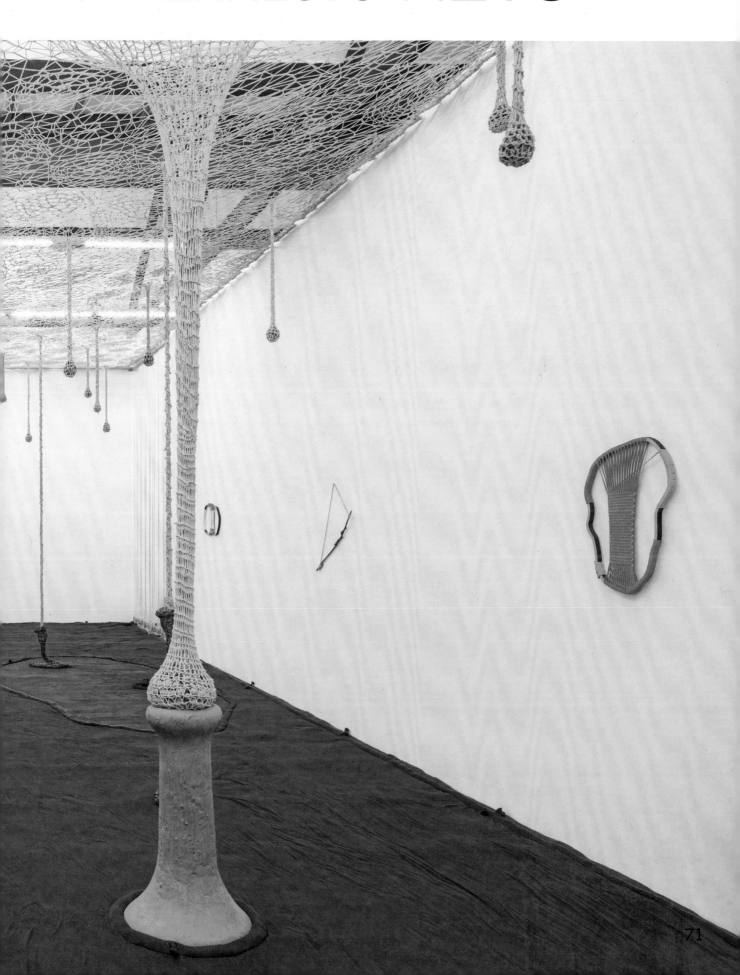

Fabian Knecht
Unveränderung / Unchange, 2016
98 handgefertigte manipulierte Thermometer /
98 handmade manipulated thermometers
Maße variabel / Dimensions variable

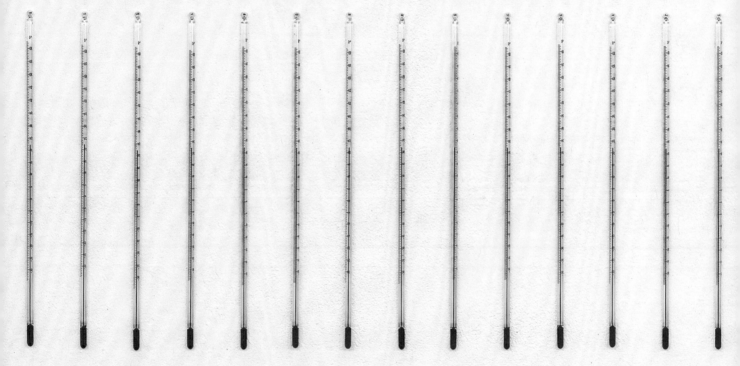

FABIAN KNECHT

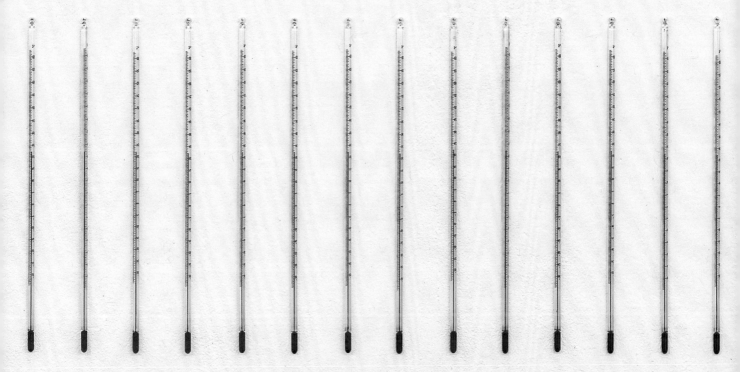

74

2

Ressourcen / Resources

Ressourcen

Sebastian Schneider

Scheinbar schwerelos bewegt man sich als Betrachter*in durch das Innere eines stillgelegten Kühlturms; in den nächsten Einstellungen fliegt das Kameraauge über eine Tagebauanlage und eine Ölbohrinsel. Durch den dunklen Himmel schießen explodierende Feuerwerkskörper. *Controlled Burn*, ein Film von Julian Charrière, handelt von Feuer und Verbrennung sowie den Architekturen moderner Energiegewinnung. Der Künstler bezeichnet unsere Gegenwart als Pyromoderne, ein Zeitalter, in dem Verbrennung allgegenwärtig ist – sei es zur Freisetzung von Energie oder in Form von zerstörerischen Bränden. Charrière adressiert eine der größten Herausforderungen, die der menschengemachte Klimawandel an uns stellt. Wie können wir die Erderwärmung auf weniger als 1,5 Grad begrenzen, wenn wir zutiefst von Formen der Energiegewinnung abhängig sind, die diesem Vorhaben entgegenstehen? Sind die Methoden, mit denen wir uns die Welt seit Anbeginn der Industrialisierung zu eigen machen, noch legitim? Die in diesem Fragment versammelten Künstler*innen widmen sich solchen Fragen und formulieren mit ihren Werken konkrete, poetische oder erfinderische Antworten, in denen sowohl Ressourcen als auch unser Zugriff auf sie neu gedacht werden.

In Charrières Fall ist es ein kleiner Eingriff in das filmische Kontinuum, der eine Irritation unserer Sehgewohnheiten hervorruft und zum kritischen Nachdenken über das Industriezeitalter anregt: Der Künstler lässt die Explosionen des Feuerwerks rückwärts abspielen. Die biomorphen Formen, die die Feuerwerkskörper in den Nachthimmel zeichnen, erinnern an Insekten und Pflanzen – also an Lebewesen, deren vor Millionen von Jahren abgelagerte Biomasse die heutigen Ölvorkommen hervorgebracht haben. Durch ihr Auftauchen (und ihren Zerfall) in der feurigen Luftlandschaft werden sie zu

Wiedergängern eines Kreislaufs, den der Mensch mit seiner von ihm im Industriezeitalter beanspruchten Vormachtstellung außer Kontrolle gebracht hat.

Feuer steht auch am Anfang des Werkprozesses von Lee Bae. Der Künstler stellt in seinem Brennofen Holzkohle her, die er zu reliefartigen Wandbildern zusammenfügt. Seine Werke eröffnen ein beeindruckendes Spektrum der Farbe Schwarz, das Bae durch Polieren der Oberflächen weiter steigert. Anders als bei Charrière, der in seinem Film die Vogelperspektive einnimmt, um menschliche Eingriffe zur Ressourcengewinnung erfahrbar zu machen, zoomt Bae auf den Rohstoff Holz und die historischen und narrativen Bezüge, die dem Material selbst innewohnen. Holzkohle, die durch Verbrennen gewonnen wird, gleichzeitig aber dazu dient, das Verlöschen von Feuer zu verhindern, steht für Bae metaphorisch für den Kreislauf von Leben und Tod.

Das Thema Materialkreisläufe findet seine Fortsetzung in einem Werk von Jannis Kounellis, in dem der Künstler Kohlesäcke auf Stahlplatten anordnet und mit massiven Stahlträgern fixiert. Fast gewaltsam scheint er so ein Gegensatzpaar zu vereinen: Kohle, die für Wärme und Energie steht, und Stahl, ein kalter und die Zeiten überdauernder Werkstoff. Dennoch gibt es zwischen den Materialien eine Verbindung, die in der Kette ihrer Herstellung liegt: Kohle ist der Brennstoff, der zur Stahlerzeugung genutzt wird. Das Werk regt dazu an, über die Prozesse stofflicher und energetischer Verwandlung sowie das alchemistische Potenzial dieser Vorgänge nachzudenken, und schließt somit an Charrières Videoarbeit an. Gleichzeitig spielt für Kounellis die historische Dimension seiner Materialien eine entscheidende Rolle. Das Werk verweist auf die Stahlerzeugung zur Zeit der Industrialisierung im 18. Jahrhundert und damit auf eine Epoche, die von der zügellosen Ausbeutung natürlicher Rohstoffe gekennzeichnet ist.

Romuald Hazoumè beschäftigt sich seit Beginn seiner künstlerischen Karriere mit der Frage, wie sich das Vorhandensein – oder Nichtvorhandensein – von Ressourcen auf eine Gesellschaft auswirkt. Als wiederkehrendes Element seiner Kunst hat er Kanister aus Plastik auserkoren, die in seinem Heimatland Benin häufig verwendet werden, um Erdöl aus dem rohstoffreichen Nachbarland Nigeria einzuschmuggeln. Hazoumès Installation *Rat Singer: Second Only to God!* besteht aus einem gekenterten Fischerboot, dessen Fracht sich in Form zahlreicher Ölkanister aus Plastik ins Meer respektive den Ausstellungsraum ergießt. Das Werk ruft mit seiner einprägsamen Bildsprache vielfältige Assoziationen wach, die von der Ausbeutung

und Umweltzerstörung auf dem afrikanischen Kontinent bis hin zur Fluchtthematik reichen. Tatsächlich bezieht sich Hazoumè auf Papst Benedikt XVI., der bei einem Besuch in Benin Kritik an einer Vermischung der christlichen Liturgie mit Religionen wie Voodoo übte, wie sie in vielen westafrikanischen Gesellschaften praktiziert wird. In den Worten des Papstes erkannte Hazoumè eine koloniale Bevormundung, auf die seine Installation mit bitterem Spott reagiert: Der Werktitel ist eine Verballhornung des englisch ausgesprochenen Nachnamens von Joseph Ratzinger (Papst Benedikt XVI.), und somit bleibt kein Zweifel, wen die Ratte darstellen soll, die in der Installation auf dem Boot sitzt und sich feist an dem Unglück zu erfreuen scheint. In Hazoumès Werk formuliert sich eine Kritik, die ein zentrales Thema zeitgenössischer afrikanischer Denker*innen und Künstler*innen aufgreift: Die Besinnung auf den kulturellen, geistigen und rohstofflichen Reichtum ihres Kontinents und die Behauptung einer selbstbewussten Rolle in der Weltpolitik des 21. Jahrhunderts.[1]

Erfolgt Hazoumès Rückgriff auf Ölkanister auch in der ironischen Absicht des Künstlers, dem westlichen Publikum genau das vorzusetzen, was es für »typisch afrikanisch« hält, verwendet Bahzad Sulaiman in seiner Arbeit Alltagsgegenstände, die auf die zivilisatorischen Standards in Industrienationen hindeuten. Waschmaschinen, Kühlschränke und sonstige Haushaltsgeräte erleichtern das alltägliche Leben, ihr Betrieb ist aber ohne elektrische Energie undenkbar. Sulaimans Installation Chor, die aus einer Vielzahl ausgesonderter elektronischer Haushaltsgeräte besteht, führt uns deren schiere Masse vor Augen. Der Künstler betrachtet die Geräte nicht als Müll, sondern als Stellvertreter der Menschen, denen sie einst gehörten. Wie um deren Individualität zu unterstreichen, verleiht Sulaiman den Geräten eine »Stimme«, die sich zu einem die Installation begleitenden Chor zusammenfügt. Des Weiteren bestückt er sie im Inneren mit farbigem Licht und macht so die elektrische Energie sichtbar, die für ihren Betrieb benötigt wird. Ihr kommt bei der Erreichung der Klimaziele eine so bedeutende wie ambivalente Rolle zu. Einerseits verspricht etwa der Umstieg vom Verbrennungsmotor auf E-Mobilität eine signifikante Reduktion der CO_2-Ausstöße, andererseits würden für eine Umstellung im globalen Maßstab Energiemengen benötigt, die bisher nur durch fossile Energieträger erzeugt werden können.

Längst ist es nicht nur die Wissenschaft, die versucht, Lösungen für Dilemmata wie diese zu entwickeln. Auch zeitgenössische Künstler*innen widmen sich aktiv solchen Fragen. Sie begreifen künstlerisches Schaffen – also das freie und ergebnisoffene Imaginieren und Experimentieren – als Ressource, um innovative Ideen

für Veränderung hervorzubringen. Ein Künstler, der bereits seit den 1970er-Jahren in diesem Feld arbeitet, ist Peter Fend. Mit seinen Werken zielt er darauf ab, globalen Problemen wie Rohstoffnachfrage und Rohstoffverteilung, Ausbeutung und Umweltzerstörung entgegenzuwirken. Seit Langem beschäftigt er sich intensiv mit der Möglichkeit, Algen als ökologisch nachhaltige Energieträger einzusetzen. Das in der Kunsthalle Mannheim gezeigte Video sowie die Texte, Landkarten und Zeichnungen resultieren aus den Experimenten des Künstlers, Algenvorkommen in der Nord- und Ostsee zur Energiegewinnung zu nutzen. Seine Arbeit in diesem Feld demonstriert, dass er schon früh Vertrauen in ein Verfahren setzte, das Regierungen und Unternehmen erst jetzt für sich entdecken.

Es ist die Sensibilität von Künstler*innen für die sie umgebende Welt, aus der Innovationen hervorgehen, die insbesondere in der Klimakrise neue Impulse liefern. Beispielhaft dafür stehen auch Olaf Holzapfels Arbeiten mit Naturmaterialien wie Stroh, Heu oder Reet. Bei seinen Strohbildern handelt es sich ähnlich wie bei Bae um Materialbilder, bei denen das Material vorgibt, was daraus entstehen kann: Holzapfels am Computer skizzierte konstruktivistische Kompositionen resultieren unmittelbar aus dem linearen Charakter der Halme. So entstehen Bilder, die sich auch mit ihren Titeln direkt auf die Naturräume beziehen, aus denen sie stammen. Sie sind sowohl abstrakt als auch konkret, denn sie handeln von Natur und sie *sind* Natur. Damit vermitteln sie, dass das Natürliche wertvoll ist. Holzapfel ist an einer solchen Neubewertung natürlicher Materialien, aber auch an den Wechselbeziehungen interessiert, in denen Mensch und Umwelt stehen: »Wir werden uns der Natur und Naturmaterialien als Partner wieder mehr zuwenden, einfach weil es ökonomisch und auch ästhetisch sinnvoll ist. Und weil wir nur mit ihr im Ausgleich überleben werden.«[2]

[1] Vgl. Felwine Sarr, *Afrotopia*, Berlin 2019.
[2] *Kunst ⇆ Handwerk. Zwischen Tradition, Diskurs und Technologien*, hrsg. von Barbara Steiner, Ausst.-Kat. Kunsthaus Graz u. a., Wien 2019, S. 106.

Resources

Sebastian Schneider

As a viewer, one moves seemingly weightlessly through the interior of a decommissioned cooling tower; in the footage that follows, the eye of the camera flies over an open-pit mine and an oil rig. Exploding fireworks shoot through the dark sky. *Controlled Burn*, a film by Julian Charrière, deals with fire and burning as well as the architectures of modern power generation. The artist refers to our present as "pyromodernity," an age in which burning is omnipresent—be it to produce energy or in the form of destructive fires. Charrière addresses one of the biggest challenges with which man-made climate change confronts us. How can we limit global warming to less than 1.5 degrees when we are so deeply dependent on forms of energy generation that impede this objective? Are the methods with which we have taken ownership of the world since the beginning of industrialization still legitimate? The artists brought together in this fragment devote themselves to such questions and with their works formulate concrete, poetic, or ingenious responses in which both resources and our access to them is conceived anew.

In Charrière's work, it is a small intervention in the filmic continuum, which confuses our habits of seeing and prompts critical consideration of the industrial age: the artist has the firework explosions played backward. The biomorphic forms that the fireworks draw in the night sky call to mind insects and plants—thus living beings whose biomass deposited millions of years ago produced the oil deposits of today. Through their appearance (and dissolution) in the fiery air landscape, they become revenants of a cycle that human beings have swung out of control with the hegemony they have asserted in the industrial age.

Fire also stands at the beginning of Lee Bae's work process. In his firing oven, the artist produces charcoal that he then assembles to create relief-like wall pictures. His works open up an impressive spectrum of the color black, which Bae augments further by polishing the surfaces. Unlike in the work by Charrière, who takes a bird's-eye view in his film in order to make it possible to experience human interventions to extract resources, Bae zooms in on wood as a raw material as well as the historical and narrative references inherent in the material itself. For Bae, charcoal, which is obtained through burning, but simultaneously helps prevent fires from going out, stands metaphorically for the cycle of life and death.

The topic of material cycles finds a continuation in a work by Jannis Kounellis, in which the artist arranged sacks of coal on steel panels and fastened them on with massive steel girders. He thus seems to bring together a pair of opposites in an almost violent way: coal, which represents warmth and energy, and steel, a cold substance that endures the test of time. A connection between the materials is nevertheless found in the chain of their production: coal is the fuel used in making steel. The work prompts viewers to think about processes of energy transformation and the alchemical potential of these processes and is thus related to Charrière's video work. For Kounellis, the historical dimension of his materials plays a crucial role at the same time. The work refers to the production of steel during the age of industrialization in the eighteenth century and hence to an epoch characterized by the unbridled exploitation of natural raw materials.

Romuald Hazoumè has occupied himself since the beginning of his artistic career with the question of how the availability—or scarcity—of resources affects a society. He selected plastic canisters that are frequently used in his home country of Benin in order to smuggle crude oil out of Nigeria, a neighboring nation rich in raw materials, as a recurring element in his art. Hazoumè's installation *Rat Singer: Second Only to God!* consists of a capsized fishing boat whose cargo gushes into the sea and/or the exhibition space in the form of numerous plastic oil canisters. With its memorable imagery, the work evokes diverse associations, ranging from exploitation and the destruction of the environment on the African continent to the topic of fleeing. Hazoumè refers to Pope Benedict XVI, who while on a visit to Benin expressed criticism of the combining of the Christian liturgy with religions like voodoo, as is practiced in many West African societies. In the words of the Pope, Hazoumè

recognized a colonial paternalism, to which his installation reacts with bitter mockery: the title of the work is a malapropism of how the surname of the previous Pope, Joseph Ratzinger, is pronounced in English, and there is thus no doubt about whom the rat sitting on the boat in the installation and apparently taking great delight in the wreckage is meant to represent. Hazoumè's work formulates a critique that takes up a central theme for contemporary African thinkers and artists: reflection on their continent's wealth, culturally, intellectually, and in terms of raw materials, and the assertion of a self-confident role in the global politics of the twenty-first century.[1]

While Hazoumè's use of oil canisters also takes place with the artist's ironic intention of presenting to the Western audience precisely what it regards as "typically African," in his work, Bahzad Sulaiman makes use of everyday objects that recall the standards of civilization in industrialized nations. Washing machines, refrigerators, and other household appliances simplify daily life, but their operation is inconceivable without electrical energy. Sulaiman's installation *Chor* (Choir), which consists of a wide range of discarded electrical household appliances, confronts us with their sheer mass. The artist does not regard the devices as garbage, but instead as representatives of the people to whom they once belonged. As if to underscore their individuality, Sulaiman has given the appliances a "voice," which is assembled to create a choir that accompanies the installation. Moreover, he has also equipped them on the inside with colored light and thus makes visible the electrical energy that is required for their operation. In achieving climate-related targets, this energy is ascribed a role that is as significant as it is ambivalent. On the one hand, the switch from combustion engines to e-mobility, for instance, promises a considerable reduction in CO_2 emissions, while on the other hand masses of energy that can hitherto only be generated using fossil fuel energy sources would be necessary for implementation on a global scale.

It has long since been not only science that attempts to develop solutions for dilemmas like this; contemporary artists are also actively devoting themselves to such questions. They see artistic work—thus imagining and experimenting freely and open-endedly—as a resource for bringing forth innovative ideas for change. One artist who has already been working in this field since the 1970s is Peter Fend. With his works, he aims to counter global problems like the demand for and distribution of raw materials, exploitation, and environmental

destruction. For a long time, he has occupied himself intensively with the possibility of utilizing algae as an ecologically sustainable energy source. The video as well as the texts, maps, and drawings presented at the Kunsthalle Mannheim result from the artist's experiments to make use of the abundance of algae in the North and Baltic Seas to generate energy. His work in this field demonstrates that, at an early point in time, he already put his trust in a process that governments and companies are just now discovering for themselves.

The sensitivity of artists to the world around them can lead to the emergence of innovations that provide new impulses, particularly in the climate crisis. Olaf Holzapfel's works with natural materials like straw, hay, or reeds represent this exemplarily. As in Bae's work, his straw pictures represent material pictures in which the material stipulates what can be created from it: Holzapfel's constructivist compositions sketched on a computer develop directly from the linear character of stalks. What are thus created are pictures that also make direct reference with their titles to the natural spaces from which they originate. They are both abstract and concrete, since they both deal with nature and also *are* nature. The pictures therefore communicate that the natural is valuable. Holzapfel is interested in such a reassessment of natural materials, but also in the interdependencies between human beings and the environment: "We will again turn more towards nature and natural materials as a partner, simply because it makes sense in economic and aesthetic terms. And because we will only survive in balance with it."[2]

[1] See Felwine Sarr, *Afrotopia* (Berlin: Matthes & Seitz, 2019).

[2] *Arts ⇄ Crafts: Between Tradition, Discourse and Technologies*, ed. Barbara Steiner, exh. cat. Kunsthaus Graz et al. (Vienna: VfmK Verlag für moderne Kunst GmbH, 2019), p. 106.

Lee Bae
Issu du feu sp-7, 2003
Kohle auf Leinwand / Charcoal on canvas
170 × 260 cm

LEE BAE

Julian Charrière
Controlled Burn, 2022
4K-Film (Farbe, Ton / Color, sound)
32 min
Film still

JULIAN CHARRIÈRE

Peter Fend / Ocean Earth & Eve Vaterlaus
Macrocystis, 2009
Video (Farbe, Ton / Color, sound)
6:05 min
Video stills

PETER FEND

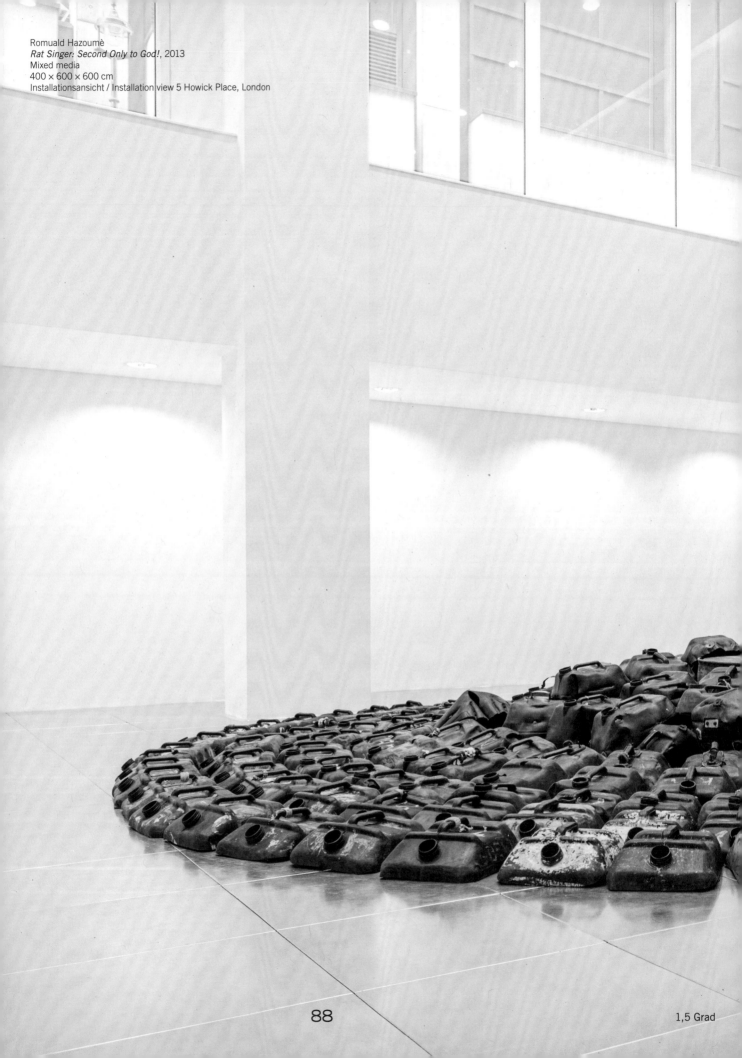

Romuald Hazoumè
Rat Singer: Second Only to God!, 2013
Mixed media
400 × 600 × 600 cm
Installationsansicht / Installation view 5 Howick Place, London

ROMUALD HAZOUMÈ

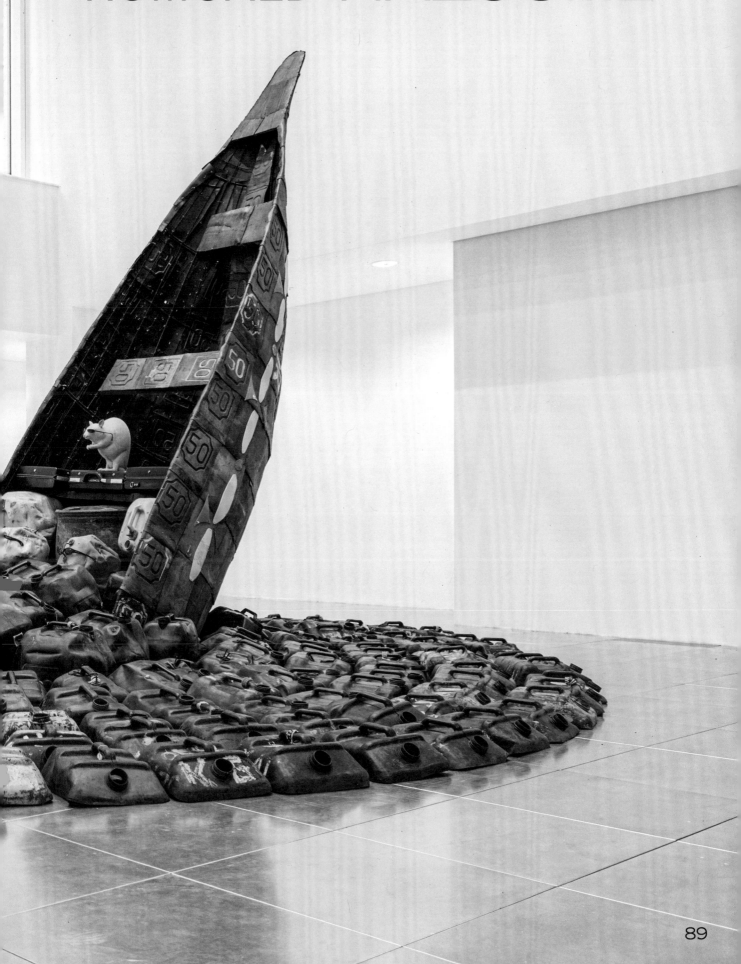

Jannis Kounellis
Senza titolo / Ohne Titel / Untitled, 1985
Stahl, Kohle, Sackleinen, Farbe / Steel, charcoal, burlap, paint
250 × 181 × 28 cm
Kunsthalle Mannheim, Leihgabe des Förderkreises für die Kunsthalle
Mannheim e. V. seit 2000 / On loan from the Friends of the
Kunsthalle Mannheim e. V. since 2000

JANNIS KOUNELLIS

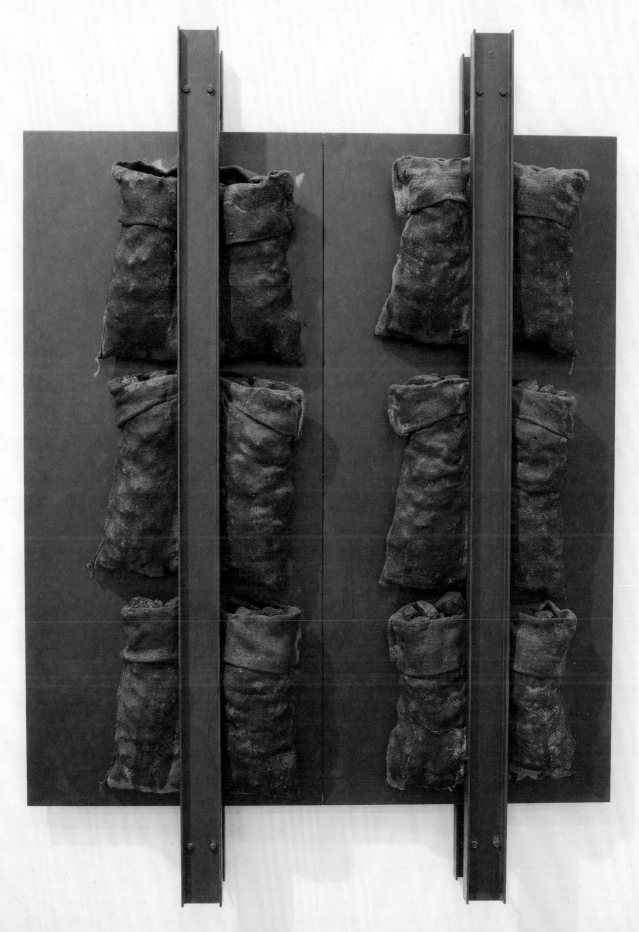

Olaf Holzapfel
Ozean (Norden), 2019
Stroh auf Holz / Straw on wood
167 × 188 cm

Olaf Holzapfel
Blaues Gras, 2022
Indigo-handgefärbtes Stroh auf Holz / Indigo hand-dyed straw on wood
210 × 140 cm

OLAF HOLZAPFEL

Bahzad Sulaiman
Chor / Choir, 2021
Mixed media
Maße variabel / Dimensions variable
Installationsansicht / Installation view
Zentrum für Internationale Lichtkunst, Unna

1,5 Grad

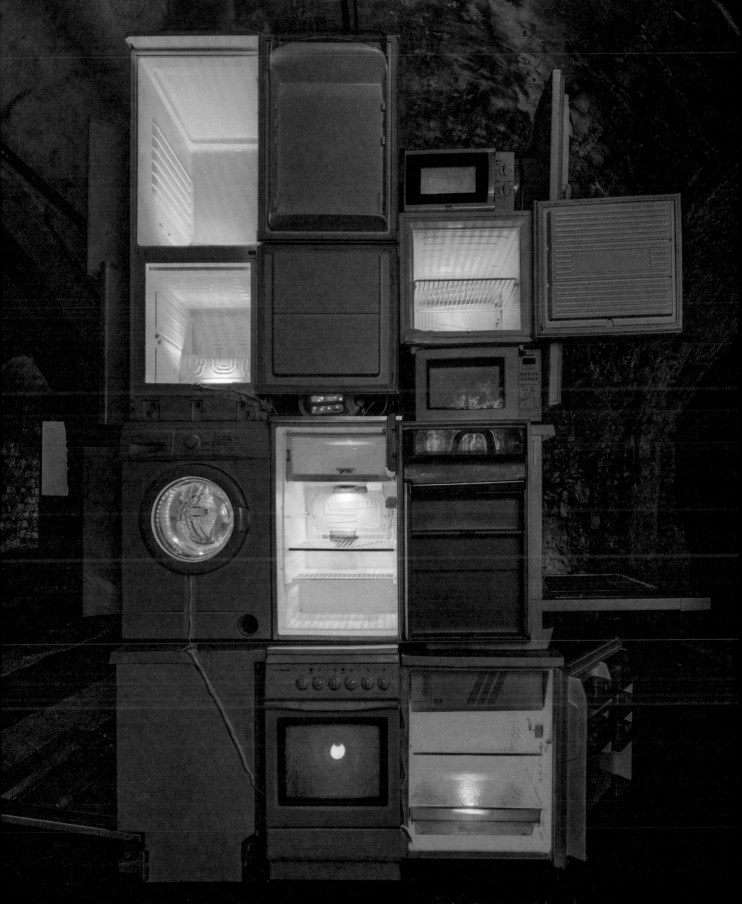

3

Labor /
Laboratory

Labor

Sebastian Schneider

Das Labor, verstanden als Ort des Experiments, der offenen Forschung und der Innovation, dient als gedanklicher Bezugspunkt dieses Fragments der Ausstellung. Den Auftakt bildet *Supergas*, eine frühe Arbeit des Künstlerkollektivs SUPERFLEX, die an der Schnittstelle von sozial engagierter Kunst, Entwicklungszusammenarbeit und Umweltschutz operiert. Gemeinsam mit Expert*innen konstruierten SUPERFLEX eine transportable Biogasanlage, die tierische und menschliche Fäkalien in Energie umwandelt. Sie soll Menschen im Globalen Süden, die ihren Energiebedarf bisher mit Feuerholz decken, eine nachhaltige Alternative zur Energieversorgung bieten. SUPERFLEX erprobten die Biogasanlage zuerst in Tansania. Hier zeigte sich, dass der durchschnittliche Viehbestand einer Familie in ländlichen Gebieten ausreicht, um ihren Energiebedarf mit der Anlage zu erbringen. *Supergas* bildet eine inhaltliche Brücke zwischen diesem Fragment der Ausstellung und dem vorangegangenen. Jedoch rücken hier die ästhetischen Qualitäten des Experiments selbst in den Vordergrund: Einzelne Bestandteile der Anlage wie eine große Kugel aus Plastik, die als Reaktor dient, formieren das Werk. Dem sind im Ausstellungsraum Dokumentationsmaterialien hinzugefügt, die den Einsatz der Anlage in verschiedenen Kontexten zeigen. Die Materialien verdeutlichen die Begriffsverschiebung, die SUPERFLEX in Bezug auf ihr Schaffen treffen: Sie bezeichnen ihre Arbeiten als Werkzeuge, die von Benutzer*innen angewendet werden.[1]

Das Labor kann aber auch zu einer Form des Displays werden, die einen neuen Werkbegriff hervorbringt. Tomas Kleiner entschied sich im Vorfeld der Ausstellung bewusst dazu, kein fertiges Werk auszuwählen, sondern seine aktuelle Beschäftigung mit Schwebezuständen und der Mobilisierung von Pflanzen als offene Forschung

ins Museum zu überführen. Skizzen, Dokumentationsfotos oder auch praktische Versuche bringen das Publikum in direkten Kontakt mit Kleiners *Æronauten*. Bei Letzteren handelt es sich um Experimente mit Ballons aus Bioplastik, die mit Helium befüllt sind. An ihnen sind nasse Schwämme befestigt, die dem Aufstieg zumindest so lange entgegenwirken, bis das Wasser verdunstet ist; ebenso verflüchtigt sich das Helium, die Ballons sinken schlaff zu Boden. Kleiner betrachtet das ziellose Dahintreiben der Ballons als Sinnbild für den aktuellen Schwebemoment, in dem wir uns durch die sich überlagernden ökologischen und politischen Krisen befinden. Die Tatsache, dass die Ballons in hohem Maße in ihren Kontext eingebunden sind, dass jeder Luftstoß im Raum Auswirkung auf sie hat, lässt Kleiner über Kontroll- und Zielverlust, aber auch das Potenzial von Richtungsänderungen nachdenken.

In der Arbeit von Kleiner deutet sich ein Moment des Spekulativen an, das sich bei Susanne M. Winterling / The Kalpana[2] fortsetzt. Ausgehend von dem durchaus realistischen Szenario, dass sich die Erde in einen Wüstenplaneten verwandelt, beschäftigt sich die Gruppe mit der Frage, wie das Überleben in klimatischen Extremsituationen gesichert werden kann. Ihre in diesem Fragment der Ausstellung präsentierte Installation ist maßgeblich inspiriert vom Rann von Kachchh, eine für ihre extreme Kargheit bekannte Salzwüste im Grenzgebiet von Indien und Pakistan. Das Werk stellt die Landkarte eines fiktiven Wüstenplaneten dar und dient als Display, auf dem The Kalpana künstlerische Spekulationen über mögliche neue Lebensformen anstellen. Diese speisen sich sowohl aus biologischen Phänomenen, die den Rann von Kachchh als Ökosystem einzigartig machen, als auch aus Mythen, die dort entstanden. So beziehen sich die Künstler*innen etwa auf die Pflanze Pilu, die es trotz der herrschenden Ödnis vermag, ein nährendes Ökosystem aufzubauen. Die einzelnen in der Arbeit vereinten Elemente geben Impulse für einen Posthumanismus, in dessen Zuge der Mensch seine Rolle radikal verändert. Er adaptiert zunehmend nichtmenschliche Lebensformen, die durch ihre enormen Anpassungsfähigkeiten selbst in unwirtlichsten Landschaften überleben.

Wenn der Mensch infolge der Klimakrise in einen posthumanistischen Zustand eintritt, stellt sich die Frage, ob auch eine Bewegung in die andere Richtung – eine Erweiterung von menschlicher Handlungsmacht in den Bereich des Nichtmenschlichen – möglich ist. Dieser Frage geht Kyriaki Goni in einer Arbeit nach, die ihren Ausgangspunkt in der wissenschaftlichen Entdeckung hat, dass sich digitale Daten in der DNA von Pflanzen speichern lassen. Auch wenn

diese Forschung noch in ihren Kinderschuhen steckt, tun sich hier Möglichkeiten auf, um Herausforderungen des digitalen Zeitalters zu begegnen: Wie können die wachsenden Datenmengen archiviert werden? Wer verfügt über sie? Welchen CO_2-Abdruck hinterlassen Großserver? Gonis *Data Garden* rankt sich um eine Pflanze, die rund um die Akropolis in Athen heimisch ist und die sich angeblich ideal für die Speicherung von Daten eignet. Allerdings verwischt die Künstlerin mit ihrer Multimedia-Installation, die Expert*innen-Interviews, wissenschaftlich anmutende Zeichnungen und 3D-Modelle zusammenführt, bewusst die Grenzen zwischen Fakt und Fiktion. Als Betrachter*in gerät man in einen Zwischenbereich von Wahrheit und Täuschung.

Ein vergleichbarer Effekt stellt sich bei Andreas Greiner ein. Auf den ersten Blick hält man *Jungle_Memory_0010* für eine Aufnahme eines besonders dicht bewachsenen Waldes. Erst beim genauen Hinsehen wachsen Zweifel an der Echtheit der Abbildung – der Stamm des Baumes ist zu mächtig, das Blattwerk scheint sich identisch zu wiederholen. Greiner, der in seiner Kunst untersucht, welche Einflüsse der Mensch auf die biologischen und atmosphärischen Prozesse unserer Erde hat, greift für *Jungle_Memory* auf Künstliche Intelligenz (KI) zurück: auf selbstlernende Computerprogramme, die in großen Datenmengen Muster erkennen und Korrelationen herstellen. Auf pointierte Art und Weise verdeutlicht Greiners Bild, das sich aus Tausenden Baumfotografien generiert, das paradoxe Verhältnis, in dem wir zum Wald stehen. Wir halten ihn für einen Ort unbeschädigter Natürlichkeit und übersehen dabei, dass er insbesondere in Mitteleuropa seit Jahrhunderten zutiefst vom Menschen geprägt, wenn nicht sogar eigens für dessen Zwecke gepflanzt worden ist. Ebenso erinnert die künstliche Landschaft von *Jungle_Memory* unter formalästhetischen Gesichtspunkten an Gaming, und damit an das Welten-Machen, die Schaffung einer Technosphäre, in der sich Natur und Technik neuartig verbinden.

Trevor Paglen setzt hier an und problematisiert die Versuche, biologische Materie mathematisch zu entschlüsseln. Seine Fotografien greifen ein Motiv auf, das in der Kunstgeschichte ikonisch geworden ist: die Wolke. Allerdings werden die Darstellungen bei Paglen von einem feinen Lineament überlagert, welches sich zurückhaltend, aber bestimmt in das Bild einschreibt. Der Künstler hat es erzeugt, indem er die Wolkenbilder von einem Algorithmus scannen ließ, der auf Gesichtserkennung trainiert ist. Die KI scheiterte daran, physiognomische Strukturen in den amorphen Formen der Luftgebilde zu identifizieren, und schlug in Linienführung aus. Paglens Experiment mag zunächst harmlos erscheinen. Im Kontext seines Schaffens,

das der kritischen Auseinandersetzung mit dem technisch-militärischen Überwachungsapparat der USA gewidmet ist, verdeutlicht es jedoch, dass unsere Lebenswelt zutiefst von modernsten Technologien durchdrungen ist, die Informationen über menschliches (und nichtmenschliches) Verhalten sammeln.

In einem Akt der Aneignung bemächtigen sich Künstler*innen bildgebender Verfahren, um Prozesse wie diese sicht- und verhandelbar zu machen. Daniel Canogars visuelle Kompositionen generieren sich aus Daten des europäischen Energieverbrauchs, die im Internet frei zugänglich sind, und übersetzen sie live in abstrakte, sich permanent verändernde Formen. *Phloem*, so der Titel seines Werkes, bezeichnet die Nährstoffe transportierenden Stränge in Pflanzen. Canogar verknüpft den Begriff mit den unsichtbaren Energieströmen, die die moderne Lebenswelt aufrechterhalten. Die auf den Screens im Atrium der Kunsthalle Mannheim installierte Arbeit führt uns von der machtpolitischen Bedeutung von Daten bei Greiner und Paglen zurück zu einem Anliegen, das im Kern der Ausstellung *1,5 Grad* steht: In dem aktuellen, von tiefgreifenden ökologischen Veränderungen geprägten Zeitalter können wir uns nicht länger als vereinzelte Individuen betrachten. Vielmehr müssen wir einsehen, dass wir miteinander verbunden sind und dass unsere akkumulierten Handlungen Spuren auf diesem Planeten hinterlassen.

[1] Vgl. Barbara Steiner, *SUPERFLEX/TOOLS*, Köln 2003, S. 5.
[2] The Kalpana besteht aus den Künstler*innen Susanne M. Winterling und Goutam Ghosh sowie dem Wissenschaftler Bodhisattva Chattopadhyay.

Laboratory

Sebastian Schneider

Laboratories, understood as places for experiments, the conducting of open-ended research, and innovation, serve as a conceptual point of reference for this fragment of the exhibition. It begins with *Supergas*, an early work by the artist collective SUPERFLEX, which operates at the interface between socially engaged art, development cooperation, and environmental protection. In collaboration with experts, SUPERFLEX constructed a transportable biogas facility that transforms animal and human feces into energy. It is intended to offer a sustainable alternative energy supply to people in the Global South who have hitherto covered their energy needs with firewood. SUPERFLEX first tested the biogas plant in Tanzania. Here, it was shown that the average number of livestock owned by a family in rural areas suffices to enable the facility to fulfill the family's energy demands. *Supergas* forms a content-related bridge between this fragment of the exhibition and the previous one. But here, the aesthetic qualities of the experiment are themselves foregrounded: individual components of the facility, such as the large plastic sphere that serves as the reactor, shape the work. It is supplemented in the exhibition space with documentation materials presenting the use of the plant in various contexts. The materials illustrate the shift in terminology that SUPERFLEX affect in connection with their work: they call their works tools used by users.[1]

Laboratories can, however, also become a form of display that gives rise to a new concept of work. During the preparations for the exhibition, Tomas Kleiner deliberately decided not to select a completed work, but instead to transpose his current occupation with states of disequilibrium and the mobilization of plants to the museum as open research. Sketches,

documentation photos, or practical trials bring the audience into direct contact with Kleiner's *Æronauten*. The latter involves experiments with balloons made of bioplastic and filled with helium. Attached to them are wet sponges, which prevent them from rising for at least as long as it takes for the water to evaporate; the helium dissipates as well, and the balloons sink flaccidly to the floor. Kleiner regards the aimless drifting of the balloons as an allegory for the floating moment in which we currently find ourselves, owing to the overlapping ecological and political crises. The fact that the balloons are extensively integrated within their context, that every blast of air into the space has an effect on them, prompts Kleiner to contemplate loss of control and objectives, but also the potential of changes in direction.

Kleiner's work points to a speculative moment that is continued in the work of Susanne M. Winterling / The Kalpana.[2] Starting from a quite realistic scenario, that of the earth being transformed into a desert planet, the group occupies itself with the question of how survival can be ensured in extreme climate situations. The installation presented in this fragment of the exhibition is significantly inspired by the Great Rann of Kutch, a salt marsh in the desert in the border region between India and Pakistan, which is known for its extreme aridity. The work shows a map of a fictitious desert planet and serves as a display on which The Kalpana presents artistic speculations about new forms of life. They are inspired by both biological phenomena that make the Rann of Kutch a unique ecosystem, and also by myths that have arisen there. The artists thus make reference, for instance, to the Pilu plant, which manages to develop a nourishing ecosystem for itself despite the prevailing wasteland. The individual elements brought together in the work provide impulses for a posthumanism in whose course human beings radically alter their role. They increasingly adjust to nonhuman life-forms that are able to survive even in the most inhospitable landscapes as a result of their tremendous abilities to adapt.

If humankind is entering a posthumanist state due to the climate crisis, the question that arises is whether a movement in the other direction—an extension of human agency into the realm of the nonhuman—is also possible. Kyriaki Goni examines this question in a work that has its starting point in the scientific discovery that digital data can be stored in the DNA of plants. Even though this research is still in its infancy, possibilities for dealing with challenges of the digital age nonetheless arise here: How can the increasing volumes of

data be archived? Who controls them? What CO_2 footprint do large servers leave behind? Goni's *Data Garden* revolves around a plant that is endemic around the Acropolis in Athens and is ostensibly ideal for the storage of data. With her multimedia installation, which brings together interviews with experts, scientific-seeming drawings, and 3D models, the artist, however, deliberately blurs the boundaries between fact and fiction. As a viewer, one enters an intermediate area between truth and deception.

A comparable effect occurs in the work of Andreas Greiner. One initially takes *Jungle_Memory_0010* to be a picture of a particularly densely growing forest. It is upon closer examination that doubts about the authenticity of the image arise—the trunk of the tree is too thick, and the foliage seems to be repeated in an identical way. Greiner, who looks at people's influences on the biological and atmospheric processes of our planet in his work, employed artificial intelligence (AI) to create *Jungle_Memory* on self-learning computer programs that recognize patterns in large quantities of data and produce correlations. Greiner's picture, which is generated from thousands of pictures of trees, trenchantly visualizes the paradoxical relationship that we have to the forest. We regard it as a place of intact naturalness and thus overlook the fact that it has been profoundly shaped by human beings, particularly in Central Europe, if not even planted specifically for their purposes. Under formal aesthetic aspects, the artificial landscape of *Jungle_Memory* also calls to mind gaming, and thus the making of worlds, the creation of a technosphere in which nature and technology are interconnected in a novel way.

Trevor Paglen begins here and problematizes attempts to decode biological matter mathematically. His photographs take up a motif that has become iconic art history: clouds. In Paglen's work, however, the pictures are overlaid with a fine lineament, which is inscribed in the pictures in a reserved but determined way. The artist generated it by having pictures of clouds scanned by an algorithm trained to recognize faces. The AI failed to identify physiognomic structures in the amorphous forms of the airy views, and instead produced layouts of lines. Paglen's experiment might seem harmless at first. But in the context of his work, which is dedicated to a critical examination of the techno-military surveillance apparatus of the United States, it illustrates that our lifeworld is deeply permeated by the most modern technologies, which compile information about human (and nonhuman) behavior.

Artists make use of imaging techniques to make processes like these visible and negotiable in an act of appropriation. Daniel Canogar's visual compositions are generated from data on energy consumption in Europe that is freely accessible on the internet and translates it live into abstract, constantly changing forms. *Phloem,* the title of his work, refers to the living tissue in plants that transports nutrients. Canogar associates the term with the invisible flows of energy that maintain the modern living environment. The work, which is installed on screens in the atrium of Kunsthalle Mannheim, leads us from the importance of data from the perspective of power politics in the work of Greiner and Paglen back to a concern that is central to the exhibition *1.5 Degrees*: in the current age characterized by far-reaching ecological changes, we can no longer view ourselves as isolated individuals. We must instead realize that we are connected to one another and that our accumulated actions leave traces on this planet.

[1] See Barbara Steiner, *SUPERFLEX/ TOOLS* (Cologne: Verlag Walter König, 2003), p. 5.
[2] The Kalpana consists of the artists Susanne M. Winterling and Goutam Ghosh and the scientist Bodhisattva Chattopadhyay.

Daniel Canogar
Phloem, 2022/23
Digitale Visualisierung / Digital visualization
Maße variabel / Dimensions variable

Kyriaki Goni
A Dense, Hidden Network of Roots
(aus der Multimedia-Installation / from the multimedia installation *Data Garden*), 2020
Grafit und Bleistift auf Papier / Graphite and pencil on paper
120 × 160 cm

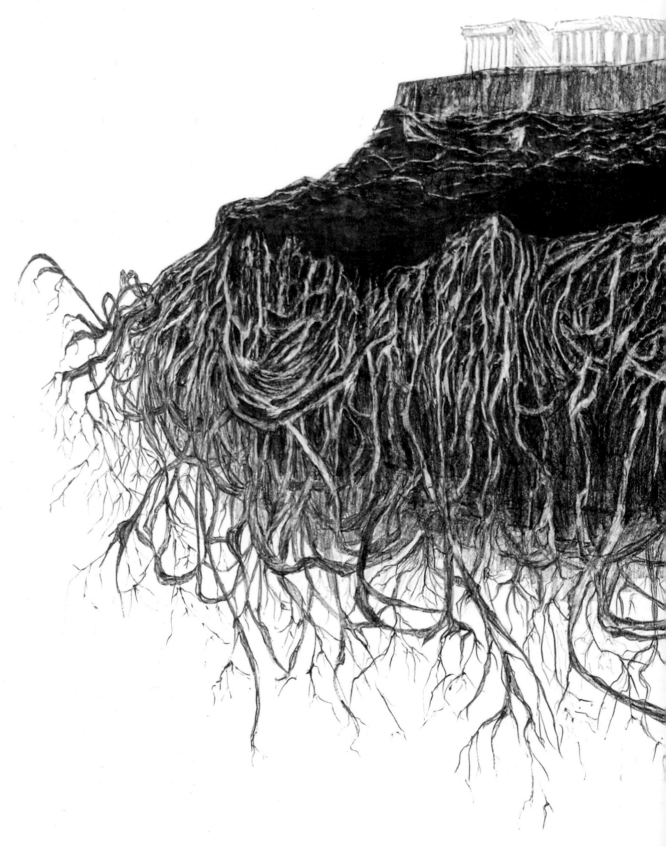

KYRIAKI GONI

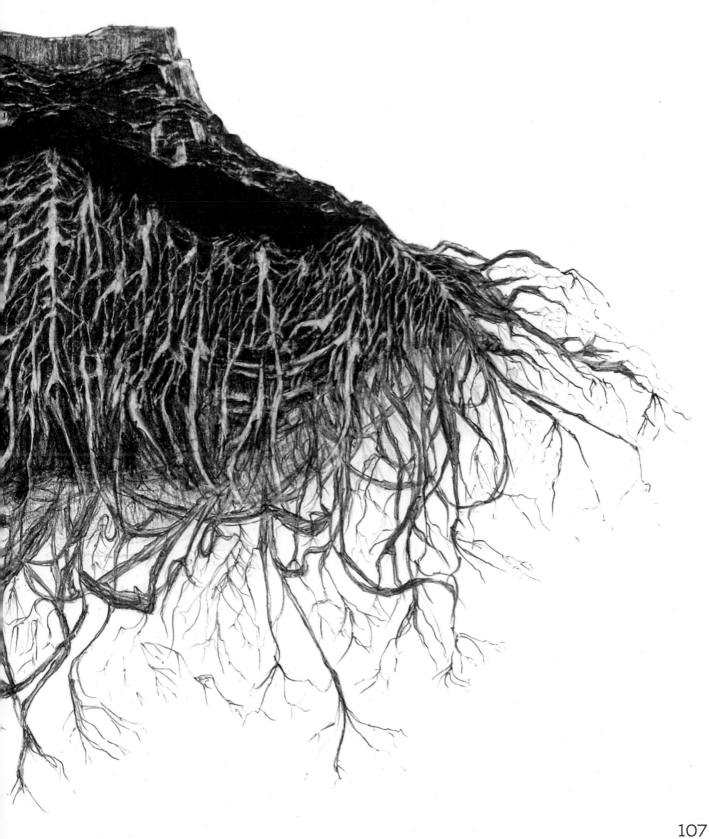

Andreas Greiner
Jungle_Memory_0010, 2019
Kunstdruck auf Hahnemühle Photo Rag, entspiegeltes
Glas in Museumsqualität, gestufter Rahmen aus dunklem
Erlenholz mit CNC-gefrästem Abstandhalter, Bild mittels
KI aus Tausenden von Waldaufnahmen generiert,
programmiert von Daan Lockhorst / Fine-art print on
Hahnemühle photo rag, museum antireflective glass,
dark alder wood level designed frame with CNC-milled
spacer, image created with an AI trained on thousands of
forest images, programmed by Daan Lockhorst
149,8 × 215,8 cm

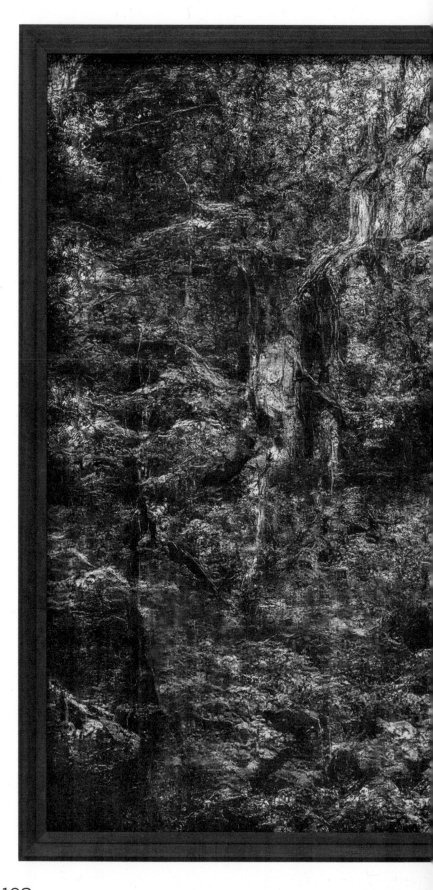

ANDREAS GREINER

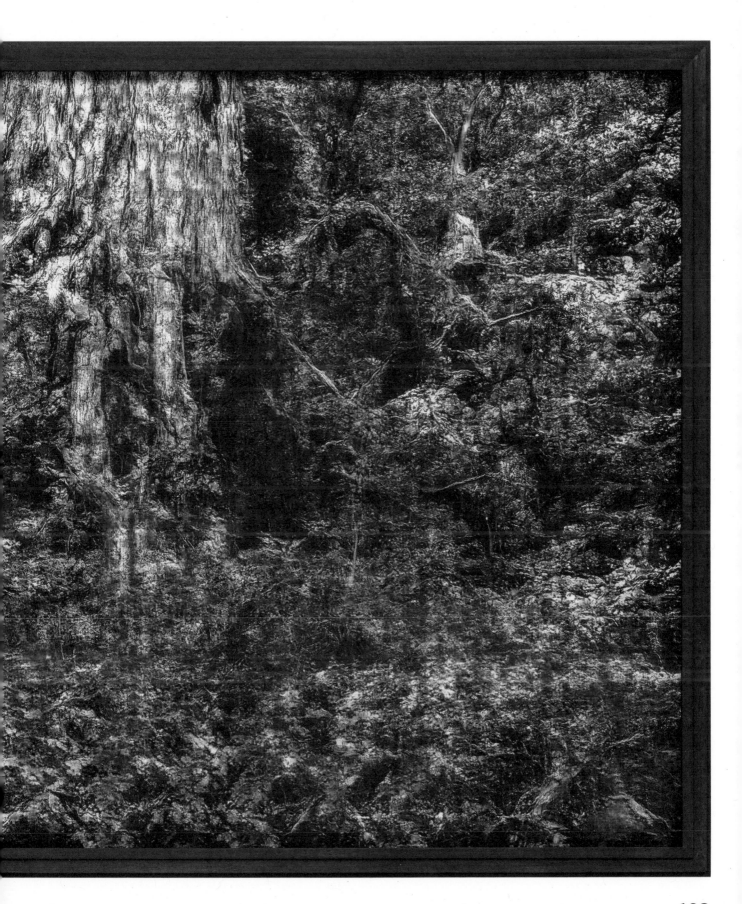

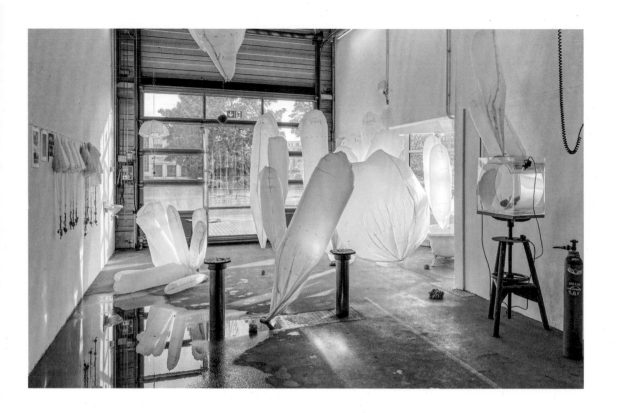

Tomas Kleiner
ÆRONAUTS, 2022
Experiment mit helium- und windbasierten Flugkörpern aus Bioplastik /
Experiment with helium- and wind-based floating bodies made of bioplastics
Installationsansicht / Installation view Ando Future Studios, Düsseldorf

Tomas Kleiner
Kartoffel-Fallschirm, 2022
Fallschirmseide, Aramidschnur, Gummiband, Kartoffel, Hängesystem aus Metall /
Parachute silk, aramid cord, rubber band, potato, hanging system made of metal,
75 × 50 × 50 cm (Maße im Flugzustand / Dimensions in flight condition)
Editionsansicht / Edition view

TOMAS KLEINER

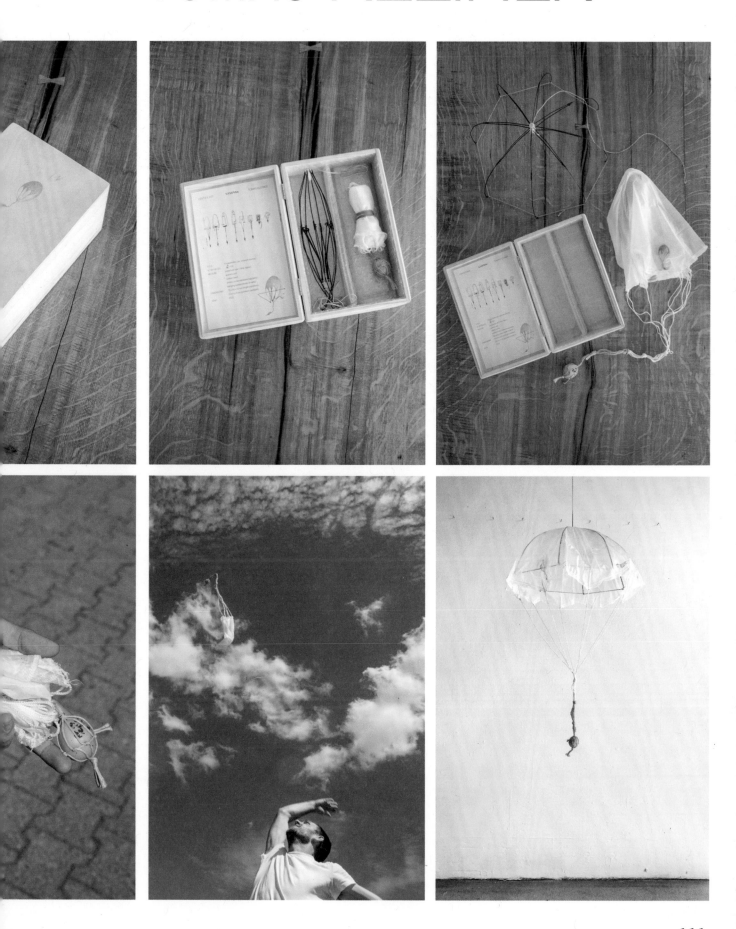

Trevor Paglen
CLOUD #211
Region Adjacency Graph, 2019
Thermosublimationsdruck / Dye sublimation print
121,9 × 203,2 cm

1,5 Grad

TREVOR PAGLEN

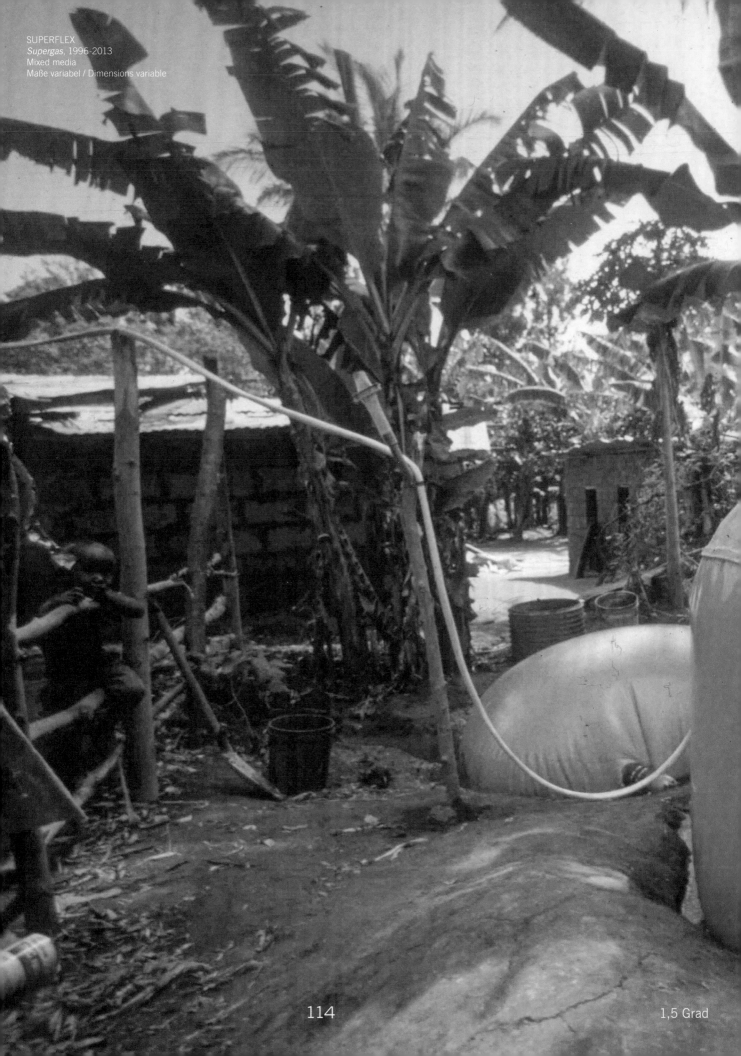

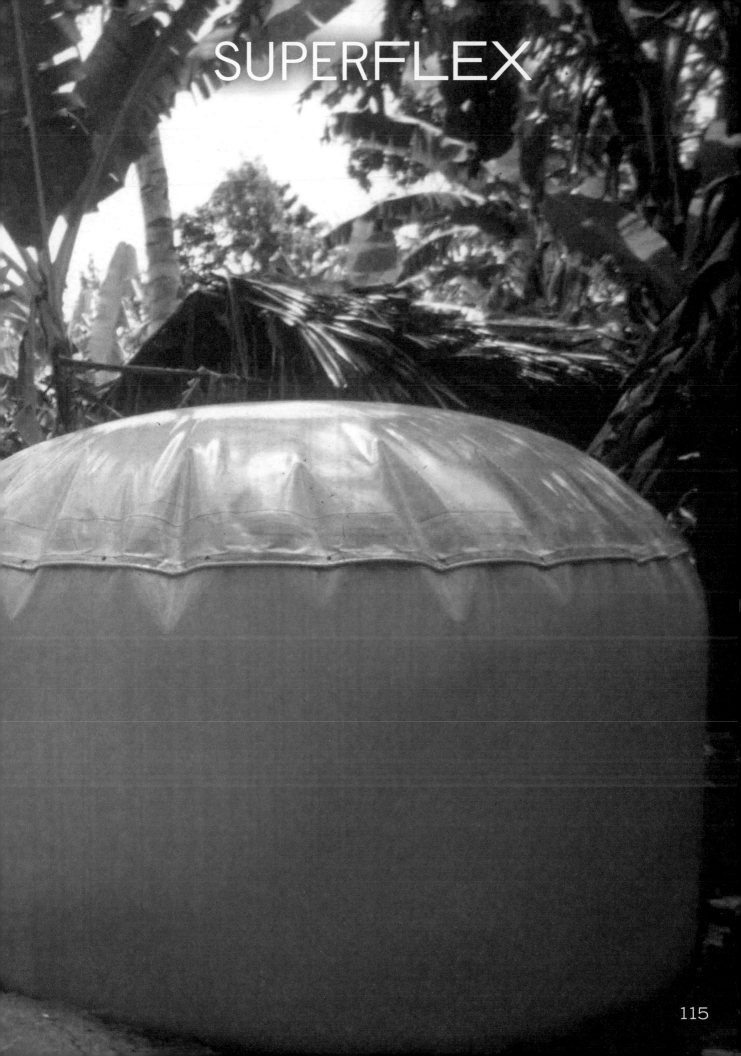

SUPERFLEX

Susanne M. Winterling / The Kalpana
the shape of the tortoise / embankment, 2020
Mixed media
Maße variabel / Dimensions variable
Installationsansicht / Installation view
Kunstverein Freiburg

4

Lebewesen / Creatures

Lebewesen

Sebastian Schneider

Menschen, Tiere und andere Lebewesen interagieren auf unterschiedlichste Art und Weise. Meist nimmt der Mensch dabei eine gewaltsame Rolle ein, etwa wenn er Tiere tötet oder Wälder rodet. In westlichen Kulturkreisen wirken bis heute die griechische Philosophie der Antike und das Christentum, die eine klare Grenze zwischen Mensch und Umwelt konsolidieren. Im Kern dieser Anthropozentrik steht die Annahme, dass alles auf der Welt für den Menschen geschaffen worden sei.[1] Jedoch übersieht eine solche Selbstbestimmung des Menschen die kulturelle Bedeutung, die etwa Tieren auf einem gemeinsam bewohnten Planeten zukommt. Eine Unterscheidung in denkende Menschen und instinktgetriebene Lebewesen wird vor diesem Hintergrund immer fragwürdiger. Vielmehr sollte man überdenken, ob Intelligenz, Handlungsmacht, aber auch soziale Praktiken wie Gemeinsinn und Fürsorge rein menschliche Qualitäten sind. Was daraus resultiert, ist eine Ethik der Verantwortung, die erforscht, »wie das Zusammenleben mit Tieren und anderen Nicht-Menschen in Zeiten ökologischer Krisen und geopolitischer Konflikte gestaltet werden kann«.[2]

In der künstlerischen Beschäftigung mit solchen Fragen nimmt Joseph Beuys eine Vorreiterrolle ein. Im Rahmen seiner Aktion *Coyote, I Like America and America Likes Me* isolierte sich der Künstler im Mai 1974 für mehrere Tage von der Außenwelt und lebte zusammen mit einem Kojoten in den Räumen einer New Yorker Galerie. Der dabei entstandene Film dokumentiert, wie Beuys versucht, sich dem Tier anzunähern, und wie sich zwischen den beiden ein zaghaftes Vertrauensverhältnis entwickelt. Beuys verlieh mit dieser Aktion seiner Kritik am US-amerikanischen Imperialismus Ausdruck. Den Kojoten, ein in den indigenen Kulturen des nordamerikanischen

Kontinents mit mythologischer Bedeutung aufgeladenes Tier, betrachtete Beuys als Träger spirituellen Wissens. Er erhoffte sich, mit dem Tier in einen Dialog zu treten und dessen spirituelle Energie zu erfahren – eine Energie, die die kapitalistische Staatsform der USA nahezu gänzlich verdrängt habe. Beuys' künstlerischer Ansatz, Tieren – aber auch organischen Materialien – eine Wirkmacht auf die Gesellschaft zuzuschreiben, findet aktuell vor allem bei jungen Künstler*innen großen Widerhall. In ihrem autobiografischen Roman konstatiert Nastassja Martin, »dass ein Dialog mit den Tieren möglich ist, auch wenn dieser sich nur selten in einer kontrollierbaren Form manifestiert«.[3]

Ein solches Konzept der animistischen Vermischung liegt auch MOOTHERR, einer raumfüllenden Installation von Laure Prouvost, zugrunde. In ihrem Zentrum befindet sich eine Kreatur, die mit ihren Tentakeln an einen Kraken erinnert. Gleichzeitig verfügt sie auch über Brüste, mit denen sie ihren abwesenden, aber aus der Ferne stets um Aufmerksamkeit buhlenden Nachwuchs nährt. Prouvost führt in der Installation das Bild der sorgenden Mutter mit dem des Unterwassertiers zusammen. Letzteres fasziniert uns durch sein Reproduktionsverhalten, weil es sich so sehr von dem des Menschen unterscheidet (Oktopusweibchen sterben kurz nach der Eiablage). Durch diese Vermischung von Mensch und Tier erhalten soziale Konventionen, wie das Aufwachsen in einer Kernfamilie mit zweigeschlechtlichen Eltern, aber auch mütterliche Fürsorge einen kritischen Impuls.

Ähnlich wie bei Prouvost handelt es sich auch bei der Skulptur von Germaine Richier um einen Hybrid. Ihre *Große Gottesanbeterin* trägt sowohl die Züge eines Menschen als auch die eines Insekts. In der verzerrten Figur mit den ausgemergelten Gliedern manifestiert sich Schmerz. Gleichzeitig geht von ihr etwas Unheimliches aus, da sie zum Sprung anzusetzen scheint. Auffällig ist auch, dass Richier das Tier überdimensioniert groß darstellt. Es ist dieses Spiel mit Skalen, das eine Veränderung des Sehens, Blickens und Erscheinens hervorruft. Auch Lili Fischer nutzt dies als künstlerische Strategie, um sich der Welt zu nähern und sich in ein anderes Lebewesen einzufühlen. Sie setzt sich seit Jahren intensiv mit Schnaken auseinander – ein Insekt, das im Gegensatz zu Schmetterlingen oder Faltern kulturgeschichtlich kaum beachtet wird. Die Künstlerin interessiert sich für die transparenten Flügel sowie die feinen, vielgliedrigen Beine der Schnake. Fischer erschafft stark vergrößerte, aber ansonsten naturalistische Schnakenskulpturen, die frei im Raum schweben und durch ihre Gleichzeitigkeit von Fragilität und Stärke faszinieren.

Auch Anne Duk Hee Jordan und Pauline Doutreluingne greifen das Prinzip der Größenverschiebung auf: Ihr Film *Brakfesten /*

La Grande Bouffe zoomt auf Vorgänge in der Welt der Insekten, die mit bloßem Auge kaum zu erfassen wären. Als Setting dienen Stämme von Bäumen, die wegen Borkenkäferbefall gefällt wurden. Die Künstler*innen haben das tote Holz an einzelnen Stellen so präpariert, dass sich perfekte Lebensbedingungen für Insekten und Vögel bieten. Ganz wie in dem französischen Kultfilm, der dem Werk seinen Titel gibt, wohnt man als Zuschauer*in einem bunten Treiben aus Nahrungsaufnahme und Fortpflanzung bei. Entgegen einer pessimistischen Lesart, die die Borkenkäferplage nur als Symptom der Klimakrise begreift, rückt der Film die symbiotischen Potenziale in den Vordergrund, die selbst in toter Materie für das Fortbestehen eines Ökosystems verborgen liegen. Jordan und Doutreluingne bringen damit zum Ausdruck, dass der Einfluss des Menschen auf die Umwelt irreversibel ist, und man gerade deshalb nicht den vermeintlichen Urzustand einer unbeschädigten Natur herbeisehnen sollte. Vielmehr gilt es, Lösungen zu suchen, um sich in der Gegenwart mit anderen Lebensformen, aber auch mit unbelebter Materie auf neue Art und Weise zu verbinden.

In inhaltlicher Nähe dazu steht das Video *GT Grantourismo* von Günther und Loredana Selichar. Es zeigt aus der Ich-Perspektive eine rasante Fahrt über eine kurvenreiche Landstraße. Der Blick auf die Außenwelt, die sich zentralperspektivisch vor dem eigenen Auge ausbreitet, wird durch Insekten, die an die Windschutzscheibe klatschen, immer mehr erschwert. Ihre Rückstände hinterlassen dort ein Schlieren ziehendes Action-Painting. Über 20 Jahre nach seinem Entstehen ruft das Video Erinnerungen an ein Alltagsphänomen der Vergangenheit wach: Die toten Insekten, die sich nach längeren Autofahrten auf der Windschutzscheibe eines Fahrzeugs ansammelten. Aus heutiger Perspektive kann das Werk als bissiger Kommentar auf das Insektensterben gelesen werden, gleichzeitig unterstreichen seine Soundeffekte – das Aufprallen der Fliegen auf der Windschutzscheibe – die konfliktgeladene Beziehung, in der Menschen und Tiere stehen.

Marianna Simnett geht diesem Thema in einem anderen Kontext nach. Ihre Fotoserie *Covering* entstand auf einem Gestüt für Rennpferde und dokumentiert das Scheitern eines Versuchs, eine Stute zu decken. In den Bildern vermittelt sich schonungslos die Gewalt, die mit diesem erzwungenen Geschlechtsakt auf mehreren Ebenen einhergeht: das düstere Setting, die Versuche, die Stute zu bändigen, und schließlich ihr Tritt in die Genitalien des Hengsts. Auch wenn sich das Pferd damit erfolgreich gegen seine Begattung wehrt, wird hier keine Erfolgsgeschichte erzählt. Die Körper der Tiere wirken an ihren intimsten Stellen verwundet; als Betrachter*in ahnt man, dass sich

am Geschäftsmodell der Pferdezucht trotz der Gegenwehr der Stute nichts ändern wird. Simnett verwendet eine Drucktechnik, bei der sich das Bildmotiv verändert, wenn man es aus unterschiedlichen Blickwinkeln ansieht. Somit aktivieren die Betrachter*innen die Szenen, indem sie sich im Raum bewegen. Die Künstlerin zielt damit darauf ab, dass der Akt des Betrachtens in den Akt der Zucht einbezogen wird.

Simnetts Werk wird eine Skulptur aus der Sammlung der Kunsthalle Mannheim gegenübergestellt: *Miracolo* von Marino Marini. Zu sehen ist ein steigendes Pferd, das einen winzig wirkenden Reiter abwirft. Marini wurde am Ende des Zweiten Weltkriegs Zeuge einer solchen Szene, die er in den folgenden Jahren immer wieder als Motiv aufgriff. Anders als bei Reiterstatuen üblich, zeigt Marini den Reiter nicht als schreitenden Imperator. Das sich losreißende Pferd vermittelt die Kraft sowie die Handlungsmacht des Tieres. Im Kontext der Ausstellung *1,5 Grad* interpretieren wir Marinis Werk als visuelle Darstellung einer Mensch-Tier-Beziehung, in der sich das Tier aus seiner Unterwerfung befreit. Die Tatsache, dass Wildtiere seit einigen Jahren ungehemmt in Städte vordringen, zeigt, dass ein solcher Aufstand der Tiere keine Fantasie ist.[4] Das Anthropozän ist nicht nur das Zeitalter des Menschen. Es provoziert auch eine Antwort der Tiere.

[1] Vgl. Gabriela Kompatscher, »Mensch-Tier-Beziehungen im Licht der Human-Animal Studies«, hrsg. von Bundeszentrale für politische Bildung, 29.5.2019, https://www.bpb.de/themen/umwelt/bioethik/290626/mensch-tier-beziehungen-im-licht-der-human-animal-studies/ (12.11.2022).

[2] Jessica Ullrich, »Ökologie. Editorial«, in: *Tierstudien,* 6, 13, März 2018, S. 7–14, hier S. 8.

[3] Nastassja Martin, *An das Wilde glauben*, Berlin 2021, S. 98.

[4] Die Ausbreitung von Wildschweinen und Füchsen in Berlin sei hier als relativ harmloses Beispiel genannt. Durchaus problematischer sind die Attacken von Affen auf Stadtbewohner*innen in Indien oder Thailand. Aufsehen erregte ebenfalls ein Puma, der 2020 durch Santiago de Chile streifte. Häufig ist es der Verlust ihrer Habitate, der Tiere zu diesen ungewöhnlichen Streifzügen zwingt.

Creatures

Sebastian Schneider

Humans, animals, and other living creatures interact in very diverse ways. Human beings generally play a violent role in this, for instance by killing animals or clearing forests. In Western cultures, the Greek philosophy of antiquity and Christianity, which consolidate a clear boundary between human beings and the environment, continue to have an influence until today. Central to this anthropocentrism is the assumption that everything in the world was created for people.[1] But such human self-determination overlooks the cultural significance ascribed, for example, to animals on a jointly inhabited planet. A differentiation into thinking persons and living beings driven by instinct thus becomes ever more questionable against this backdrop. One should instead consider whether intelligence, agency, or social practices, such as community spirit and care, are solely human qualities. What results from this is an ethics of responsibility that examines "how coexistence with animals and other nonhuman beings can be designed at a time of ecological crises and geopolitical conflicts."[2]

Joseph Beuys takes on a pioneering role in the artistic occupation with such questions. Within the framework of his action *Coyote, I Like America and America Likes Me*, the artist isolated himself from the outside world for several days in May 1974 and lived with a coyote in the rooms of a gallery in New York City. The film created during this time documents Beuys's attempts to approach the animal and how a trusting relationship develops between the two of them. With this action, Beuys expressed his criticism of American imperialism. Beuys saw the coyote, an animal charged with mythological significance in the Indigenous cultures of the North American continent, as a bearer of spiritual knowledge. His hope was to enter into

dialogue with the animal and experience its spiritual energy—an energy that the capitalist government in the United States has almost entirely suppressed. Beuys's artistic approach of ascribing an impact on society to animals—but also to organic materials—is currently finding great resonance, in the work of young artists in particular. In her autobiographical novel, Nastassja Martin postulates that "dialogue with animals is possible, even if it is only rarely manifested in a controllable form."[3]

Such a concept of animistic commingling also underlies *MOOTHERR*, a room-filling installation by Laure Prouvost. At its center is a creature whose tentacles call to mind an octopus. At the same time, the female being also has breasts, with which she nourishes her offspring, who, though absent, always demand attention from the distance. In the installation, Prouvost thus merges the image of the caring mother with that of the underwater animal. The latter fascinates us with its reproductive behavior, because it differs so greatly from the actions of human beings (female octopi die shortly after laying their eggs). Social conventions like maternal care or growing up in a nuclear family with parents of both sexes obtain a critical impulse from this amalgamation of humans and animals.

As in Prouvost's work, the sculpture by Germaine Richier is also a hybrid. *La mante, grande* (Large Praying Mantis) bears the characteristics of both a human being and an insect. Pain is manifested in the distorted figure with emaciated limbs. It simultaneously radiates an uncanny quality that seems to indicate it is about to leap. Richier's larger-than-life rendering of the animal is also striking. It is this play with scales that gives rise to a change in seeing, looking, and appearing. Lili Fischer also uses this as an artistic strategy for approaching the world around her and for empathizing with a different living being. She has been intensively examining gnats—an insect that in contrast to butterflies or moths has been neglected in cultural history—for years. The artist is interested in the gnat's transparent wings as well as its fine legs with multiple joints. Fischer produces greatly enlarged but otherwise naturalistic gnat sculptures that float freely in space and fascinate as a result of their concurrence of fragility and strength.

Anne Duk Hee Jordan and Pauline Doutreluingne also take up the principle of a shift in size: their film *Brakfesten / La Grande Bouffe* zooms into processes in the world of insects that would be barely visible to the naked eye. The trunks of trees felled due to a bark beetle infestation serves as the setting.

The artists prepared the dead wood at individual points in such a way that perfect living conditions for insects and birds are offered. Just as in the French cult film that provides the title of the work, viewers witness a colorful hustle and bustle of consuming food and procreating. Contrary to a pessimistic reading, which regards the plague of bark beetles solely as a symptom of the climate crisis, the film foregrounds the symbiotic potentials for the survival of ecosystems that are found even in dead matter. Jordan and Doutreluingne thus express the fact that the influence of humans on the environment is irreversible, and that, for precisely this reason, one should not yearn for the supposedly original state of an unspoiled nature. It is instead necessary to seek solutions so as to connect oneself with other life-forms as well as with inanimate matter in a different way in the present.

The video *GT Grantourismo* by Günther and Loredana Selichar is linked to this with respect to content. It shows a fast drive along a winding road from the driver's perspective. The view of the outside world that spreads out before one's own eyes from a central perspective is made increasingly difficult by the insects splatting against the windshield. Their remains leave behind a streaked action painting. Over twenty years after it was produced, the video brings to mind memories of an everyday phenomenon of the past: the dead insects that collected on the windows of a vehicle after a long drive. From the perspective of today, the work can be read as a biting commentary on the death of insects, while its sound effects—the thudding of flies against a windshield—simultaneously underscore the conflictual relationship between human beings and animals.

Marianna Simnett addresses this topic in a different context. Her photo series *Covering* was produced on a stud farm for race horses and documents the failure of an attempt to cover a mare. In the pictures, the violence connected with this forced sex act on several levels is bluntly communicated: the gloomy setting, the attempt to subdue the mare, and finally her kick in the stallion's genitals. Even though the horse thus successfully resists being copulated, no success story is related here. The bodies of the animals seem to be wounded at their most intimate points; as a viewer, one senses that, despite the mare's resistance, nothing in the business model of horse breeding farms will change. Simnett makes use of a printing technique in which the picture motif changes when seen from different perspectives. Viewers thus activate the scenes by moving through space. The artist therefore aims to incorporate the act of viewing into the act of breeding.

Simnett's work is juxtaposed with a sculpture from the collection of the Kunsthalle Mannheim: *Miracolo* (Miracle) by Marino Marini. What can be seen is a rearing horse throwing off a tiny-seeming rider. Marini witnessed such a scene at the end of World War II and took it up as a motif again and again in the years that followed. Unlike what is otherwise customary in the case of equestrian statues, Marini does not show the rider as a striding emperor. The horse breaking loose communicates the animal's power and agency. In the context of the exhibition *1.5 Degrees*, we interpret Marini's work as a visual representation of a human-animal relationship in which the animal liberates itself from its subjugation. The fact that wild animals have been penetrating cities uninhibited for a number of years shows that such resistance by animals is not a fantasy.[4] The Anthropocene is not only the age of human beings. It also provokes a response by animals.

[1] See Gabriela Kompatscher, "Mensch-Tier-Beziehungen im Licht der Human-Animal Studies," ed. Bundeszentrale für politische Bildung (Federal Agency for Civic Education), May 29, 2019, https://www.bpb.de/themen/umwelt/bioethik/290626/mensch-tier-beziehungen-im-licht-der-human-animal-studies/ (accessed November 12, 2022).

[2] Jessica Ullrich, "Ökologie: Editorial," *Tierstudien* 6, no. 13 (March 2018): 7–14, esp. 8.

[3] Nastassja Martin, *An das Wilde glauben* (Berlin: Matthes & Seitz, 2021), p. 98.

[4] The spread of wild boar and foxes in Berlin is mentioned here as a relatively harmless example. Attacks by apes on urban dwellers in India or Thailand are much more problematic. A puma that roamed through Santiago de Chile in 2020 also caused a sensation. Animals are frequently forced to make such unusual forays due to the loss of their habitat.

Joseph Beuys
I Like America and America Likes Me, 1974
16-mm-Film (Farbe und S/W, Ton / Color and b/w, sound)
37 min, Regie / Director: Helmut Wietz
Film still

JOSEPH BEUYS

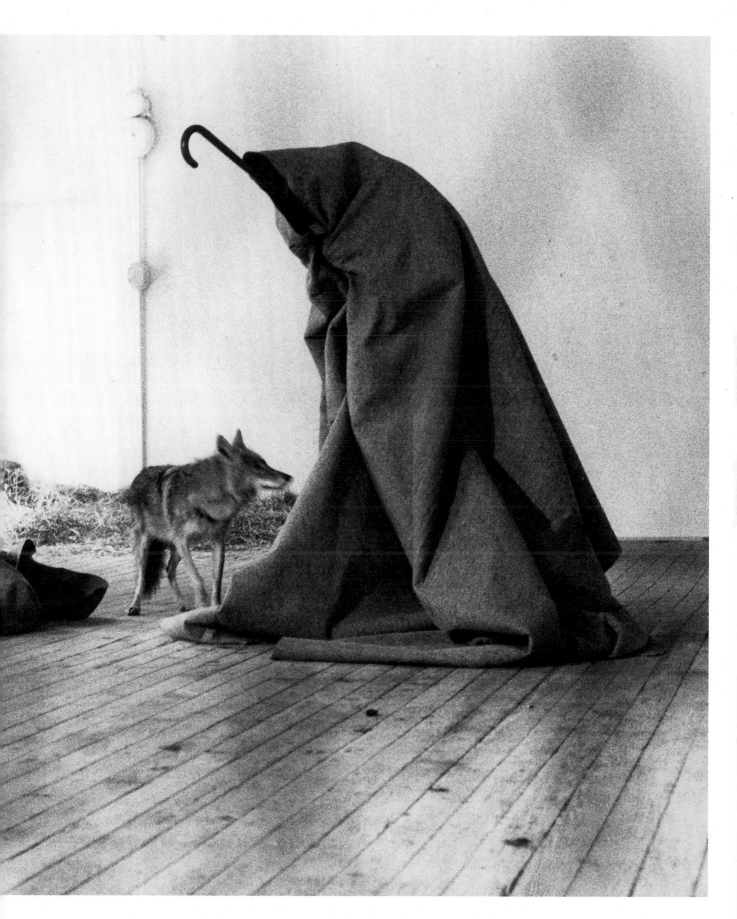

Marino Marini
Miracolo / Wunder / Miracle, 1953
Bronze / Bronze
247,1 × 193 × 180 cm
Kunsthalle Mannheim

MARINO MARINI

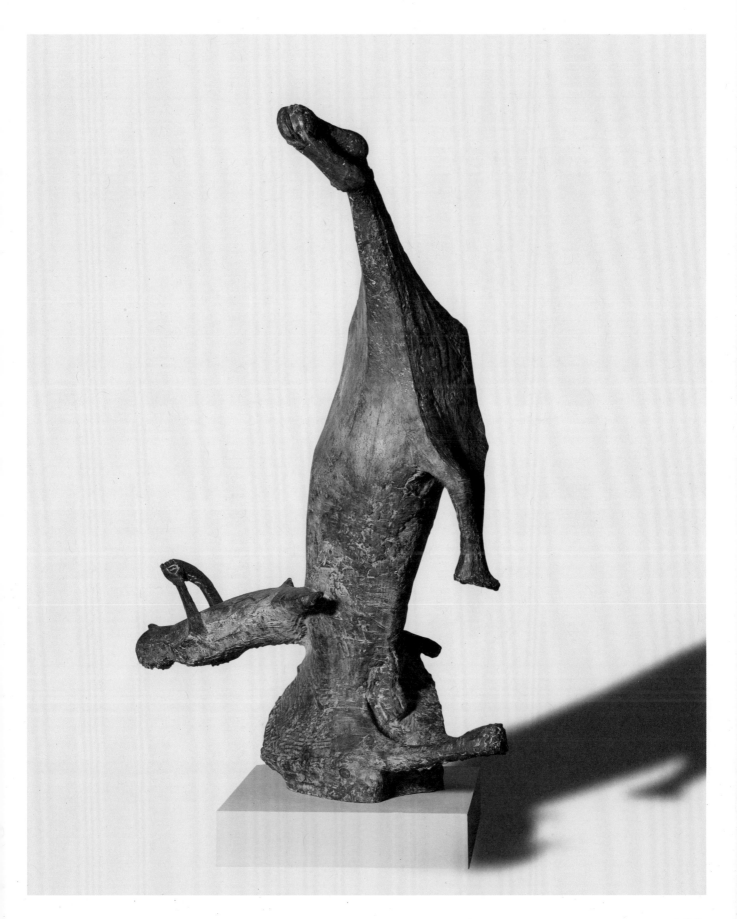

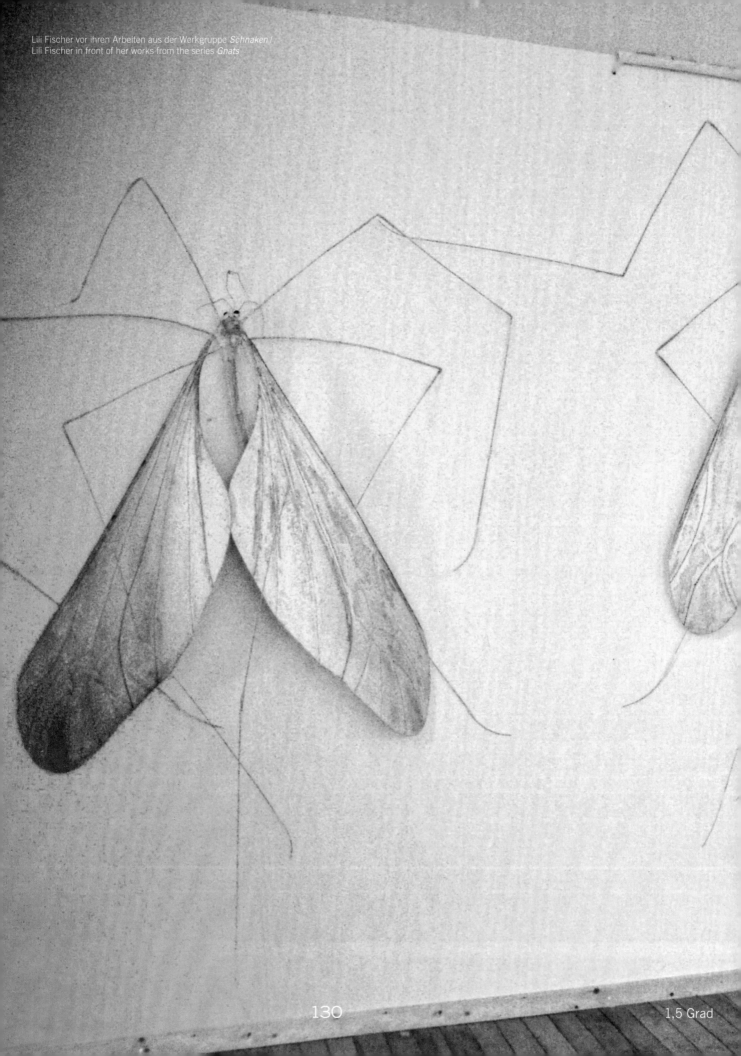

LILI FISCHER

Anne Duk Hee Jordan & Pauline Doutreluingne
Brakfesten / La Grande Bouffe, 2022
Video (Farbe, Ton / Color, sound)
28:14 min
Video stills

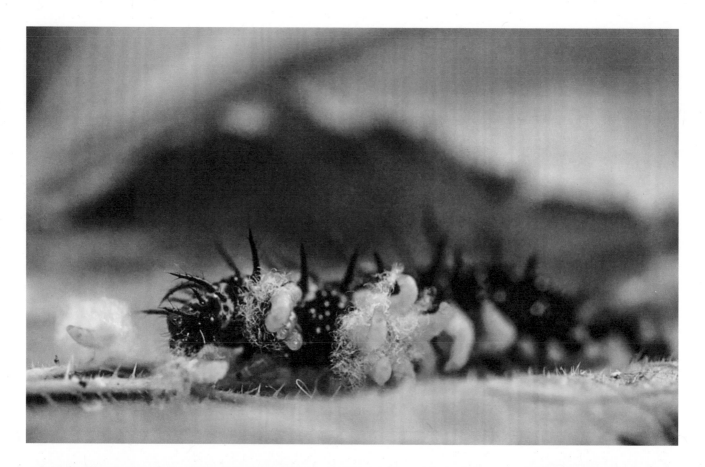

ANNE DUK HEE JORDAN

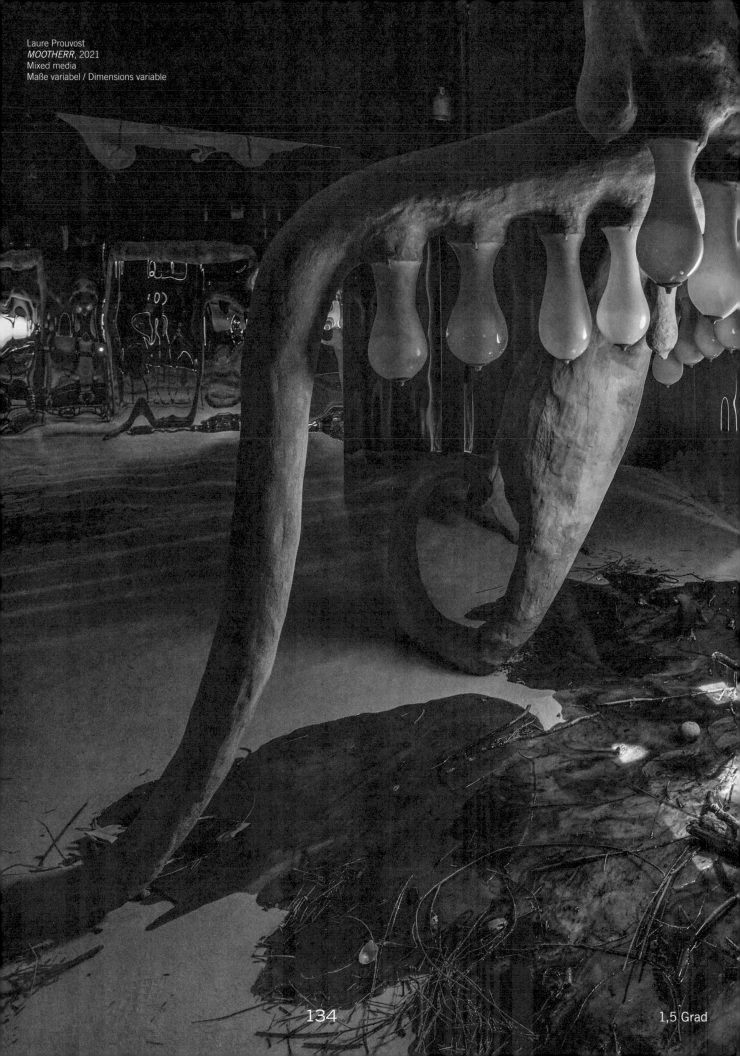

Laure Prouvost
MOOTHERR, 2021
Mixed media
Maße variabel / Dimensions variable

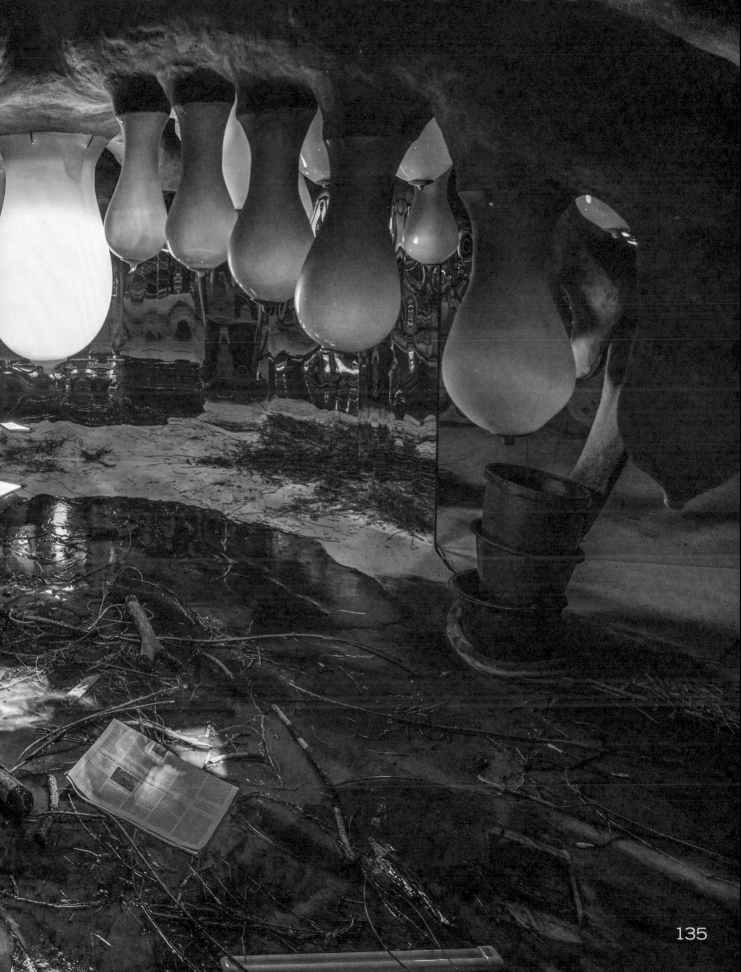

LAURE PROUVOST

Germaine Richier
La mante, grande / Große Gottesanbeterin /
Large Praying Mantis, 1946
Bronze / Bronze
162 × 46 × 91 cm
Kunsthalle Mannheim, Leihgabe des Landes Baden-Württemberg seit 1970 /
On loan from the State of Baden-Württemberg since 1970

GERMAINE RICHIER

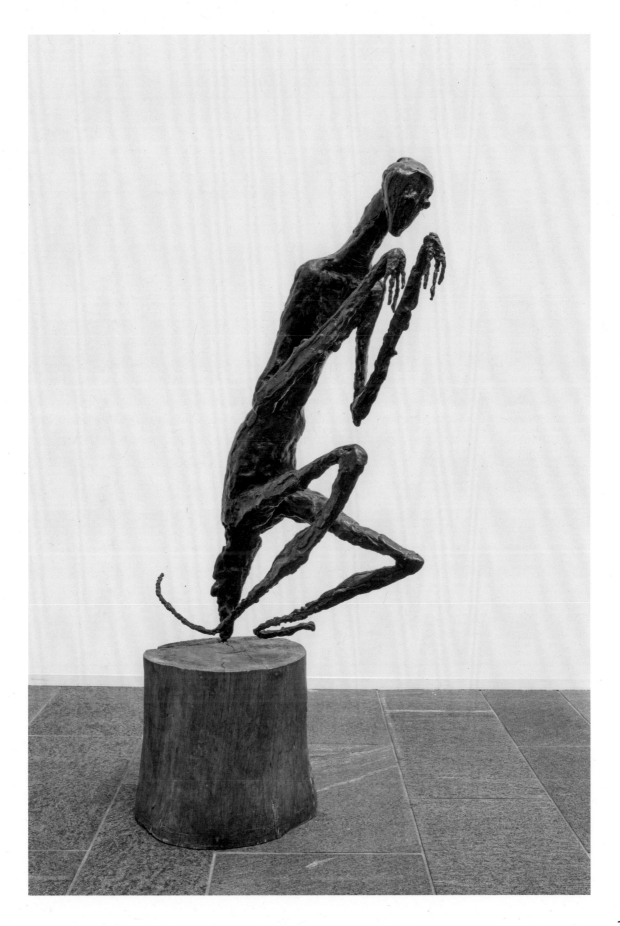

Günther & Loredana Selichar
GT Granturismo, 2001
Video (Farbe, Ton / Color, sound)
5:10 min
Video still

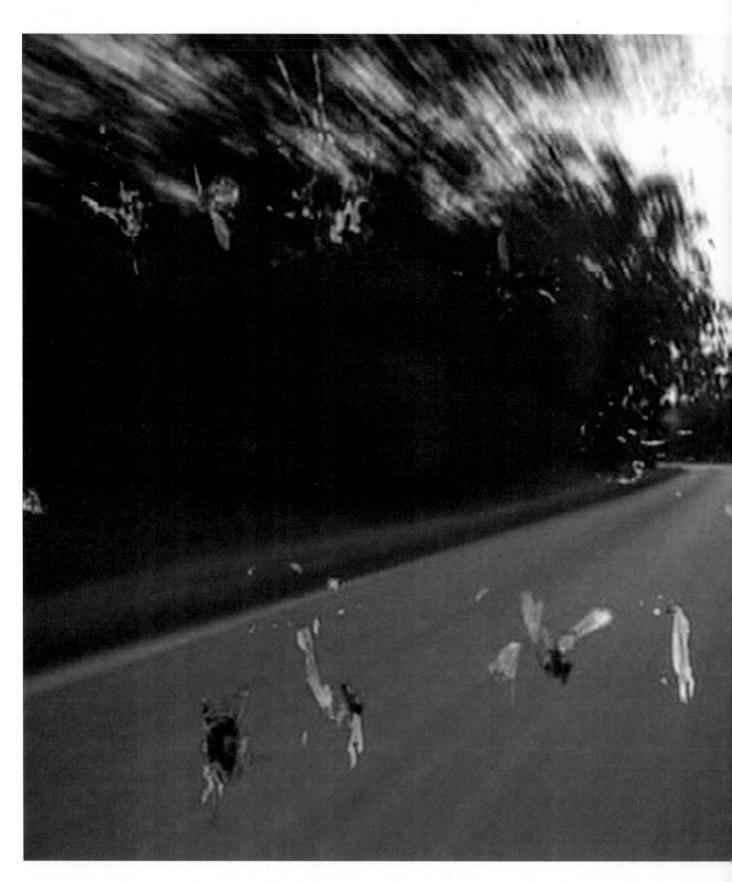

138

GÜNTHER & LOREDANA
SELICHAR

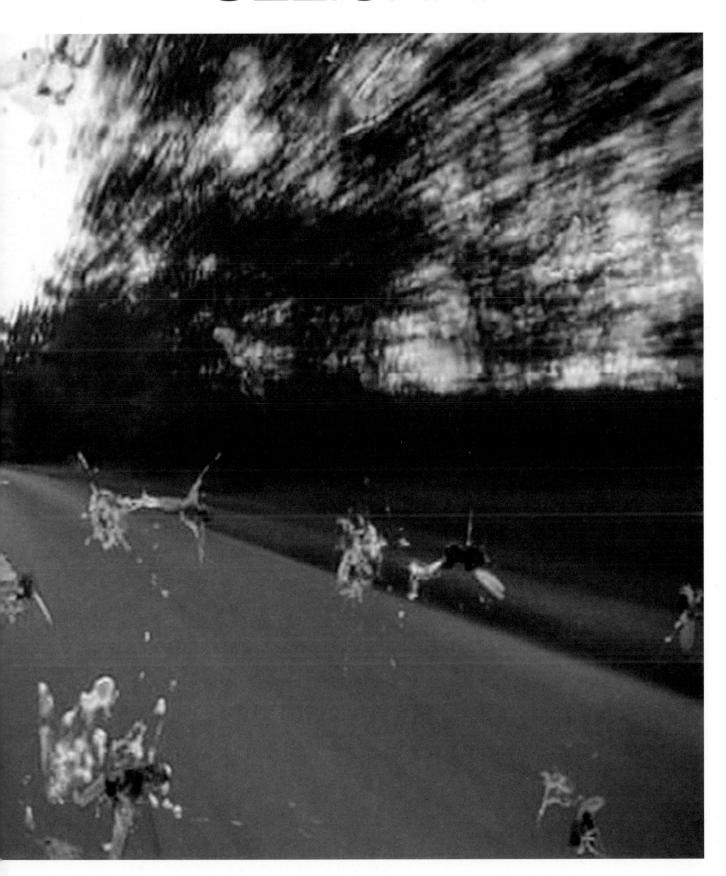

Marianna Simnett
Covering (sure thing), *Covering (bloodstock)*, *Covering (brood)*, *Covering (rogue)*, 2020
Lentikular-Animationen / Lenticular animations
60 × 119 cm

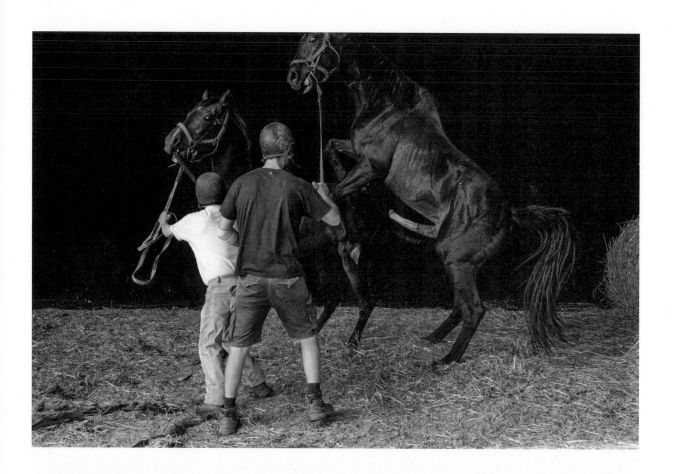

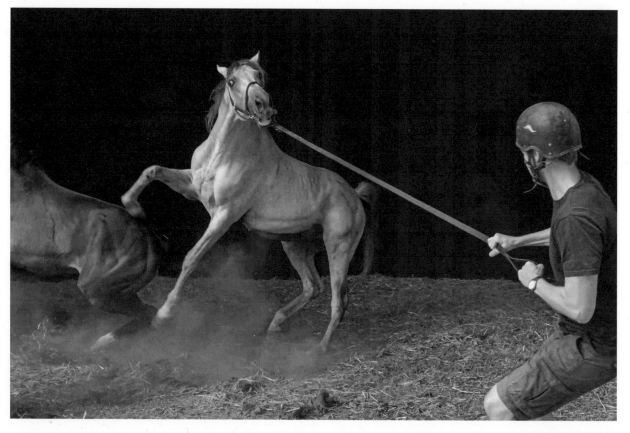

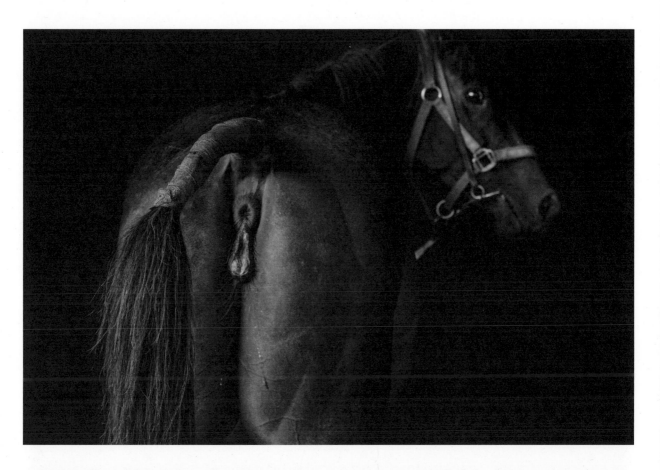

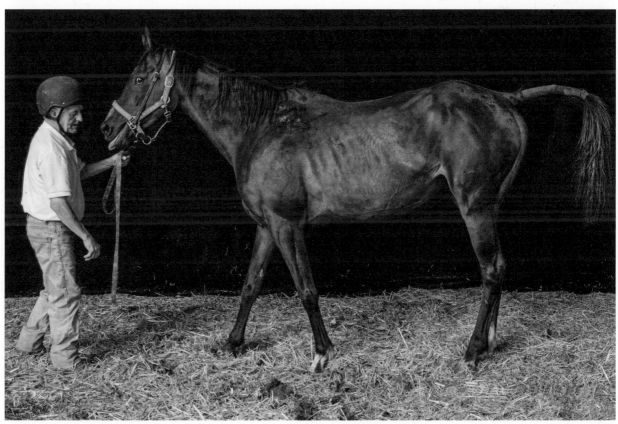

Kosmos / Cosmos

Kosmos

Sebastian Schneider

Seit Menschengedenken fasziniert uns der Kosmos. Was verbirgt sich in den unendlichen Weiten des Universums? Welche Kräfte üben der Mond, die Sterne und andere Himmelskörper auf uns aus? In sämtlichen Kulturen und zu jeder Zeit haben Fragen wie diese unterschiedlichste gedankliche Konzepte hervorgebracht – Kosmologien, auf denen religiöse Lehren, naturwissenschaftliche Erkenntnisse, aber ebenso popkulturelle Phänomene fußen. Auch in der bildenden Kunst resultieren viele Werke aus der tiefen Faszination für den Kosmos. Den in diesem Fragment der Ausstellung vereinten Künstler*innen ist gemein, dass sie die Welt als ganzheitliches System von Abhängigkeiten begreifen, in dem sich alle Bestandteile gegenseitig bedingen. In der Kombination der Werke vollzieht sich eine Bewegung, die bei Otobong Nkanga in der Tiefe des Meeres beginnt. Von dort setzt sie sich ans Land fort, wo Anselm Kiefer das Leben der Pflanzen und deren Verbindung zu den Sternen in den Blick nimmt. Den räumlichen Abschluss bildet das Weltall an sich, dem sich neben Kiefer auch Eva Gentner widmet.

Die großformatige Tapisserie *Unearthed – Twilight* von Otobong Nkanga zieht die Betrachter*innen mit ihrer Farbigkeit und Textur sofort in den Bann. Ein blauer Ozean nimmt den Großteil der Bildfläche ein. Nur ein kleiner Streifen im oberen Teil des Bildes, der eine Küste darstellt, setzt sich in Grün vom dominierenden Blau ab. Die blaue und die grüne Farbfläche liegen wie Sedimente übereinander. Beim Betrachten des Bildes wandert man mit den Augen aus der Tiefe des Meeres an Land. Eine rötliche Linie, die sich von der Unter- bis zur Oberkante erstreckt, leitet diese Blickrichtung. Über die malerischen Farbschlieren der Kettfäden, die manchmal wogen wie maritime Ströme, spannt sich ein weißes Netz, das sich über das

gesamte untere Drittel des Bildes zieht und mit dem die Künstlerin auf das menschliche Begehren, das Meer zu kartieren, anspielt. Etwas weiter oben entdeckt man Körperteile, Arme und Hände, die sich auf dem Meeresgrund abgelagert haben. Nkanga faszinieren die motorischen Fähigkeiten des menschlichen Greifapparats. Die dargestellten Gesten des Tastens, Grabens und Greifens symbolisieren Tätigkeiten, die bei der Gewinnung von Bodenschätzen zum Einsatz kommen. Hier wirken die Gliedmaßen wie ausgesonderte Ersatzteile und verweisen sowohl auf die Automatisierung der Arbeit als auch auf den rücksichtslosen Verschleiß menschlicher Arbeitskraft, wie sie die Industrialisierung und Globalisierung von Anbeginn mit sich brachten. Unverkennbar rufen sie aber auch Erinnerungen an die im Mittelmeer Ertrunkenen wach, die auf der Suche nach einem anderen Leben mit ebenjenem bezahlten. Als Europäer*innen müssen wir uns fragen, ob wir ihre Geschichten weiterhin verdrängen wollen.

Trotzdem geht Nkangas Werk weit über die pessimistische Beschreibung eines Ist-Zustands hinaus. Die Künstlerin begeistert das physikalische Gesetz, nach dem Energie nicht zerstört werden kann, denn sie geht immer nur von einem auf einen anderen Träger über. Ihr Bild, das sich in eine aquatische und eine terrestrische Zone teilt, handelt von diesen energetischen Kreisläufen. Mineralien – dargestellt in Form von kleinen Kreisen – überwinden die Grenzen, die durch die Elemente Wasser und Erde scheinbar gegeben sind, und bevölkern das gesamte Bild. Sie stehen für stoffliche Prozesse und den Austausch von Energie, die in die Natur einfließt und dort neue Lebensformen hervorbringt. Das Konzept der energetischen Übertragung ermöglicht es Nkanga, die vermeintlichen Gegensätze – von Wasser und Erde, aber auch Leben und Tod – aufzuweichen. Dass das eine auch das andere sein kann, kommt auch in dem von ihr gewählten Werktitel *Twilight* – also Zwielicht – zum Ausdruck.

Nkangas metaphysische Überlegungen finden eine Fortsetzung bei Anselm Kiefer. Sein Werk *The Secret Life of Plants for Robert Fludd* besteht aus verschiedenen Darstellungen des Firmaments, auf die der Künstler Sternbilder in Form eingegipster Zweige aufgebracht hat. Kiefer bezieht sich mit seinem Werk auf den englischen Mystiker und Alchemisten Robert Fludd (1574–1637), der zu den bekanntesten Naturphilosophen seiner Zeit zählt. Von Fludd stammt die Aussage, dass jeder Pflanze auf der Erde ein Stern am Firmament entspreche. Diese These weitete er auf den Menschen aus, den er als Mikrokosmos und damit als kleine Kopie des Makrokosmos begriff. Fludds Analogie von Mikro- und Makrokosmos und die daraus resultierenden Überlegungen zur Schöpfung sowie der Korrelation von irdischem

und himmlischem Leben stehen im Gegensatz zu einer »Entschlüsselung der Welt mithilfe von Geometrie und Mathematik, wie sie etwa Galileo Galilei und René Descartes vertreten haben«.[1] Kiefer verstärkt die Spannung zwischen mythischem und rationalem Wissen, indem er die Sterne in seinem Bild nach einer von der NASA entwickelten Nomenklatur benennt. Damit thematisiert er die enorme Bedeutung, die Technik seit jeher in der Astronomie zukommt. Von Ferngläsern bis zu Planetarien – das menschliche Bedürfnis, das Weltall zu verstehen, hat eine Vielzahl von Apparaturen und eigens dafür bestimmten Bauwerken hervorgebracht.

Mit einem solchen Bauwerk beschäftigt sich Kiefer schon seit Langem: Die historische Sternwarte in der indischen Stadt Jaipur, die er zum Motiv vieler seiner Werke gemacht hat. Die in der Kunsthalle Mannheim gezeigte Arbeit greift die runde Architektur des Observatoriums auf, ersetzt ihre Treppe aber durch eine Leiter, die direkt in das Firmament zu führen scheint. Ähnlich wie bei Nkanga lässt sich bei Kiefer die Fläche des Bildes in zwei Zonen aufteilen: in einen irdischen und einen himmlischen Bereich, wobei letzterer einen Großteil der Bildfläche ausmacht. Auch hier fügt der Künstler den Sternen Notate hinzu, die von der NASA stammen. In dem Werk wird die Bedeutung der Astronomie im Indien des 17. Jahrhunderts, also vor der Kolonialisierung des Landes durch die Briten, thematisiert. Gleichzeitig erzählt es davon, dass Astronomie längst nicht mehr nur ein Feld philosophischer Tätigkeit ist, sondern eng mit politischer Expansion und ideologischer Deutungsmacht verknüpft ist.

An dieses Thema knüpft Eva Gentner mit ihren Zeichnungen der Serie *Implementation of Geocentrism* an. Ausgehend von der Tatsache, dass die Anzahl der Satelliten im All in der jüngeren Vergangenheit enorm angestiegen ist (und weiter zunehmen wird), stellt sich die Künstlerin die Frage, wie diese zusätzlichen Lichtquellen den Nachthimmel beeinflussen werden. Was bedeutet es für die Astronomie, wenn ihre Anschauungsobjekte nicht mehr natürlichen Ursprungs, sondern menschengemacht sind? Und was sagt der Fakt, dass diese »Sterne« die Welt umkreisen, über die Stellung aus, die der Mensch im kosmologischen Gefüge behauptet? Gentners Zeichnungen spekulieren über mögliche neue Sternbilder und schlagen Namen für sie vor. Dabei schöpft die Künstlerin aus einem Pool von Namen und Begriffen, die eng mit Personen, Technologien und Rohstoffen verknüpft sind, die bei den aktuellen Vorhaben, das Weltall zu kolonisieren, eine besondere Rolle spielen. In ironischer Weise greift Gentner die kolonialistische Praxis auf, Sternbilder in eroberten Gebieten entsprechend der eigenen kulturellen Prägung umzubenen-

nen. In Sternbildern mit Namen wie Mikroskop, Zirkel oder Pendeluhr manifestiert sich eine unhinterfragte Affirmation des technischen Fortschritts und eine vermeintliche geistige Überlegenheit des Westens.

Während Nkanga und Kiefer in ihren Werken ein holistisches Bild der Welt skizzieren und dazu einladen, die eigene Verortung innerhalb dieses Gefüges zu überdenken, thematisiert Gentner die menschlichen Bemühungen, in immer neue Sphären vorzudringen. Damit ruft sie auch die Überlegungen eines möglichen Exodus von der Erde wach. Dass es sich dabei längst nicht mehr um eine Science-Fiction-Utopie handelt, beweisen die staatlichen und privaten Akteure, die mit Hochdruck daran arbeiten, andere Planeten zu bevölkern. Entgegen politischen Absichten wie dem 1,5-Grad-Ziel oder einer kritischen Auseinandersetzung mit modernen Lebensstandards, setzt sich in den Geschäftsmodellen von Blue Origin, SpaceX oder Virgin Galactic eine Logik der kolonialen Expansion fort, die diesen Planeten an seine Grenzen gebracht hat.

[1] *Anselm Kiefer. Die Holzschnitte*, hrsg. von Antonia Hoerschelmann, Ausst.-Kat. Albertina, Wien, Ostfildern 2016, S. 131.

Cosmos

Sebastian Schneider

The cosmos has fascinated us since time immemorial. What is hidden in the boundless vastness of the universe? What forces do the moon, the stars, and other celestial bodies exert on us? Questions like these have given rise to a wide range of theoretical concepts—cosmologies on which religious teachings, scientific findings, but also pop culture phenomena are based—in all cultures and at all times. In visual art, many works have also resulted from the profound fascination with the cosmos. The artists brought together in this fragment of the exhibition share the fact that they regard the world as a holistic integrated system of interdependencies in which all the components are mutually dependent. A movement takes place in the combination of the works, beginning with Otobong Nkanga's work in the depths of the ocean. It continues from there onto land, where Anselm Kiefer takes a look at the life of plants and their connection to the stars. Outer space itself, to which, besides Kiefer, Eva Gentner also dedicates herself, forms the spatial conclusion.

The large-format tapestry *Unearthed—Twilight* by Otobong Nkanga immediately captivates viewers with its colorfulness and texture. A blue ocean takes up the majority of the picture surface. A small strip in the upper part of the picture, which depicts a coast, stands out from the dominant blue. The blue and green color fields lie on top of one another like sediments. When looking at the picture, one's eyes wander from the depths of the ocean to land. A reddish line extending from the bottom to the top edge guides the viewing direction. Spanning over the painterly color streaks of the warp threads, which undulate at times like maritime currents, is a white net that is pulled over the entire bottom third of the

picture and with which the artist alludes to the human desire to chart the ocean. Somewhat further upward, one discovers body parts, arms and hands, deposited on the seabed. Nkanga is fascinated by the motor skills of the human gripping apparatus. The gestures of touching, digging, and grasping that are depicted symbolize activities involved in the extraction of natural resources. Here, the appendages evince sorted spare parts and reference both the automation of work and also the ruthless wear and tear on humans that industrialization and globalization have brought along with them from the very beginning. They, however, also unmistakably evoke memories of those individuals who have drowned in the Mediterranean, who paid for their search for a new life with their lives. As Europeans, we must ask ourselves whether we want to continue suppressing their stories.

Nkanga's work nevertheless goes far beyond a pessimistic description of a current state. The artist is captivated by the physical law according to which energy cannot be destroyed, since it always merely passes from one bearer to another. Her picture, which is divided into an aquatic and a terrestrial zone, deals with this circulation of energy. Minerals—rendered in the form of small circles—transcend the boundaries that seem to be stipulated by the elements of water and earth and populate the entire picture. They represent material processes and the exchange of energy, which flows into nature and brings forth new forms of life there. The concept of energy transmission enables Nkanga to blur alleged opposites, of water and soil, but also life and death. The fact that one can also be the other is also expressed in the title that she selected for the work: *Twilight*.

Nkanga's metaphysical considerations find a continuation in the work of Anselm Kiefer. His *The Secret Life of Plants for Robert Fludd* consists of various depictions of the firmament, on which the artist applied stellar constellations in the form of plastered branches. With his work, Kiefer references the English mystic and alchemist Robert Fludd (1574–1637), who was one of the most well-known natural philosophers of his time. Fludd argued that every plant on Earth corresponds to a star in the sky. He expanded this theory to include human beings, which he understood as a microcosm and thus as a small copy of the macrocosm. Fludd's analogy of micro- and macrocosm and the resulting considerations on the creation as well as the correlation between earthly and heavenly life stand in contrast to a "decoding of the world

with the aid of geometry and mathematics as represented by Galileo Galilei and René Descartes, for example."[1] Kiefer intensifies the tension between mythical and rational knowledge by naming the stars in his picture based on a nomenclature developed by NASA. He thus addresses the huge significance that has always been given to technology in astronomy. From telescopes to planetariums—the human need to understand outer space has spawned a wide range of apparatuses and buildings intended specifically for them.

Kiefer has occupied himself with one such building in particular for a long time: the historical astronomical observatory in the Indian city of Jaipur, which he has made the motif of many of his works. The work presented at Kunsthalle Mannheim takes up the round architecture of the observatory, but replaces its steps with a ladder that seems to lead directly up to the firmament. As in Nkanga's work, the surface of the picture can be divided up into two zones: into an earthly and a heavenly area, with the latter comprising a majority of the picture surface. The artist has also added notations that come from NASA to the stars here. In the work, the importance of astronomy in the India of the seventeenth century, hence prior to the colonization of the country by the British, is addressed. At the same time, it tells of the fact that astronomy has long since not been solely a field of philosophical activity, but is also closely related to political expansion and ideological power of interpretation.

Eva Gentner also deals with this topic with her drawings in the series *Implementation of Geocentrism*. Starting from the fact that the number of satellites in outer space has increased enormously in the recent past (and will continue to grow), the artist poses the question of how these additional sources of light will affect the night sky. What does it signify for astronomy if its object of study no longer has a natural origin, but is instead man-made? And what does the fact that these "stars" orbit the planet say about the position that human beings claim in the cosmological order of things? Gentner's drawings speculate about possible new stellar constellations and propose names for them. In doing so, the artist draws from a pool of names and terms that are closely associated with individuals, technologies, and raw materials that play a particular role in current plans to colonize outer space. In an ironic way, Gentner thus takes up the colonialist practice of renaming constellations in conquered regions corresponding to one's

own cultural imprinting. An unquestioned affirmation of technical progress and the supposed intellectual superiority of the West is manifested in constellations with names like Microscope, Circle, or Pendulum Clock.

While Nkanga and Kiefer sketch a holistic picture of the world in their works and invite viewers to consider their own personal location within this framework, Gentner addresses the human strivings to penetrate ever-new spheres. She thus also evokes considerations of a possible exodus from Earth. The fact that this has long been more than a science-fiction utopia is shown by the governmental and private actors that are pulling out all the stops in order to populate other planets. Contrary to political intentions, such as the aim of limiting global warming to 1.5 degrees or a critical examination of modern living standards, in the business models of Blue Origin, SpaceX, or Virgin Galactic, there is a continuation of a logic of colonial expansion that has pushed this planet to its limits.

[1] *Anselm Kiefer: The Woodcuts*, ed. Antonia Hoerschelmann, exh. cat. Albertina, Vienna (Ostfildern: Hatje Cantz, 2016), p. 131.

Eva Gentner
AI, CRISPR/Cas9, Deep learning, Robot (aus der Serie /
from the series *Implementation of Geocentrism*), 2021
Filzstift auf historischem Papier / Felt-tip pen on historical paper
34 × 26 cm

EVA GENTNER

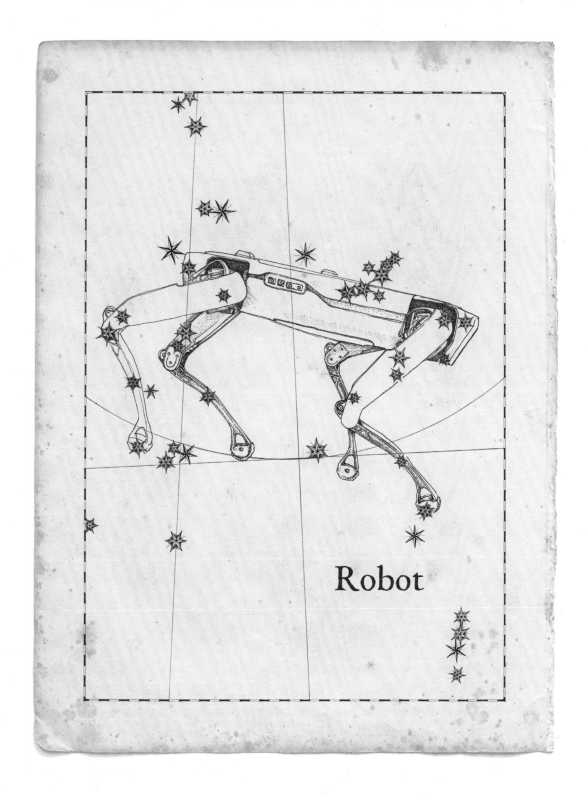

Robot

Anselm Kiefer
Jaipur, 2005
Mischtechnik, Emulsion, Blei auf Leinwand /
Mixed technique, emulsion, lead on canvas
560 × 380 cm
Kunsthalle Mannheim, Kiefer-Sammlung Grothe in der Kunsthalle Mannheim /
Kiefer Collection Grothe at the Kunsthalle Mannheim

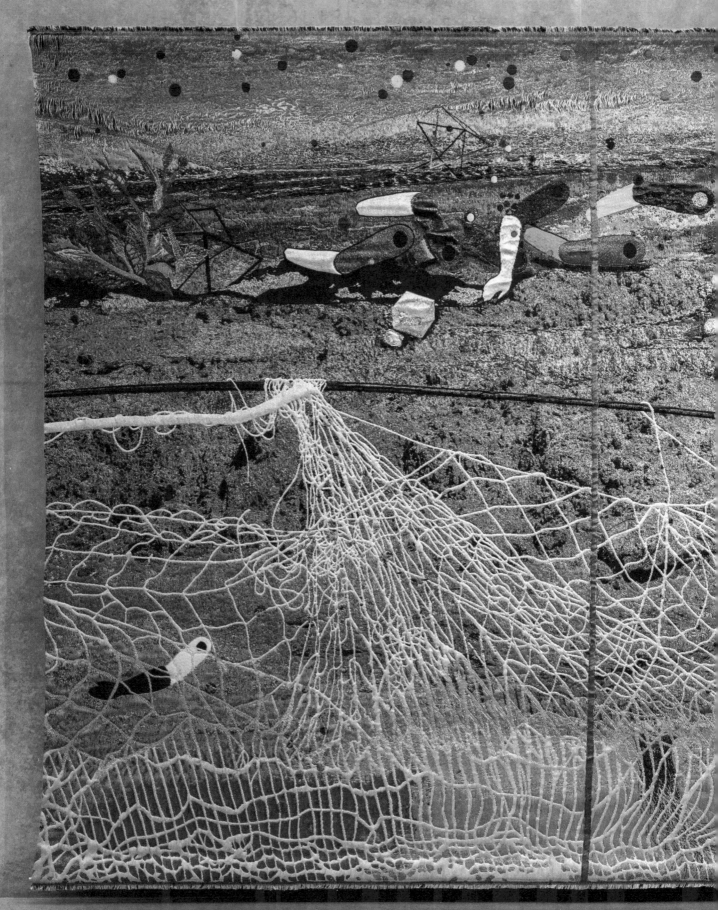

Otobong Nkanga
Unearthed – Twilight, 2021
Tapisserie / Tapestry
350 × 600 cm
Installationsansicht / Installation view Kunsthaus Bregenz

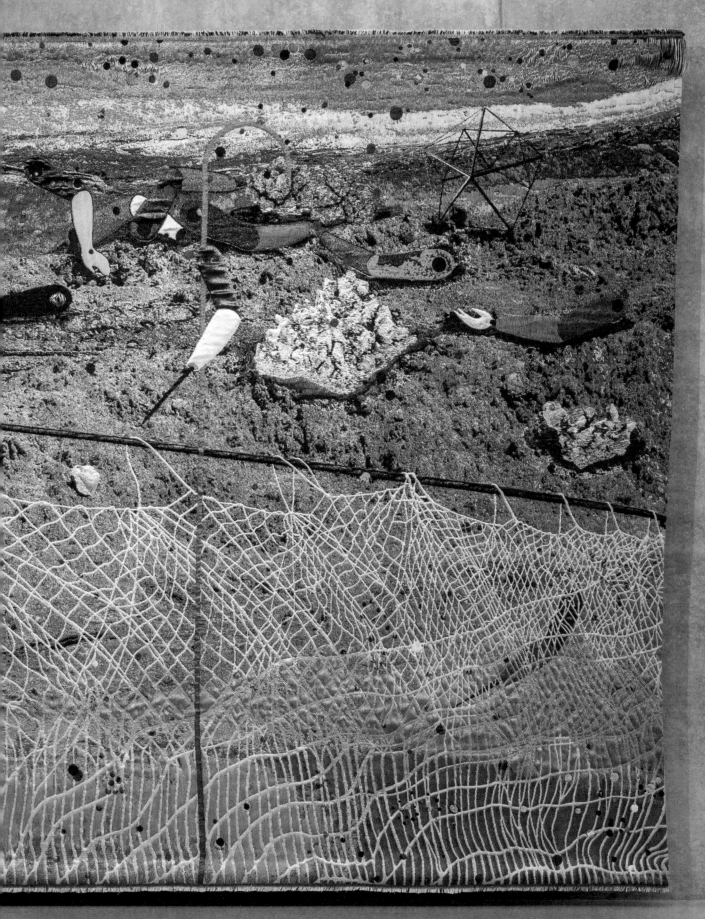

1,5 Grad

6

Natur-Bilder / Pictures of Nature

Inge Herold

Natur-Bilder

Ein Blick in die Sammlung der Kunsthalle Mannheim

Der künstlerische Blick auf die Natur hat sich in den letzten Jahrzehnten drastischer verändert als in den Jahrhunderten zuvor. Die verheerenden Effekte des menschengemachten Klimawandels für Natur und Landschaft fordern viele Künstler*innen zu Bestandsaufnahmen oder kritischen Stellungnahmen heraus. Im 19. Jahrhundert oszillierte das Bild der Landschaft noch zwischen der Darstellung eines arkadischen Idylls einerseits und der einer erhabenen, ehrfurchtgebietenden Landschaft andererseits. Die vom Menschen gestaltete und kultivierte Natur stand der unberührten gegenüber, imaginierte Idealkompositionen sollten bald real Gesehenem weichen. Auch die am Ende des 19. Jahrhunderts einsetzende Industrialisierung und die damit einhergehende Transformation von Natur und Landschaft prägte die Kunst. Die Sammlung der Kunsthalle Mannheim spiegelt all dies wider: Die Exponate reichen von der inhaltlich aufgeladenen stimmungsvollen Malerei der Romantik über die abbildhafte Naturdarstellung des Realismus bis hin zum Interesse der Impressionist*innen an flüchtiger Atmosphäre, an malerischen Momentaufnahmen. Die Sehnsucht nach dem Süden spielt eine ebenso große Rolle wie der Blick auf Naturdetails.

Zahlreiche deutsche Künstler*innen wie etwa Heinrich Bürkel (1802–1869) reisten nach Italien oder ließen sich dort nieder. Sie studierten nicht nur die geschichtsträchtigen Stätten und Relikte der antiken Kultur, sondern suchten auch das Licht und die Farben des Südens, stellten die mediterrane Landschaft als Ort der Sehnsucht dar. Bürkel feiert in seiner *Campagna-Landschaft mit Aquädukt* (1839) das zeitlose Idyll ländlichen Lebens, während die technischen Errungenschaften der römischen Zeit dem Verfall anheimgefallen sind und nur noch als beeindruckende, aber funktionslose Ruinen die Landschaft zergliedern. Ob es sich hier um einen kritischen Kommentar handelt, der das Unbehagen an der Zivilisation formuliert, oder um ein Lamento angesichts des Verfalls einstiger Größe, bleibt offen.

Caspar David Friedrich (1774–1840) wählt in seinem kleinformatigen Gemälde *Abend* (1824), ein Meilenstein romantischer Malerei, einen radikalen Bildausschnitt: Fast die gesamte Leinwand wird vom Farbspiel des abendlichen Himmels eingenommen. Die Erde ist zu

einem schmalen Streifen reduziert. Friedrichs Darstellung stellt einen Bruch mit der Tradition der Landschaftsmalerei dar; den Betrachtenden ist der Boden unter den Füßen entzogen, wodurch eine Verortung in der Natur und der Welt unmöglich wird. Die Grenzenlosigkeit des Abendhimmels lässt Mensch und Erde unbedeutend werden, die Schönheit des Himmels wirkt überwältigend. Nicht zuletzt verbirgt sich in der Darstellung auch eine religiöse Dimension, die sowohl durch die schiere Größe des Himmels als auch durch die Bildperspektive – den nach oben gerichteten Blick – angedeutet wird.

Das Naturverständnis der Impressionist*innen zielt dagegen auf die Entzauberung der romantisch überhöhten Landschaftsdarstellung ihrer Vorgänger*innen. Es sind das Spiel des Lichtes und die Flüchtigkeit des Sinneneindrucks, die sie interessieren, und damit malerische Aspekte sowie atmosphärische Erscheinungen. Dies trifft auch auf das Gemälde *Quai du Pothuis, Pontoise* von Camille Pissarro (1830–1903) zu, das 1868 entstanden ist. Doch schon Pissarro beobachtet auch aufmerksam die allmähliche Veränderung der Landschaft durch die Industrie: In der Mitte der Komposition platziert er einen rauchenden Fabrikschlot.

Auch Eugen Bracht (1842–1921) interessieren malerische Fragestellungen sowie die Industrialisierung, die sich verändernd auf die Landschaft auswirkt. In seinem beinahe apokalyptisch anmutenden Gemälde *Hoeschstahlwerk, Dortmund, Mittagspause* von 1906 türmen sich kolossale Dampf- und Rauchschwaden über einem düsteren Fabrikgelände. Kühltürme und Schornsteine ragen bedrohlich in den Himmel und wirken durch bläulich-violette Lichtreflexe wie magisch erleuchtet. Im Dunkeln bleiben die Arbeiter*innen, die sich schemenhaft zwischen den Ackerfurchen im Vordergrund bewegen. Auch wenn wie bei den französischen Impressionist*innen flüchtige Erscheinungen im Vordergrund stehen, lässt sich das Bild doch auch als Statement lesen, das eindrücklich die Veränderung von Landschaft und menschlichem Dasein vor dem Hintergrund veränderter Produktions- und Arbeitsbedingungen konstatiert.

Edvard Munch (1863–1944) dagegen nutzt Natur und Landschaft zur symbolischen Darstellung psychischer Extremzustände. Er zeigt in seinem 1900/01 entstandenen Gemälde *Aussicht von Nordstrand* einen Blick auf den Oslofjord in Norwegen. Ihn interessiert nicht die getreue Naturdarstellung, sondern die Visualisierung eines emotionalen Erlebnisses, erzeugt durch abstrahierende Vereinfachung. So nimmt die größere der beiden Inseln am oberen Bildrand, die im nachtblauen Himmel schweben, die Form eines geschlossenen Mundes ein. Der kleine Wanderer auf der Uferstraße

wirft einen langen Schatten und wird optisch von dunklen Natur-
formen und Schatten bedrängt – sie geben der Darstellung einen
bedrohlichen Charakter. Zwei weitere formale Besonderheiten stellen
die Perspektive von weit oben herab sowie die Horizontlosigkeit dar:
Der Platz des Menschen in der Welt ist gefährdet, die Natur scheint
dem Einsamen keinen Schutz zu bieten.

Auch der Schweizer Ferdinand Hodler (1853–1918) lädt seine
Motive symbolisch auf, doch vertritt er ein positiveres Naturverständ-
nis. In seinem Gemälde *Lied in der Ferne* (1904/05) feiert er den Ein-
klang des Menschen mit der Natur, im wahrsten Sinne des Wortes,
wie der Titel bestätigt. Die gefühlsbetonte Pose der Frau untermauert
dies, sie deutet, den Kopf wie lauschend zurückgelegt, mit den Hän-
den auf ihr Herz und visualisiert damit in Haltung und Gewandung die
Verbundenheit des Menschen mit der Natur – das Grün ihres Klei-
des knüpft die Verbindung zur Landschaft. Während Hodler in seinen
menschenleeren, auf Distanz angelegten Darstellungen der Schweizer
Bergwelt die Natur selbst zum Stimmungsträger macht, übernimmt in
diesem symbolistischen Gemälde die Figur diese Funktion: zwischen
Sehnsucht, Hoffnung und Verlangen.

Während Ernst Ludwig Kirchner (1880–1938) als Mitglied der
Dresdner Künstlervereinigung Brücke mit seinen Großstadtszenen
der frühen 1910er-Jahre das moderne Bild der Metropole Berlin fest-
hielt, wird wenig später die unberührte Landschaft für ihn zur Rettung
und künstlerisch zum Mittel, um Emotionen zu visualisieren. Noch
während des Ersten Weltkriegs flieht er krank und morphiumsüchtig
vor dem Soldatenleben in die Schweiz. Viele seiner dort entstande-
nen Landschaftsbilder zeigen, dass er in der Natur einen Ruhepunkt
suchte. In dem Gemälde *Bergbach* (1919/20) hielt er die Schweizer
Alpenwelt in expressiven, kräftigen Farben fest. Die schroffen blau-
violetten Felsen und die expressive, fast ekstatische Pinselführung
scheinen seine eigene innere Erregung zu spiegeln.

Ganz kühl dagegen geben sich die Maler*innen der Neuen
Sachlichkeit in ihrer nüchternen Darstellung der Umwelt. So schildert
etwa der Mannheimer Eugen Knaus (1900–1976) die Veränderung
der Stadtlandschaft durch die zunehmende Mobilität. In einer dynami-
schen Komposition zeigt er in seinem 1929 entstandenen Gemälde
den Blick von oben herab auf die Rheinbrückenauffahrt, die das Grün
der dicht stehenden Bäume durchschneidet.

Seine *Ansicht von Grötzingen bei Durlach* gestaltet Georg
Scholz (1890–1945) im Jahr 1925 ähnlich einer Miniatur- oder Spiel-
zeuglandschaft, die sich wie ein Panorama der altniederländischen
Landschaftsmalerei vor den Augen eines Betrachtenden ausbreitet.

Die grüne, sonnenbeschienene Topografie ist von kleinen Häusern besiedelt. Unten im Tal macht sich, im Schatten liegend, die Industrie breit und beginnt die Landschaft zu verändern. Scholz stellt es uns frei, ob wir das Aufeinandertreffen von Idylle und Industrie kritisch oder gelassen auslegen.

In den 1950er-Jahren wird die realistische Malerei abgelöst von der Abstraktion. Eine neue, von Zwängen befreite Weltanschauung schlägt sich nun in einer formlosen, spontanen, zum Teil aggressiv und gestisch gesetzten Malweise nieder, die inhaltlich und formal der Entwurzelung des Menschen und den Zerstörungen durch den Krieg entspricht, oft aber auch auf die neuesten Errungenschaften der Naturwissenschaft und Technik bezogen wird. Die Atomphysik hatte erstmals ihre verheerenden Kräfte für Natur und Mensch offenbart. So stellen etliche Künstler*innen einerseits die Fortschritte dar, andererseits aber auch das Potenzial der Gefährdung. Winfred Gaul (1928–2003) etwa visualisiert in seinem 1956/57 entstandenen Gemälde *Pracht der Zerstörung* die Faszination des Destruktiven.

Die Auseinandersetzung mit unserer Umwelt gipfelt in den 1970er-Jahren in der Land Art. Künstler*innen arbeiten jetzt direkt in der Landschaft mit dem dort vorgefundenen Material und transformieren es. Richard Long arrangiert in *Spring Circle* von 1991 unterschiedlich große, auf einer Wanderung durch die französische Champagne gefundene Kalksteine zu einem Ring mit mehr als fünf Metern Durchmesser. Während er in anderen Werken die Veränderungen und Spuren festhält, die seine Wanderungen hinterlassen, verwendet er hier Bruchstücke der Landschaft selbst, die zu Erinnerungsstücken werden. Auf diese Weise findet Long einen neuen Ausdruck für die uralte Beziehung zwischen Kunst und Natur in der archaischen Urform des Kreises.

Mario Merz (1925–2003), Vertreter der italienischen Arte povera, dagegen geht es um die existenzielle Frage des Wohnens. In seinen Iglus beschwört er schon ab den späten 1960er-Jahren die Bedeutung und Qualität unseres immer fragiler werdenden Lebensraums. Ähnlich poetisch, aber auch gefährdet wirken die sogenannten Reishäuser von Wolfgang Laib, in denen er das Haus als Urform menschlicher Behausung mit dem Reis als elementarem Grundnahrungsmittel kombiniert.

Pictures of Nature: A Look at the Collection of the Kunsthalle Mannheim

Inge Herold

The artistic view of nature has changed more drastically in the past few decades than in previous centuries. The devastating effects of man-made climate change for nature and landscape have prompted many artists to take stock or express themselves critically. In the nineteenth century, the picture of the landscape still oscillated between the depiction of an arcadian idyll on the one hand and a sublime, awe-inspiring landscape on the other. The nature designed and cultivated by people was juxtaposed with an unspoiled landscape; imagined ideal compositions would soon give way to what could actually be seen. At the end of the nineteenth century, emerging industrialization and the related transformation of nature and landscape also influenced art. The Collection of the Kunsthalle Mannheim reflects all of this: the exhibits range from the atmospheric, content-laden painting of Romanticism to realism's nearly true-to-life representation of nature to the Impressionists' interest in fleeting atmospheres, in painterly snapshots. The yearning for the south played just as large a role as the examination of details of nature.

Numerous German artists, including, for instance, Heinrich Bürkel (1802–1869), traveled to Italy or settled down there. They not only studied places steeped in history and relics of the culture of antiquity, but also sought the light and colors of the south, and rendered the Mediterranean landscape as a place of longing. In his *Campagna-Landschaft mit Aquädukt* (Aqueduct in the Roman Campagna, 1839), Bürkel celebrated the timeless idyll of rural life, while the technical achievements of the Roman era have deteriorated and only still bisect the landscape as impressive, but functionless ruins. The question of whether this was intended as a critical commentary formulating a malaise

in society or as a lament about the decline of past greatness remains open.

In his small-format painting *Abend* (Evening, 1824), a milestone of Romantic painting, Caspar David Friedrich (1774–1840) selected a radical picture detail: nearly the entire canvas is taken up by the colorful spectacle of the evening sky, with the earth reduced to a narrow strip. Friedrich's picture represents a break with the tradition of landscape painting: the ground has been pulled out from under the feet of viewers, thus making it impossible to situate oneself in nature and the world. The boundlessness of the evening sky makes human beings and the earth insignificant; the beauty of the heavens seems overwhelming. A religious dimension is also concealed in the picture, indicated by both the sheer vastness of the sky and the perspective of the image— the gaze directed upward.

The Impressionists' understanding of nature, in contrast, aimed at demystifying the romantically superelevated depiction of the landscape of their predecessors. What interested them were the play of light and the fleetingness of sensory impressions, and thus painterly aspects and atmospheric phenomena. This also applies to the case of the painting *Quai du Pothuis, Pontoise* by Camille Pissarro (1830–1903), which was produced in 1868. But Pissarro also already attentively observed the gradual change in the landscape brought by industry: in the center of the composition, he positioned a smoking factory chimney.

Eugen Bracht (1842–1921) was also interested in painterly questions as well as industrialization, which was having a transformational effect on the landscape. In his almost apocalyptic-seeming painting *Hoeschstahlwerk, Dortmund, Mittagspause* (Hoesch Steel Works, Dortmund, Lunch Break, 1906), colossal clouds of steam and smoke tower above a bleak factory landscape. Cooling towers and smokestacks rise threateningly into the sky and seem to be magically illuminated as a result of bluish-violet light reflections. The workers moving schematically between the furrows in the foreground remain in darkness. Fleeting phenomena are in the foreground as in the work of the French Impressionists, though the picture can nonetheless also be read as a statement that magnificently situates the alteration of the landscape and human existence against the backdrop of changed production and working conditions.

Edvard Munch (1863–1944), on the other hand, used nature and landscape to represent extreme psychological states symbolically.

162

In his painting painting *Utsikt fra Nordstrand* (View from Nordstrand) produced in 1900–01, he shows a view of the Oslofjord in Norway. What interested him was not depicting nature faithfully, but instead visualizing an emotional experience, rendered by means of abstracted simplification. The larger of the two islands floating in the midnight blue sky on the upper edge of the picture takes the form of a closed mouth. The smaller wanderer on the coast road casts a long shadow and is harried visually by dark natural forms and shadows—they are what gives the picture a threatening character. Two other formal features are the perspective downward from far above and the lack of a horizon: the place of people in the world is in danger, and nature seems to offer no protection to the forlorn.

The Swiss artist Ferdinand Hodler (1853–1918) also charged his motifs symbolically, but presents a more positive understanding of nature. In his painting *Lied in der Ferne* (The Song from Far Away, 1904–05), he celebrates people's harmony with nature, in the truest sense of the word, as confirmed by the title. The woman's emotive pose underscores this: with her head leaned back as if listening and her hands on her heart, she indicates and thus visualizes, in both pose and garb, the connection between human beings and nature—the green of her dress establishes the link to the landscape. While Hodler made nature itself a bearer of atmosphere in his deserted depictions of the Swiss mountain world from a distance, in this symbolic painting, the figure takes on this function: between yearning, hope, and desire.

Though Ernst Ludwig Kirchner (1880–1938), as a member of the Dresden-based artists' group Brücke, recorded the modern image of the metropolis Berlin with his big city scenes of the early 1910s, a few years later, the unspoiled landscape became his salvation and an artistic means for visualizing emotions. During World War I, ill and addicted to morphine, he left army life and traveled to Switzerland. Many of the landscape pictures that he produced there show that he was looking for a restful place in nature. In the painting *Bergbach* (Mountain Brook, 1919–20), he captured the Swiss alpine world in bold, expressive colors. The jagged, bluish-violet rocks and the expressive, almost ecstatic brushwork seem to reflect his own inner excitement.

The painters of New Objectivity, by contrast, present themselves quite coolly in their sober depiction of the environment. The Mannheim-born Eugen Knaus (1900–1976) portrays the transformation of the cityscape resulting from increasing mobility. In one dynamic composition, a painting made in 1929, he shows a view from above of the approach to the Rhine Bridge, transected by the green of the densely standing trees.

Georg Scholz (1890–1945) designed his *Ansicht von Grötzingen bei Durlach* (View from Grötzingen, near Durlach) of 1925 resembling a miniature or toy landscape, which spreads out before the eyes of viewers like a panorama of early Dutch landscape painting. The green, sunlit topography is populated by small houses. Below in the valley, industry, lying in shadow, spreads and begins changing the landscape. Scholz leaves it up to us whether we interpret the coming together of idyll and industry in a critical or serene manner.

In the 1950s, realistic painting was supplanted by abstraction. A new view of the world freed of constraints was now reflected in a formless, spontaneous, in part aggressive, and gestural painting style that corresponded in form and content to the uprooting of people and the destruction caused by the war, but in which reference was also often made to the newest achievements in the natural sciences and technology. Nuclear physics had revealed its devastating power for nature and people for the first time. Quite a few artists thus depicted progress on the one hand and the potential for danger on the other. Winfred Gaul (1928–2003), for instance, visualized the fascination with the destructive in his painting *Pracht der Zerstörung* (The Glory of Destruction), created in 1956–57.

The examination of our environment culminated in the 1970s in Land Art. Artists now worked directly in the landscape with the material found there and transformed it. In *Spring Circle* of 1991, Richard Long arranged limestones of various sizes found on a hike through the Champagne region of France to create a ring with a diameter of more than five meters. While he preserved the changes and traces left behind by his hikes in other works, here he made use of fragments of the landscape itself, which became mementoes. In this way, Long found new expression for the age-old relationship between art and nature in the archaic, primeval form of the circle.

Mario Merz (1925–2003), a representative of Italian Arte Povera, on the other hand, was interested in the existential question of habitation. In his igloos, he already began evoking the importance and quality of our increasingly fragile living environment in the late 1960s. The rice houses of Wolfgang Laib, in which he combines the house as basic form of human dwelling with rice as a fundamental basic foodstuff, seem similarly poetic, but also at risk.

CASPAR DAVID FRIEDRICH

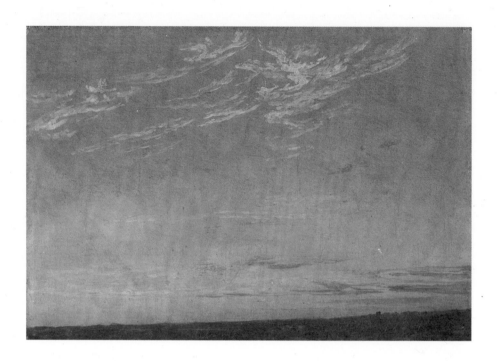

Caspar David Friedrich
Abend / Evening, 1824
Öl auf Leinwand auf Hartfaserplatte / Oil on canvas and hardboard
20 × 27,5 cm
Kunsthalle Mannheim

1,5 Grad

HEINRICH BÜRKEL

Heinrich Bürkel
Campagna-Landschaft mit Aquädukt /
Aqueduct in the Roman Campagna, 1839
Öl auf Leinwand / Oil on canvas
58 × 87 cm
Kunsthalle Mannheim

EUGEN BRACHT

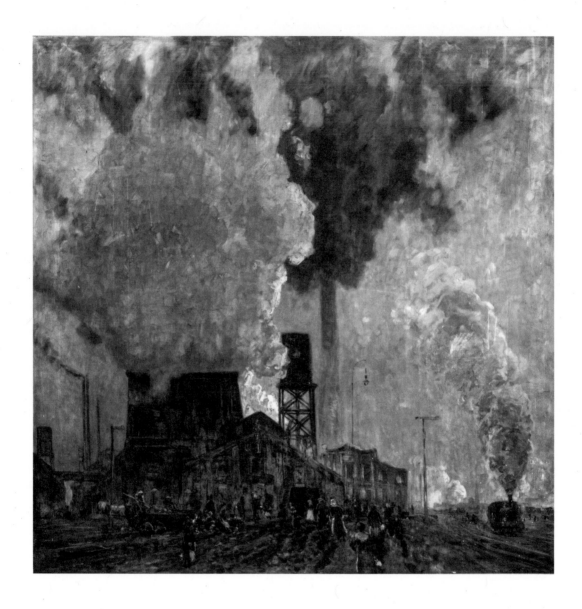

Eugen Knaus
Rheinbrückenaufgang / Rhine Bridge Appróach, 1929
Öl auf Leinwand / Oil on canvas
70 × 85 cm
Kunsthalle Mannheim

Eugen Bracht
Hoeschstahlwerk, Dortmund, Mittagspause /
Hoesch Steel Works, Dortmund, Lunch Break, 1906
Öl auf Leinwand / Oil on canvas
138 × 138 cm
Kunsthalle Mannheim

Georg Scholz
Ansicht von Grötzingen bei Durlach / View from Grötzingen, near Durlach, 1925
Öl und Tempera auf Holzpappe / Oil and tempera on pulpboard
70 × 100 cm
Kunsthalle Mannheim

EUGEN KNAUS GEORG SCHOLZ

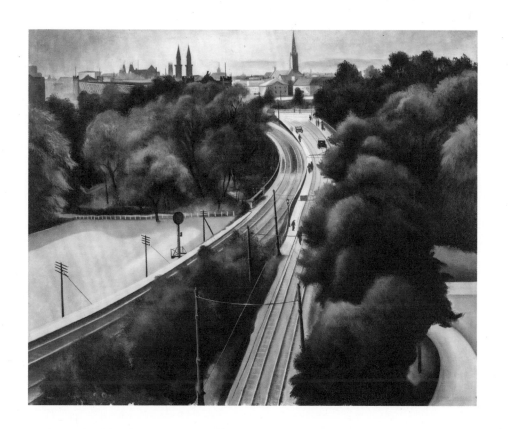

EDVARD MUNCH

Edvard Munch
Utsikt fra Nordstrand / Aussicht von Nordstrand /
View from Nordstrand, 1900/01
Öl auf Leinwand / Oil on Canvas
71,5 × 100 cm
Kunsthalle Mannheim

1,5 Grad

FERDINAND HODLER

Ferdinand Hodler
Lied in der Ferne / The Song from Far Away, 1904/05
Öl auf Leinwand / Oil on canvas
91 × 72 cm
Kunsthalle Mannheim

ERNST LUDWIG KIRCHNER

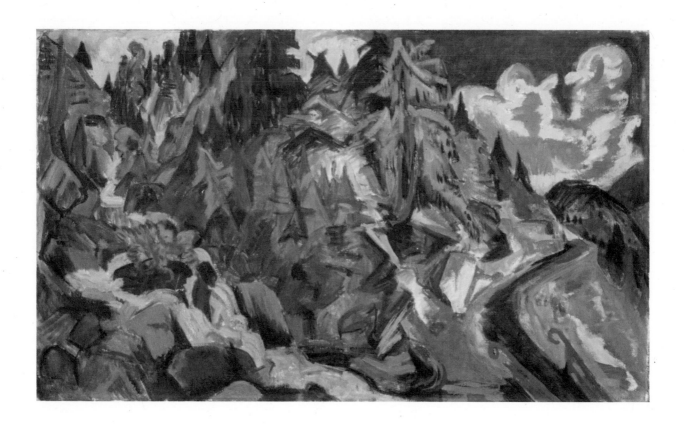

Ernst Ludwig Kirchner
Bergbach / Mountain Brook, 1919/20
Öl auf Leinwand / Oil on canvas
91 × 152 cm
Kunsthalle Mannheim

WINFRED GAUL

Winfred Gaul
Pracht der Zerstörung / The Glory of Destruction, 1956/57
Öl auf Hartfaserplatte / Oil on hardboard
97,7 × 146,8 cm
Kunsthalle Mannheim

WOLFGANG LAIB

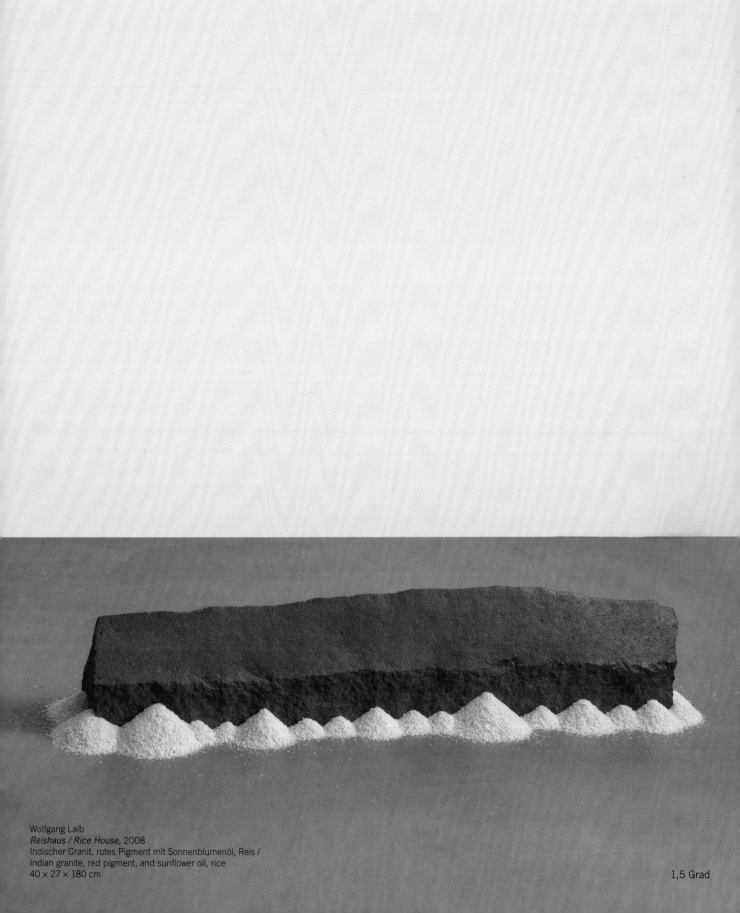

Wolfgang Laib
Reishaus / Rice House, 2008
Indischer Granit, rotes Pigment mit Sonnenblumenöl, Reis /
Indian granite, red pigment, and sunflower oil, rice
40 × 27 × 180 cm

1,5 Grad

RICHARD LONG

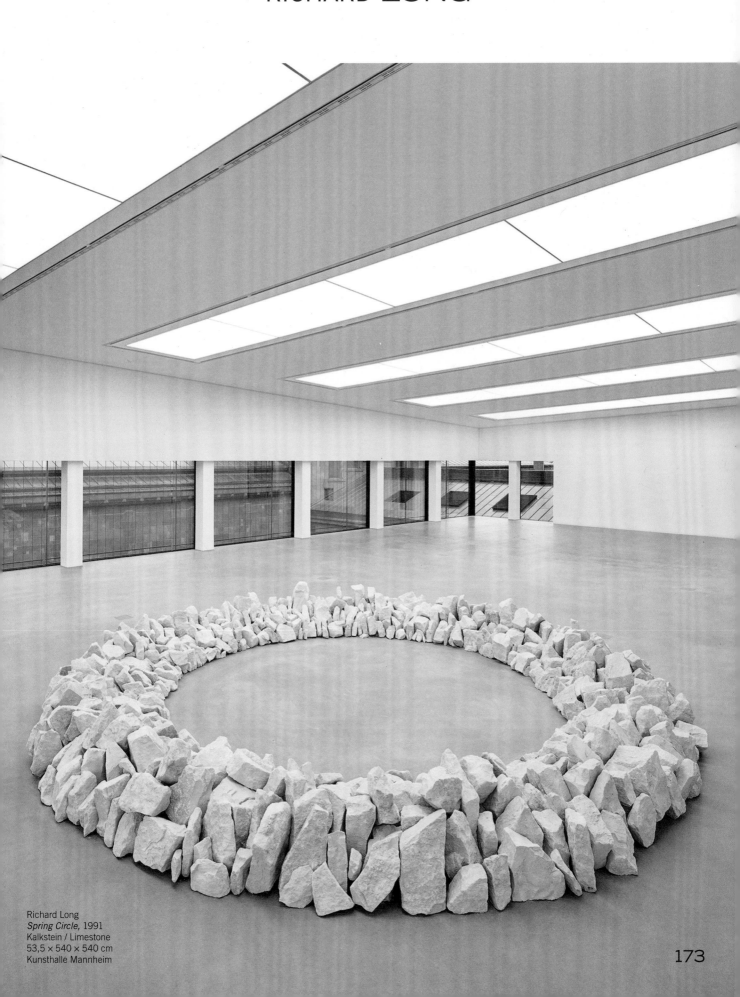

Richard Long
Spring Circle, 1991
Kalkstein / Limestone
53,5 × 540 × 540 cm
Kunsthalle Mannheim

Das Insekt / The Insect

Das Insekt – zu Darstellung in (Zeichen-)Kunst und Wissenschaft

Thomas Köllhofer

Von der Urgeschichte bis ins 19. Jahrhundert

Insekten werden schon in den frühesten, künstlerisch oder rituell gedachten bildlichen Zeichnungen wiedergegeben. Bei der ältesten bekannten Darstellung eines Käfers handelt es sich um einen kleinen, circa 25.000–30.000 Jahre alten, aus Kohle geformten Käfer. Etwas jünger ist die Ritzzeichnung eines Käfers auf einem Knochen, die etwa vor 20.000 Jahren entstand.[1] Zur kulturellen oder rituellen Bedeutung dieser frühen Darstellungen gibt es unterschiedliche Interpretationen. Bei plastischen Objekten geht man davon aus, dass sie schmuckhaft oder als Amulett getragen wurden. Wie es scheint, ist Insekten von Anfang an eine besondere Bedeutung zugekommen. Unter den aufgefundenen ältesten dokumentierten Käfertypen befinden sich auch Marienkäfer, die nach dem *Grimm'schen Wörterbuch* in deutschen Dialekten als »Gotteskühlein, Gotteskalb, Herrgottskalb, Herrgottstierchen, Herrgottsvöglein, Marienvöglein, Marienkäfer, Marienkälbchen« benannt werden.[2]

Für das Alte Ägypten ist die Bedeutung insbesondere von Skarabäen überliefert, die sich vom Bild der sogenannten Pillendreher ableitet. Dieser Käfer wurde als Glücksbringer, zeitweise auch als heilig verehrt. Da der Skarabäus Dung in fruchtbare Erde verwandelt und ihn dabei zu Kugeln – im übertragenen Sinn zu Erdkugeln – dreht, galt er als Symbol für Wiedergeburt und Metamorphose. Der ägyptische Sonnengott Harmachis wurde zum Zeitpunkt der Morgensonne als Chepre, das heißt als der, »der von selbst entstanden ist«, angesprochen. Als solcher wurde er mit dem Kopf des Pillendrehers dargestellt, da dieser für den täglichen Sonnenaufgang steht. Doch nicht nur Skarabäen, auch Bienen, Fliegen, Tausendfüßler und Skorpione finden sich auf Darstellungen im Alten Ägypten und wurden als heilig verehrt. Allerdings existierten zugleich handfeste Anweisungen, wie man einige dieser mitunter massive Schäden verursachenden Tiere bekämpfen konnte.[3] Von den Azteken weiß man, dass unter anderem Heuschrecken, Grillen, Ameiseneier oder Schmetterlingslarven als Eiweißlieferanten regelmäßig auf der Speisekarte standen.

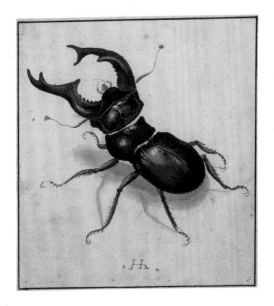

Abb. / Fig. 1
Hans Hoffmann
nach / after Albrecht Dürer
*Ein Hirschkäfer, nach Dürer /
A Stag Beetle after Dürer,*
ca. 1570–1580
Pinsel mit Wasserfarben, mit
schwarzer Einfassungslinie /
Brush with watercolor, with
black framing line
11,4 × 10,3 cm
Kupferstichkabinett, Berlin

Entsprechend häufig wurden sie etwa auf Gefäßen oder Schmuck abgebildet. In Europa ist insbesondere die Honigbiene seit 5.000 v. u. Z. als Nutztier und vielfacher Symbolträger bekannt.

Die nachweislich erste wissenschaftliche Auseinandersetzung mit Insekten findet sich bei Aristoteles (384–322 v. u. Z.), der als der Begründer der Entomologie (Insektenforschung) gilt. Erstmals wurden unzählige Tiere genauestens beobachtet und beschrieben. Die noch heute gültigen Ordnungen erkennen wir in ihren Hauptzügen bereits in den von Aristoteles unterschiedenen Gruppen: den geflügelten Insekten (pterotá) mit den Scheidenflüglern (coleoptera), den Nacktflüglern (anélytra), den Zweiflüglern (diptéra) und den Vierflüglern (tetraptéra), von denen er die flügellosen Insekten (áptera) unterschied.[4] Aristoteles' systematisierende Erfassung auf Grundlage einer detaillierten Beschreibung von Körperaufbau und Beschaffenheit hat bis heute ihre Gültigkeit ebenso wenig verloren wie die von ihm beschriebenen wesentlichen Merkmale der Insekten.

Aus dem christlichen, auf ein Leben nach dem Tod hin ausgerichteten Mittelalter sind in dieser Hinsicht nur wenige neue Beobachtungen bekannt. Nur vereinzelt wurden Flora und Fauna thematisiert, wie beispielsweise von dem Benediktinermönch Albertus Magnus (1200–1280), der in seinem Werk *De animalibus* die antiken Beobachtungen des Aristoteles mit

religiösen Anschauungen seiner Zeit zu unterlegen suchte.

In der sich das Diesseits aneignenden Renaissance wächst das Bedürfnis, die Welt naturgetreu darzustellen. Mit der Entdeckung Amerikas weitet sich der Blick auf eine ungeheure Arten- und Erscheinungsvielfalt gerade auch im Reich der Insekten. Das neu erwachte Interesse an der Wirklichkeit zeigt sich auch in Albrecht Dürers (1471–1528) überaus naturgetreuen Studien von Insekten, die aus der direkten Anschauung lebender oder toter Exemplare entstanden sind. Der Hirschkäfer, den Dürer maßstabsgenau zeichnete (Abb. 1), scheint Georg (Joris) Hoefnagel (1542–1600) fast ein Jahrhundert später zu seiner Darstellung eines Hirschkäfers inspiriert zu haben. Von Dürer stammt auch der Leitsatz, der diese Ausstellung zu Darstellungen von Insekten in Kunst und Wissenschaft überspannt: »Dann warhafftig steckt die kunst in der natur, wer sie herauß kan reyssen der hat sie.«[5] Dabei meint »reyssen«, um aus der Einleitung zu *Maria Sibylla Merian und die Tradition des Blumenbildes* zu zitieren: »Zeichnen und mehr noch zeichnerisches Erkennen und künstlerische Aneignung der natürlichen Form«; wobei zu betonen ist, »dass sich dieses Verhältnis von Natur zur Kunst nicht von selbst einstellt: Nur der hat Erfolg, der versteht, die Kunst aus der Natur zu extrahieren und diese Erkenntnis zeichnerisch umzusetzen. Erkennen wiederum schließt über die gestaltete Beobachtung hinaus die Möglichkeit der Systematisierung, ja sogar der Idealisierung ein.«[6] Was Aristoteles mit Worten benennt, klassifiziert und ordnet, beschreibt Dürer auf einer darstellenden Ebene als notwendige Voraussetzung für erforschendes Verstehen und für Erkenntnis.

Wie groß das Interesse an derartigen künstlerisch-wissenschaftlichen, eingehendes Naturstudium voraussetzenden Darstellungen im ausgehenden 16. und frühen 17. Jahrhundert war, lässt sich an zwei Beispielen deutlich ablesen. Im letzten Quartal des ausgehenden 16. Jahrhunderts schuf Georg Hoefnagel ein Kompendium von miniaturhaften Tierdarstellungen, die er den vier Elementen zuordnet. Dabei fallen vor allem die Insekten, die dem Lebensraum des Feuers zugeordnet werden, mit

überzeugend naturnahen Darstellungen ins Auge. 1592 veröffentlichte Hoefnagel im Selbstverlag eine Auswahl seiner Tierdarstellungen – darunter insbesondere nach der Natur gezeichnete Insekten –, um sie in der preiswerten Form der Radierung einem breiten Publikum zugänglich zu machen.[7]

Zehn Jahre später erschien *De Animalibus Insectis libri VII* von Ulise Aldronadi (1522–1605) als erste Publikation, die sich ausschließlich Insekten widmet. Das umfangreiche entomologische Überblickswerk ist mit zahlreichen Holzschnitten illustriert und veranschaulicht erstmals die verschiedenen Arten gegliedert nach Lebensweise und Körperbau. Dass dieses Buch erfolgreich als Raubkopie vertrieben werden konnte, lässt ahnen, dass ein beträchtliches Interesse an dieser Thematik vorhanden gewesen sein muss.

Besondere Berühmtheit erlangte im 17. Jahrhundert Maria Sibylla Merian (1647–1717), die Insekten, speziell Schmetterlinge, nicht nur beobachtete, sondern auch züchtete, nachdem sie entdeckt hatte, dass sich unterschiedliche Raupen jeweils von bestimmten Pflanzen ernähren. Durch ihre Züchtungen konnte sie alle Entwicklungsstadien von der Raupe über die Puppe zum Schmetterling eingehend studieren, um diese zeitlich aufeinanderfolgenden Stadien dann in einer einzigen Darstellung zusammenzufassen. Die Schmetterlinge wurden zudem in ihren Entwicklungsstadien nicht nur dokumentiert, sondern auch mit optisch oft unscheinbaren, tatsächlich jedoch zugehörigen Nahrungspflanzen kombiniert (Abb. 2). Selbstbewusst gelang es Merian damit, sich als Frau in einer von Männern beherrschten Domäne der Malerei zu behaupten und zugleich wissenschaftliches Neuland zu betreten, das sie künstlerisch innovativ präsentierte.[8]

Vergleichbar erfolgreich wurde Barbara Regina Dietzsch (1706–1783). Sie schuf auf akribischer Beobachtung und Wiedergabe basierende Blumenstillleben, in denen – allerdings mehr als dekorative Staffage denn als wissenschaftliche Darstellung – die unterschiedlichsten Insekten eingefügt sind. Ausgesprochen dekorativ waren diese Bilder, die konstanten Kompositionsschemata folgten, außerordentlich wirkstark und auch international gefragt.

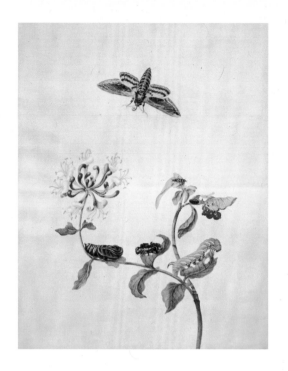

Abb. / Fig. 2
Maria Sibylla Merian
*Waldgeißblatt, Ligusterschwärmer, Raupenfliege /
Forest Honeysuckle, Privet
Hawk Moth, Caterpillar Fly,*
nach / after 1705
Aquarell, Deckfarbe /
Watercolor, opaque color
38 × 30,7 cm

Insekten in der Kunst des 20. und 21. Jahrhunderts

Von der Renaissance bis ins späte 19. Jahrhundert hatten Künstler*innen große Mühe darauf verwendet, Insekten in Auf- und Seitenansicht als dreidimensionale Erscheinungen einzufangen und möglichst anschaulich-lebendig mit allen Details – einen Schatten werfend, fliegend oder auf allen sechs Beinen stehend – darzustellen. Im 20. Jahrhundert tauchen dagegen vermehrt Bilder von toten Insekten auf. Zuvor gehörten Insekten, vor allem Fliegen, aber auch Käfer und andere Krabbeltiere, selbst Maden, als lebendiger Bestandteil zum Memento mori, also zum bildimmanenten Verweis auf die menschliche Sterblichkeit, auf die Vergänglichkeit alles Irdischen schlechthin. Hier verkörpern Insekten als potenzielle Schädlinge die aktive Zerstörung von Schönheit, Werk und Leben. Im 20. Jahrhundert jedoch werden Insekten zunehmend vom aktiv zerstörenden Getier zum Opfer von Zerstörung. Der Tod wird nicht länger mit ihnen sinnbildlich vor Augen geführt, sondern im toten Insekt zum ungeschönten bloßen Faktum.

Et les papillons se mettent à chanter heißt ein Blatt von Max Ernst (1891–1976) aus seinem Collagenroman *La femme 100 têtes* (1929), dessen phonetisch

vieldeutiger Titel als die 100-köpfige, kopflose, starrsinnige oder blutsaugende Frau zu lesen ist. Ernst lässt hier eine surreale Szene entstehen, in deren Vordergrund zahlreiche Motten und andere Insekten – vom hellen Licht angezogen – eine Gaslaterne umflattern. Der Titel insinuiert das Geräusch wiederholt gegen das Laternenglas prallender oder sich in der Flamme versengender Insekten. In einer katakombengleichen bogigen Hintergrundarchitektur stehen zahlreiche Skelette, die, ihrer Beute gewissen Sensenmännern gleich, neugierig auf das hoffnungslose Treiben um die Gaslaterne schauen.

Während bei Max Ernst todgeweihte Insekten die Laterne zumindest noch umschwirren, liegen bei Horst Janssen (1929–1995) verendete Flügelwesen auf dem Rücken, strecken ihre Gliederbeine in die Luft und sind bisweilen schon Teil des Verfallsprozesses. Nicht länger Vanitassymbol, vermag der mahnende Verweis auf die Vergänglichkeit des Irdischen keinen Ausblick mehr auf Seelenrettung und ein anderes, himmlisches Leben nach dem Tode eröffnen. Diese Insekten müssen vielmehr als Bild des endgültigen, gnaden- und damit hoffnungslosen Totseins verstanden werden. In den Darstellungen Janssens kommt eine psychologische Komponente zum Tragen, die im 20. Jahrhundert zunehmend an Bedeutung gewinnt – das Bewusstsein kreatürlicher, schutz- und hilflos ausgelieferter, vereinzelter Existenz, die sich vielfach in der Auseinandersetzung, gewissermaßen auch der Identifikation gerade mit Insektenhaftem niederschlägt.

Wenn in *Zu Don Quijote* (2000) von Thomas Löhning der Ritter von der traurigen Gestalt begleitet von Sancho Panza in selbst gebastelter Rüstung einem ungeheuerlichen Insekt entgegenreitet, so liegt das Unbehagen der Betrachter*innen in der Ungewissheit, ob dieses Tier tot ist oder ob es sich im nächsten Augenblick bewegt, um das mutige, aber doch lächerliche Gegenüber mit einem Happs einfach aufzufressen. Das Insekt ist uneindeutig zwischen gestrandetem Ungeheuer und angriffsfähigem Gegenüber gezeigt. Um ein Vielfaches größer als in Jonathan Swifts *Gullivers Reisen*, wo Fliegen so groß wie Haubenlerchen und Wespen so groß wie

Rebhühner dem Helden begegnen, verkörpert das gigantische Insekt bei Löhning die Natur selbst, mit der es der winzige Mensch in seiner Hybris aufnehmen will.

Seit dem frühen 20. Jahrhundert werden insbesondere Insekten herangezogen, wenn menschliche Ängste eine Projektionsfläche suchen. Sei es der Käfer, in den sich Gregor Samsa in *Die Verwandlung* von Franz Kafka verwandelt, seien es die fliegenden Heuschrecken auf einer Zeichnung Alfred Kubins, die den Menschen wie Kampfflieger jagen, oder sei es der Horrorfilm *The Fly (Die Fliege)* von Kurt Neumann, in dem sich ein Mensch durch eine versehentliche DNA-Vermischung in ein Mischwesen aus Insekt und Mensch verwandelt.[9]

Obgleich das Verhältnis zwischen Menschen und Insekten eine vielfach angstgrundierte Fremdheit kennzeichnet, beginnt spätestens mit den Fabeln von Jean de La Fontaine die anthropomorphe Darstellung von Insekten. So wird beispielsweise in *La cigalle et la formie (Die Grille und die Ameise)* das neutestamentliche Gleichnis von den klugen und den törichten Jungfrauen in eine moralisierende Tierfabel übersetzt: Die fleißig für den Winter vorsorgende Ameise steht der Grille gegenüber, die sich scheinbar nutzlosem Gesang hingibt und ihr der Schönheit zugewandtes Tun unter dem Spott der Ameise mit dem Tod bezahlt. Unter einem ganz anderen Vorzeichen wird das anthropomorphe Moment im Verhalten eines Insekts bei der 2019 entstandenen Videoarbeit *Mad Mieter* von M+M (Martin De Mattia und Marc Weis) lebendig. Für die ihren Gatten nach der Paarung oft verspeisende Gottesanbeterin haben die Künstler eine kleine gründerzeitliche Wohnung gebaut, in der das grüne Insekt liebes- und fleischeshungrig auf das ahnungslose Männchen wartet. Was Entomologen nüchtern als einen für die Arterhaltung sinnvollen Vorgang beschreiben, wird für die durch eine VR-Brille das Geschehen verfolgenden Betrachter*innen zu einem sich scheinbar in menschlichen Größenverhältnissen abspielenden kannibalischen Akt. Aufgrund einer optisch wie akustisch äußerst suggestiven Szenerie wechseln in den Betrachter*innen in rascher Folge Widerwille, Faszination, Angst und Amüsement, zumal die Gottesanbeterin mit ihrem wippenden Gang etwas

durchaus Menschlich-grazil-Tänzerisches hat. Allerdings spätestens dann, wenn sie beim Anblick eines kleinen Insekts in Vorfreude auf diesen Genuss an ihrem zangenartigen Greifer zu lecken scheint, beschleicht die Betrachter*innen ein Gefühl davon, dass auch sie potenziell Opfer sein könnten. Die Machtverhältnisse zwischen Mensch und Natur werden umgekehrt.

Dass das tiefgründig Unheimliche respektive die Angst vor Insekten noch immer in schützende, apotropäische Kräfte umgewandelt wird, zeigen heutzutage zahlreich auf unterschiedlichste Körperpartien tätowierte Insekten. Ähnlich dem wohl als Talisman oder Amulett getragenen Marienkäfer von vor 35.000 Jahren breitet heute der Hirschkäfer – in der christlichen Ikonografie sinnbildlich für den in Jesus verkörperten Sieg über das Böse – seine mächtigen Flügel aus. Die christliche Bedeutung wird bei Tattoos in der Regel weniger bewusst eingesetzt sein. Deutlich erkennbar aber sind die Vorbilder für diese Tätowierungen zu erkennen, die in Anlehnung an die Kupferstiche Hoefnagels entstanden sind.

Während der Tätowierer Marian Merl seine Käfer gewissermaßen durch die lebendigen Träger vitalisiert, gibt es neben Darstellungen toter Insekten insbesondere in einem Bereich der installativen Kunst seit etwa 1960 zunehmend Werke, etwa von Mark Thompson, Rosemarie Trockel, Katharina Meldner, Liang Shaoji oder Vivian Xu, bei denen lebende Insekten als Bestandteil eines Kunstwerks sichtbare Spuren hinterlassen, Kokons spinnen oder – vergleichbar mit M+Ms *Mad Mieter* – miniaturhafte Stadtlandschaften bevölkern.[10]

Schließlich gibt es neben Werken, die mehr oder weniger deutlich Vergänglichkeitssymbolik, mythologische Aspekte oder archaische Ängste thematisieren, auch künstlerische Positionen, die eine ausgesprochen positiv besetzte, durchaus empathische Auseinandersetzung mit Insekten erkennen lassen. Lili Fischer etwa widmet sich seit Jahrzehnten dem geflügelten Insekt. Ihr geht es darum, den Blick zu schärfen für die zarte Erscheinung und vielfältige Schönheit der meist als Plagegeister oder Schädlinge wahrgenommenen Schnaken oder Nachtfalter. Mitunter bietet sie den Besucher*innen gar die Gelegenheit, sich tänzerisch in eine beflügelte Motte oder in eine sich krümmend kriechende Made zu verwandeln. Fischers aus gerupftem Japanpapier »gezeichneten« Motten vermitteln die Leichtigkeit und Fragilität dieser – menschlicher Existenz in doch so manchem vergleichbaren – Flügelwesen aufs Anschaulichste.

Nana Schulz wiederum zeichnet Tierhaftes, das mit seinen artspezifischen Merkmalen wie sechs Gliederbeine, große Augen oder lange Fühler an Käfer denken lässt. Ihre Zeichnungen lösen denn auch prompt Empfindungen aus, die Menschen häufig bei der Betrachtung von Käfern haben: Neugierde, Bewunderung für die Formenvielfalt der Natur und mitunter Ekel. Ausgangspunkt für Schulz' intensive, fast schon wissenschaftliche Auseinandersetzung mit Käfern ist ihre Faszination für deren Anatomie und Verhalten. Ihre Darstellungen entstehen jedoch aus der puren Lust am Zeichnen und der Möglichkeit, zeichnend Gedanken zu ordnen. Sie überlässt sich im Strom des Zeichnens der Fantasie und schafft Wesen, die etwas ausgesprochen Insektenhaftes, zugleich aber auch etwas sehr Heiteres, In-sich-Ruhendes, Zufriedenes ausstrahlen. Obgleich es Schulz keineswegs um eine gattungsbiologische Korrektheit geht, fällt die Nähe zur Zeichnung als Hilfsmittel wissenschaftlicher Dokumentation auf.

Ein Bindeglied in dieser Hinsicht – und zwischen den für das 20. Jahrhundert typischen Darstellungen toter Insekten und der wissenschaftlichen Darstellung durch Entomologen – findet sich in den Zeichnungen von Christine Leins. Mit unzähligen hauchdünn gesetzten Punkten nähert sie sich langsam den Formen von minutiös ausdifferenzierten, geradezu fotorealistisch wirkenden Insekten. Ihre Blätter sind von einer derart behutsamen Annäherung an das Aufscheinen des jeweiligen Insekts getragen, dass jedes Einzelne in ihren Zeichnungen im Tod etwas von seiner Würde zurückerhält.

Wissenschaft und Kunst vereint auch Sinje Dillenkofer, die vom Aussterben bedrohte Insekten wie den Apollofalter oder eine Schwebfliege in entomologisch wissenschaftlichen Sammelkästen direkt abfotografiert. Durch die starke Vergrößerung erreicht sie eine grundsätzlich andere Wirkung und Aufmerksamkeit.

Wissenschaftliche Darstellungen

Hunderte Jahre nach Dürer, Merian und Hoefnagel, in einer Zeit, in der die digital reproduzierenden Medien unsere visuelle Wahrnehmung der Wirklichkeit in großen Teilen beherrschen, überrascht es und ist bedenkenswert, wenn der wissenschaftliche Zeichner und Entomologe Armin Coray nachdrücklich unterstreicht: »Zeichnen ist ein Akt geschulten Wahrnemens und Erkennens, um die Lesbarkeit der maßgebenden Merkmale zu fördern und das Verstehen zu erleichtern.«[11] Vergleichbar mit dem eingangs erwähnten Zitat Dürers sagt Coray: »Erst wer zeichnet, versteht wirklich, was er sieht!«[12]

Ein von Coray direkt nach der Natur gezeichnetes Insekt wie die Maulwurfsgrille weist derart eigenwillige Formen auf, dass man verblüfft und staunend meinen könnte, ein Fantasiegebilde wie bei Nana Schulz oder doch wenigstens eine Collage aus mehreren Insekten vor Augen zu haben. Tatsächlich handelt es sich hier aber trotz ihrer fragmentarischen Wirkung um eine Körperlichkeit, die sich der Anpassung an einen Lebensraum und damit einer Überlebensstrategie verdankt.

Es ist ein wesentlicher Unterschied, ob man ein Tier in seiner äußeren Erscheinungsform fotografisch dokumentiert oder ob man seine äußeren Merkmale, die für die Erfassung einer Art notwendig sind, dokumentieren und zeigen will – und zwar so, dass diese in einer repräsentativen Darstellung sichtbar werden. Von einer für die Wissenschaft zeichnenden Person wird verlangt, dass sie eine genaue Vorstellung davon hat, was für den forschenden Blick von Relevanz und in der wissenschaftlichen Zeichnung folglich festzuhalten ist. Deshalb vermittelt die wissenschaftliche Zeichnung einen Zugang zu Informationen, den die Fotografie nicht leisten kann. Denn die Zeichnung kann gezielter als die Fotografie gewichten, kann spezifische Charakteristika hervorheben, ohne andere Details zu vernachlässigen.

Dies veranschaulicht allein schon die reale Größe einer wissenschaftlichen Käferzeichnung: Der kleinste Käfer Europas misst circa 0,5 Millimeter, ist also mit dem bloßen Auge auf einem Objektträger kaum

mehr denn als kleiner schwarzer Punkt zu erkennen. Wenn dieses Tierchen in 60- bis 100-facher Vergrößerung nach der mikroskopischen Anschauung gezeichnet wird, entsteht das Bild eines vollständigen Insekts. Erst dieses zigfach vergrößerte Abbild ermöglicht es schließlich, alle körperlichen Charakteristika, die seine Art aufweist, zu identifizieren und es so von anderen Arten der gleichen Gruppe zu unterscheiden.

Allerdings wäre es falsch zu behaupten, dass all die neuen technischen Wiedergabe- und Reproduktionsverfahren keine Erkenntnisse liefern könnten, die der Wissenschaft nicht vergleichbar weiterhelfen. Digitale elektronenmikroskopische Fotografie oder 3D-Scanverfahren bieten neue Möglichkeiten der Darstellung und Sichtbarmachung, die für die Wissenschaft ebenso wertvoll sind wie die wissenschaftliche Zeichnung. So sind etwa zahlreiche Insektenarten weniger an der Farbe oder Form beispielsweise ihrer Flügel zu unterscheiden, sondern vor allem an der Form ihrer Geschlechtsteile. Diese Unterscheidung wurde bislang anhand zahllosen Reihungen mit kleinsten Abweichungen wissenschaftlich gezeichnet und von Entomologen entsprechend zugeordnet. Elektromikroskopische Aufnahmen bieten nun erweiterte Möglichkeiten im Erkennen von besonderen Merkmalen dieser Geschlechtsorgane.

Die Faszination solcher Aufnahmen liegt – wie ganz ähnlich schon bei den Zeichnungen der Insektenwelt seit dem 16. Jahrhundert – darin, dass sie den Betrachter*innen die bildliche Erfahrung einer Realität weit jenseits ihrer normalen Alltagsrealität ermöglichen. Betrachtet man jedoch mit dem Elektronenmikroskop entstandene Aufnahmen wie etwa den circa 1,1 Millimeter großen Kopf einer Kriebelmücke in 225-facher Vergrößerung oder den um das 130-Fache vergrößerten Penis einer Spinne, die in ihrer naturgetreu monumentalisierten Wiedergabe autonomen Formfindungen gleichen, wird nachvollziehbar, wie sich neueste technische mediale Möglichkeiten und das scheinbar altmodische Medium der Zeichnung ergänzen. Es gibt wenige Bereiche, in denen sich künstlerische und wissenschaftliche Betrachtung so nahekommen, sich überschneiden und gegenseitig befruchten wie im Bereich der Entomologie.

1 Vgl. Erwin Schimitschek,
 »III. Älteste Insektendarstellungen«,
 in: *Veröffentlichungen aus dem
 Naturhistorischen Museum*, NF 14, 1977,
 S. 13–21, hier S. 13–15.

2 Vgl. ebd., S. 14–15.

3 Vgl. Hans Bonnet, *Reallexikon der
 ägyptischen Religionsgeschichte*,
 Hamburg 2000, S. 194–195, S. 363,
 S. 698–699 und S. 720–722.

4 Siehe Sigmar Schenkling, »Die Entomologie
 des Aristoteles«, in *Illustrierte
 Wochenschrift für Entomologie*, 1, 1896,
 S. 469–473, hier S. 469–470.

5 Albrecht Dürer, *Herinn sind begriffen
 vier bücher von menschlicher Proportion*,
 Nürnberg 1528, S. 198.

6 Michael Roth, Magdalena Bushart und
 Martin Sonnabend, »Durch die Blume
 gesehen – Merian in Berlin – Merian in
 Frankfurt. Eine Einleitung«, in: *Maria
 Sibylla Merian und die Tradition des
 Blumenbildes von der Renaissance bis
 zur Romantik*, hrsg. von dens., Ausst.-
 Kat. Kupferstichkabinett, Berlin/Städel
 Museum, Frankfurt am Main, München
 2017, S. 9–12, hier S. 9.

7 Vgl. Xenia Schiemann, »Emblematik und
 Natur im Werk von Georg und Jacob
 Hoefnagel aus dem Bestand des Berliner
 Kupferstichkabinetts«, in: ebd., S. 73–87,
 hier S. 74.

8 Vgl. Martin Sonnabend, »Maria
 Sibylla Merian. Blumenmalerei und
 Naturforschung«, in: Ausst.-Kat. Berlin/
 Frankfurt 2017 (wie Anm. 6), S. 149–158,
 hier insb. S. 153.

9 Heiko Daniels danke ich für den Hinweis
 auf den Horrorfilm.

10 Ich danke Susanna Baumgartner für
 ihre Recherche zu künstlerischen
 Auseinandersetzungen mit Insekten in der
 installativen Kunst.

11 Armin Coray, in: Hans Günter
 Schmitz (Hrsg.), *Mikro / Makro.
 Naturwissenschaftliche Zeichnungen von
 Armin Coray*, Berlin 2022, S. 36.

12 Gesprächsnotiz des Verf. nach einem
 Besuch bei Armin Coray, Oktober 2022.

The Insect—On Depiction in the Art of Drawing and in Science

Thomas Köllhofer

From Prehistoric Times to the Nineteenth Century

Insects are already depicted in the earliest artistically or ritually conceived figurative drawings. The oldest known picture of a beetle is a small, roughly 25,000-to-30,000-year-old one molded from coal. A scratch-drawing of a bug on a bone, which was created approximately 20,000 years ago, is somewhat younger.[1] There are various interpretations of the cultural or ritual significance of these early pictures. In the case of sculpted objects, it is assumed that they were worn as decoration or amulets. As it appears, insects were assigned a special significance from the very beginning. Among the oldest documented types of bugs that have been found is also the ladybug, which according to the *Grimm'sche Wörterbuch* (Grimm's Dictionary) has the following names in different German dialects: "Gotteskühlein, Gotteskalb, Herrgottskalb, Herrgottstierchen, Herrgottsvöglein, Marienvöglein, Marienkäfer, Marienkälbchen,"[2] all terms that incorporate the words "God" and "Mary."

The significance of the scarab beetle in particular, which was derived from the picture of the so-called dung beetle, has been handed down from the culture of Ancient Egypt. This insect was revered as a good luck charm, and at times also as sacred. Since scarabs transform dung into fertile soil and make it into balls in the process—in a figurative sense, into terrestrial globes—they were regarded as a symbol of rebirth and metamorphosis. The Egyptian sun god Horus was addressed at the time of the rising sun as Khepri, meaning "he who created himself." As such, he was depicted with the head of a scarab beetle, since it stands for the rising of the sun each day. However, not only scarab beetles were found in pictures in Ancient Egypt and were venerated as sacred: other such insects include bees, flies, millipedes, and scorpions. At the same time, there are also concrete instructions for how to fight against animals, some of which occasionally cause damage.[3] From the Aztecs it is also known that, for instance, grasshoppers, locusts, ant eggs, or butterfly larvae could be eaten as a source of protein. They were depicted on, for example, vessels or

jewelry with corresponding frequency. In Europe, the honeybee in particular has been known as a working animal and often been ascribed particular symbolisms since around 5,000 BCE.

The first documented scientific examination of insects was conducted by Aristotle (384–322 BCE), who is regarded as the founder of entomology, or the study of insects. Countless animals were thus observed and described in great detail for the first time from ancient times. We still have the categorizations of major characteristics in the various groups as noted by Aristotle: winged insects (*pterotá*), insects whose front wings have hardened into wing cases (*Coleoptera*), conehead insects (*anélytra*), insects with a single pair of wings (*diptéra*), and insects with four wings (*tetraptéra*), from which he also differentiated wingless insects (*áptera*).[4] Aristotle's systematizing recording of body composition and habits based on detailed descriptions has not lost its validity today, just as the significant characteristics of the insects that he described remain. In this respect, only a few new observations are known from the Christian Middle Ages, an era that was oriented toward life after death. Flora and fauna were addressed only in isolation, as, for instance, by the Benedictine monk Albertus Magnus (1200–1280), who attempted to systematize Aristotle's observations from antiquity with the religious beliefs of his time in his work *De animalibus*.

In the Renaissance, there was a growing need to depict the world in a realistic way. With the discovery of the Americas, the investigation into the tremendous diversity of animal and plant species, particularly in the realm of insects, expanded. The newly awakened interest in animal reality is also shown in Albrecht Dürer's (1471–1528) very true-to-nature studies of insects, which were created based on direct contemplation of living or dead specimens. The stag beetle that Dürer drew to scale (fig. 1) seemed to have inspired Georg (Joris) Hoefnagel (1542–1600) to produce his picture of a stag beetle nearly one hundred years later. The guiding principle that spans this exhibition on depictions of insects in art and science also comes from Dürer: "Dann warhafftig steckt die kunst in der natur, wer sie herauß kan reyssen der hat sie," which can be translated roughly as: "Then, in fact, art is truly found in nature, and he who can draw it out has it."[5] "Reyssen," to quote from the introduction to *Maria Sibylla Merian und die Tradition des Blumenbildes*, here thus means: "drawing and even more so cognition through drawing and artistic appropriation of the natural form." It should be emphasized that "this relation between nature and art does not arise on its own: only those who understand how to extract art from nature and to implement this cognition in drawings. Cognition beyond designed observation in turn includes the possibility to systematize, indeed even to idealize."[6] What Aristotle named, classified, and categorized with words is what Dürer described on a representational level as a necessary prerequisite for exploratory understanding and cognition.

How great the interest in such detailed, artistic-scientific pictures based on previous study of nature was in the sixteenth and seventeenth centuries can be read clearly based on two examples. In the final quarter of the sixteenth century, Georg Hoefnagel produced a compendium of miniature pictures of animals, which he divided up according to the four elements. Particularly the insects, which are assigned to the habitat of fire, grab the eye in convincing near-natural depictions. In 1592, Hoefnagel self-published a selection of his pictures of animals—including in particular insects drawn from nature—to make them accessible to a broad audience in the inexpensive form of etchings.[7]

Ulise Aldronadi's (1522–1605) *De animalibus insectis libri VII* was published ten years later as the first publication dedicated exclusively to insects. This extensive overview of entomology is illustrated with numerous woodcuts and for the first time visualizes the structures of different species based on their way of living and body composition. The fact that there was a large market for bootleg copies of this book shows that the interest in this topic must have been considerable.

Particular fame was attained in the seventeenth century by Maria Sibylla Merian (1647–1717), who not only observed

insects, and butterflies in particular, but also bred them, after discovering that different caterpillars respectively fed on specific plants. As a result of her breeding work, she was able to conduct in-depth studies of all the developmental stages, from the caterpillar to the pupa to the butterfly, to then provide an overview of these successive phases over time in one single picture. The butterflies were documented in their stages of development, but also with the visually, often unprepossessing but actually corresponding plants on which they fed (fig. 2). Merian thus succeeded in asserting herself self-confidently as a woman in a male-dominated domain of painting, and simultaneously broke new ground scientifically, which she presented in an artistically innovative manner.[8]

Barbara Regina Dietzsch (1706–1783) achieved comparable success. She created flower still lifes based on meticulous observations and reproductions, in which—admittedly more as decoration than as scientific drawings—the most diverse insects are incorporated. These pictures were very decorative, adhered to consistent compositional schemata, were extremely powerful, and also in demand around the world.

Insects in the Art of the Twentieth and Twenty-First Centuries

From the Renaissance until into the late nineteenth century, artists made great efforts to capture insects in overview and side views as three-dimensional phenomena and to depict them as graphically and vividly as possible with all their details—casting a shadow, flying, or standing on all six legs. In the twentieth century, by contrast, pictures of dead insects increasingly appeared. Insects, and flies in particular, but also beetles and other crawling bugs, including even maggots, were incorporated in the memento mori as a vital component, thus as a reference to human mortality, to the fleetingness of absolutely all earthly life, that inhered in the picture. Here, insects embody the active destruction of beauty, work, and life as potential pests or parasites. In the twentieth century, insects increasingly went

from being actively destructive creatures to victims of destruction. With them, death was no longer presented symbolically, but instead as an unembellished, pure fact in the dead insect.

Et les papillons se mettent à chanter (And the Butterflies Begin to Sing) is the title of a plate by Max Ernst (1891–1976) from his collage novel *La femme 100 têtes* (1929), whose phonetically ambiguous title can be read as the "100-headed," "headless," "stubborn," or "bloodsucking woman." Ernst here created a surreal scene, in whose foreground numerous moths and other insects—attracted to the bright light—flutter around a gas lamp. The title insinuates the sound of insects repeatedly bumping against the glass of the lamp or being singed in the flame. In a catacomb-like arched background stand numerous skeletons, which observe the hopeless bustle around the gas lamp with curiosity like grim reapers.

While doomed insects at least still swirl around the lamp in Max Ernst's collage, in the work of Horst Janssen (1929–1995), dead winged creatures extend their many-jointed legs in the air and are sometimes already in the process of decaying. Now no longer a symbol of vanitas, the admonishing reference to the ephemerality of earthly life cannot open up any prospect of salvation for the soul and a different life in heaven after death. These insects must instead be comprehended as presenting a picture of death being definitive, merciless, and thus hopeless. In Janssen's drawings, what takes effect is a psychological component that would increasingly gain in importance in the twentieth century—the awareness of isolated natural existence surrendered helplessly and without protection that is reflected in the examination and, to some extent, also in the identification with the insect-like in particular.

When, in *Zu Don Quijote* (2000) by Thomas Löhning, the knight of the sad countenance, accompanied by Sancho Panza in self-crafted armor, rides toward a monstrous insect, the unease of viewers thus lies in the uncertainty of whether this animal is dead or whether it might move in the next moment in order to simply devour its courageous but nonetheless ridiculous

185

counterpart with one bite. The insect is presented ambiguously as something between a stranded monster and a counterpart prepared to attack. Many times larger than in Jonathan Swift's *Gulliver's Travels*, where flies as big as crested larks and wasps as big as partridges meet the hero, in Löhning's work the gigantic insect embodies nature itself, with which the tiny human in his hubris wants to challenge.

Since the early twentieth century, insects in particular have been used when human fears seek a projection screen, be it the beetle into which Gregor Samsa is transformed in *The Metamorphosis* by Franz Kafka, the flying locusts in a drawing by Alfred Kubin, which hunt human beings like fighter pilots, or the horror film *The Fly* by Kurt Neumann, in which a man is transformed into a hybrid human-insect creature as a result of an accidental intermixing of DNA.[9]

Even though the relationship between human beings and insects is characterized by an alienness that is frequently grounded in fear, at the latest with the fables of Jean de La Fontaine, insects began being depicted anthropomorphically. Thus, for instance in *La cigalle et la formie* (The Cicada and the Ant), the New Testament parable of clever and foolish virgins is translated into a moralizing animal fable: the ant preparing industriously for the winter is contrasted with the cicada, which indulges in its seemingly useless singing and pays for its activity focusing on beauty with its death, to the ant's derision. The anthropomorphic moment comes alive under quite different circumstances in the behavior of an insect in the video work *Mad Mieter*, created in 2019 by M+M (Martin De Mattia and Marc Weis). For the praying mantis, which often devours its partner after mating, the artists had a small Wilhelmine dwelling constructed, in which the green insect, hungry for love and flesh, waits for the clueless male. What entomologists prosaically describe as an occurrence that is practical for the survival of the species, for viewers, who follow what is happening through VR glasses, it becomes a cannibalistic act that seems to take place on a human scale. By virtue of the visually as well as acoustically suggestive scenery, aversion, fascination, fear, and amusement alternate in viewers in rapid succession, especially since the praying mantis with its rocking gait definitely has a human-dancing-gracefully quality. However, at the latest when viewers observe the small insect seeming to lick its grasping apparatus in anticipation of this pleasure, the feeling that they might also become its potential victim creeps up on them. The balance of power between humans and nature is reversed.

The fact that the profoundly uncanny, or rather the fear of insects continues to be transformed into protective, apotropaic forces is shown today by the numerous insects tattooed on diverse parts of the body. Like the ladybugs of 35,000 years ago probably worn as a talisman or amulet, the stag beetle—which in Christian iconography stands symbolically for the victory over evil that is embodied in Jesus—now spreads its powerful wings. In the case of tattoos, the Christian meaning is generally employed less consciously. The models for these tattoos, which are created in the style of Hoefnagel's copperplate engraving, are, however, clearly discernable.

Though the tattoo artist Marian Merl vitalizes his beetles to a certain extent by means of the living bearer of the work, there has been, particularly in the field of installation art, an increase since around 1960 in works—for instance by Mark Thompson, Rosemarie Trockel, Katharina Meldner, Liang Shaoji, or Vivian Xu—in which living animals leave behind visible traces, spin cocoons, or—comparably with M+M's *Mad Mieter*—populate miniature cityscapes as components of an artwork.[10]

Finally, in addition to works that deal more or less clearly with the symbolism of transience, mythological aspects, or archaic fears, there are also artistic positions in which a very positively connoted, extremely empathetic examination of insects can be discerned. Lili Fischer, for example, has dedicated herself for years to winged insects. She is interested in honing the gaze for the delicate appearance and manifold beauty of gnats or moths, which are generally perceived as a nuisance or pests. At times, she even offers viewers the possibility

to be transformed into a winged moth or a creeping and writhing grub. Fischer's moths, "drawn" with plucked Japan paper, very clearly convey the lightness and fragility of these winged beings—which are nevertheless comparable to human existence in some respects.

Nana Schulz, in contrast, draws the animal-like, which makes one think of beetles owing to the species-specific characteristics like six jointed legs, large eyes, or long feelers. Her drawings then also promptly trigger sensations that people often have when observing beetles: curiosity, wonder at the diversity of forms in nature, and occasionally aversion. The starting point for Schulz's intensive, nearly scientific examination of beetles is her fascination with their anatomy and behavior. Her pictures are, however, created based on a sheer desire to draw and the possibility to order her thoughts while drawing. She succumbs to fantasy while in the flow of drawing and creates creatures that radiate something pronouncedly insect-like, but at the same time a very cheerful, inherently serene, and satisfied quality. Though Schulz is not interested in any way in genus-specific biological accuracy, the closeness to drawing as an aide to scientific documentation is apparent.

A connective link in this respect—and between the pictures of dead insects that are typical of the twentieth century and scientific depiction by entomologists—is found in the drawings of Christine Leins. She slowly approaches the forms of minutely differentiated downright photorealistic-seeming insects with countless dots applied razor-thinly. Her works are underpinned by such a cautious approach to the appearance of the respective insect that every individual, even though dead, still retains something of its dignity in her drawings.

Sinje Dillenkofer, who directly photographs insects threatened with extinction, such as an Apollo butterfly or a hover-fly, in entomological scientific collection boxes, also brings together science and art. As a result of the great magnification, she achieves a fundamentally different effect and attention.

Scientific Pictures

Hundreds of years after Dürer, Hoefnagel, and Merian, at a time when digitally reproduced media dominate our visual perception of reality to a great extent, it is surprising and worthy of contemplation when the scientific illustrator and entomologist Armin Coray emphatically emphasizes: "Drawing is an act of trained observation and cognition, so as to enhance the readability of the decisive attributes and to simplify comprehension."[11] Similar to the abovementioned quote by Dürer, Coray says: "It is first individuals who draw who truly understand what they are seeing!"[12]

An insect drawn by Coray directly from nature, such as the mole cricket, displays such distinctive forms that one might think, dumbfounded and amazed, that they are looking at a figment of the imagination—as in the work of Nana Schulz—or at least at a collage made from several insects. Despite the fragmented effect of this corporeality, it results from adaptation to a specific habitat and thus a survival strategy.

There is a substantial difference between documenting an animal's outer form of appearance photographically and wanting to document and show the external characteristics, which is necessary in order to identify a species—and namely in such a way that they become visible in a representative picture. It is demanded from a person who draws for science that he or she has a very clear idea of what is of relevance for the exploratory gaze and should consequently be captured in the scientific drawing. Scientific drawings therefore provide access to information that photography is unable to provide. Since drawings can measure in a more targeted way than photographs, they can emphasize specific characteristics, but without neglecting other details.

This is already shown by the real dimensions of a scientific drawing of a beetle: the smallest beetle in Europe measures roughly 0.5 millimeters, and can thus be recognized on a slide with the naked eye as barely more than a small black dot. When this tiny animal is drawn in 60- to 100-fold magnification after being viewed through a microscope, a picture

of a complete insect appears. It is first this extremely magnified rendering that ultimately makes it possible to identify all the physical characteristics that this species displays, and hence to differentiate it from other species of the same genus.

It would, however, be incorrect to claim that all the new technical processes of picturing and reproducing are unable to provide any insights that do not help science along in a comparable fashion. Digital electron-microscopic photography or 3D scanning methods offer new possibilities for picturing and making-visible that are just as valuable for science as scientific drawing. There are, for instance, numerous insect species that can be differentiated based less on the color or shape of their wings, for example, than on the form of their genitals. This differentiation had previously been drawn scientifically based on numerous sequences with minute deviations and categorized correspondingly by entomologists. Electron-microscopic photographs now provide enhanced capabilities for recognizing the particular characteristics of these reproductive organs.

The fascination with such photographs—similarly to the sixteenth-century interest in drawings of the world of insects—lies in the fact that they facilitate for viewers a visual experience of a reality far beyond their normal everyday reality. If one, however, looks at images produced with an electron microscope, such as the roughly 1.1-millimeter-large head of a blackfly in 225-fold magnification or the penis of a spider magnified 130-fold, which resemble autonomously invented forms in their realistically monumentalized reproduction, it becomes clear how the newest technical media options and the seemingly old-fashioned medium of drawing supplement each other. There are thus few other areas in which artistic and scientific contemplation come so close to each other, overlapping and cross-fertilizing each other than in the field of entomology.

1 See Erwin Schimitschek, "III. Älteste Insektendarstellungen," *Veröffentlichungen aus dem Naturhistorischen Museum*, NF 14 (1977), pp. 13–21, esp. pp. 13–15.

2 See ibid., pp. 14–15.

3 See Hans Bonnet, *Reallexikon der ägyptischen Religionsgeschichte* (Hamburg: De Gruyter, 2000), pp. 194–95, p. 363, pp. 698–99, and pp. 720–22.

4 See Sigmar Schenkling, "Die Entomologie des Aristoteles," *Illustrierte Wochenschrift für Entomologie* 1 (1896), pp. 469–73, esp. pp. 469–70.

5 Albrecht Dürer, *Herinn sind begriffen vier bücher von menschlicher Proportion* (Nuremberg, 1528), p. 198.

6 Michael Roth, Magdalena Bushart, and Martin Sonnabend, "Durch die Blume gesehen – Merian in Berlin – Merian in Frankfurt: Eine Einleitung," in *Maria Sibylla Merian und die Tradition des Blumenbildes von der Renaissance bis zur Romantik*, ed. idem. exh. cat. Kupferstichkabinett, Berlin, and Städel Museum, Frankfurt am Main (Munich: Hirmer Verlag, 2017), pp. 9–12, esp. p. 9.

7 See Xenia Schiemann, "Emblematik und Natur im Werk von Georg und Jacob Hoefnagel aus dem Bestand des Berliner Kupferstichkabinetts," in ibid., pp. 73–87, esp. p. 74.

8 See Martin Sonnabend, "Maria Sibylla Merian: Blumenmalerei und Naturforschung," in ibid., pp. 149–58, esp. p. 153.

9 I thank Heiko Daniels for the information about the horror film.

10 My gratitude goes to Susanna Baumgartner for her research on artistic examinations of insects in installation art.

11 Armin Coray, in *Mikro / Makro: Naturwissenschaftliche Zeichnungen von Armin Coray*, ed. Hans Günter Schmitz (Wuppertal: Edition 19+, 2022), p. 36.

12 Note on the conversation by the author after a visit with Armin Coray, October 2022.

JACOB HOEFNAGEL

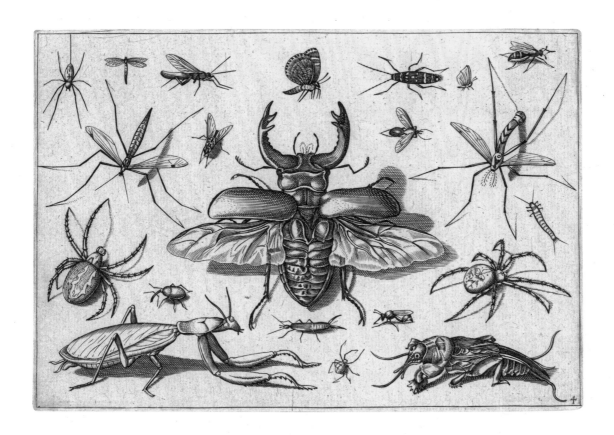

Jacob Hoefnagel
Insekten / Insects, 1630
Kupferstich / Copperplate engraving
13,4 × 19,8 cm
Herzog Anton Ulrich-Museum, Braunschweig

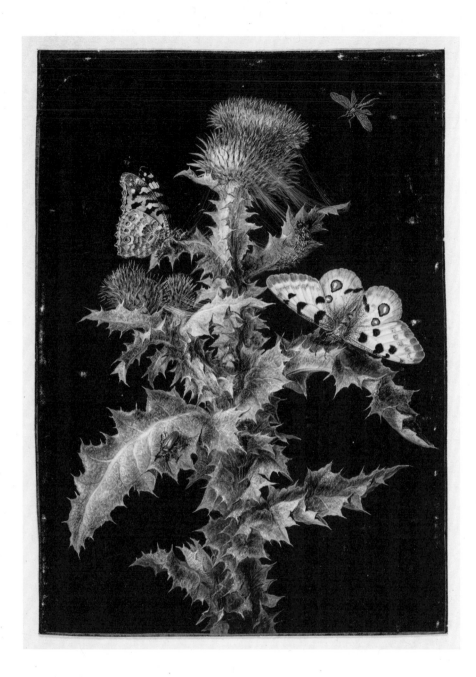

Barbara Regina Dietzsch
*Distelzweig mit zwei Schmetterlingen, Raupe, Käfer, Libelle und Spinn-
weben / Thistle Branch with Two Butterflies, Caterpillar, Beetle, Dragonfly
and Spider Webs*, undatiert / undated
Aquarell, Deckfarbe und Gummi-Arabicum-Firnis (partiell) auf Pergament /
Watercolor, opaque color, and gum arabic varnish (partial) on vellum
ca. 29 × 21 cm
Kupferstichkabinett, Berlin

190 1,5 Grad

MAX ERNST

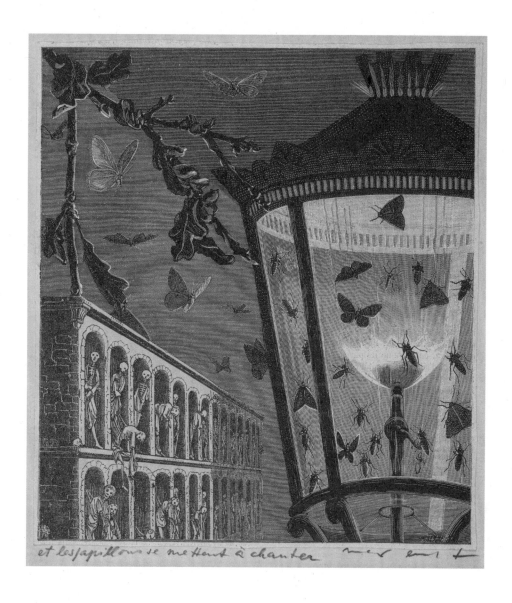

Max Ernst
*et les papillons se mettent à chanter / und die Schmetterlinge
beginnen zu singen / and the Butterflies Begin to Sing*, 1929
Collage, Blatt aus dem Collagenroman / Print from the collage novel
La femme 100 têtes
16,3 × 14,8 cm
Städel Museum, Frankfurt am Main

HORST JANSSEN

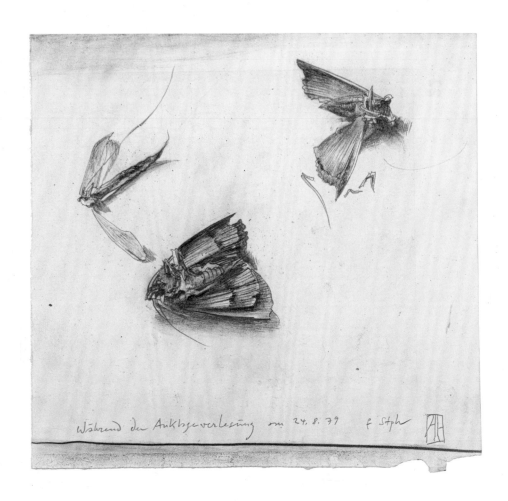

Horst Janssen
Während der Anklageverlesung am 24.8.79 /
During the Arraignment on 24.8.79, 1979
Bleistift und Farbstift auf Papier /
Pencil and colored pencil on paper
22 × 23 cm
Horst-Janssen-Museum, Oldenburg

192

1,5 Grad

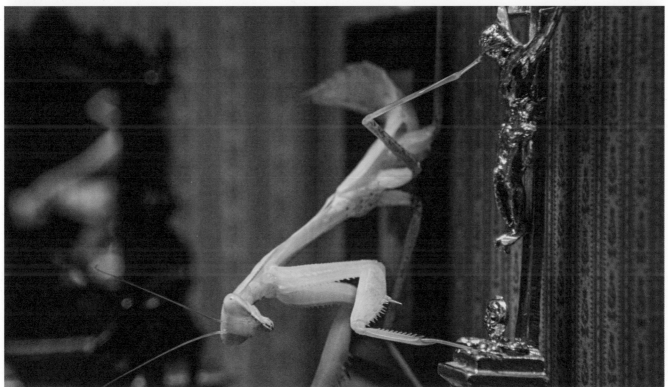

M+M,
Mad Mieter, 2019
3D-Video (Farbe, Ton / Color, sound)
6:09 min
Video stills

THOMAS LÖHNING

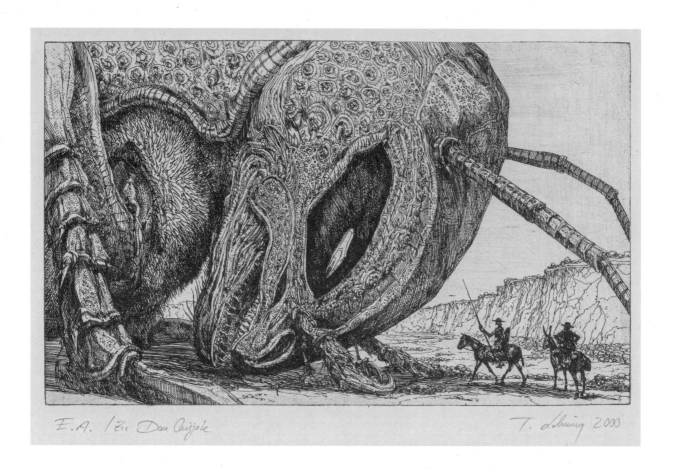

E.A. / Zu Don Quijote T. Löhning 2000

Thomas Löhning
Zu Don Quijote, 2000
Radierung / Etching
14,5 × 23,9 cm
Kunsthalle Mannheim

MARIAN MERL

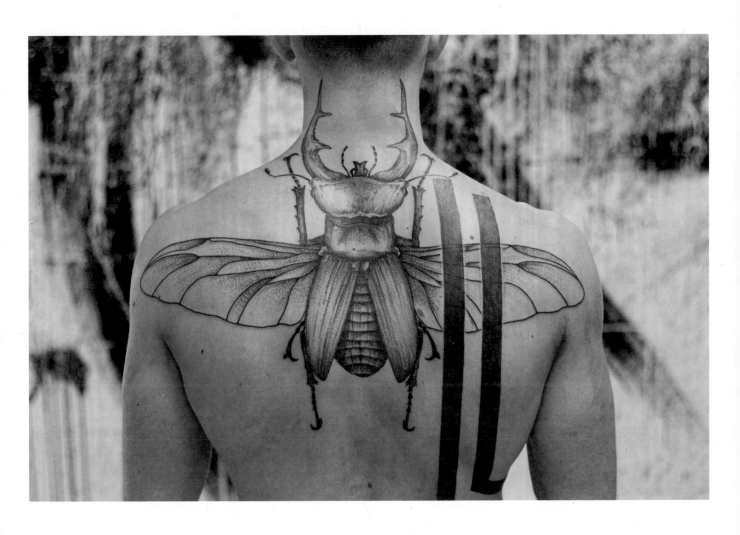

Marian Merl
Hirschkäfer / Stag Beetle, 2022
Tattoo
Träger des Tattoos / Bearer of the tattoo: Fabian

NANA SCHULZ

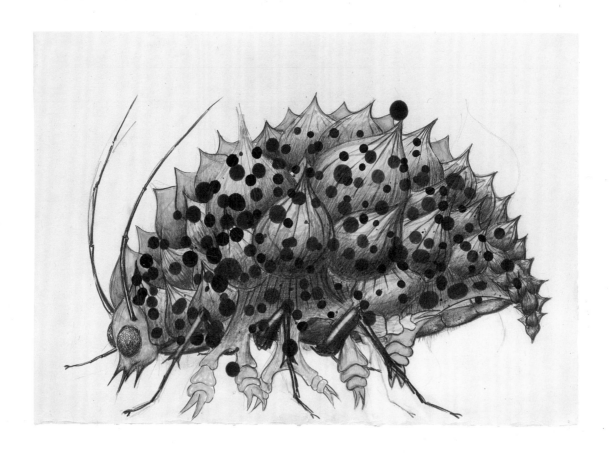

Nana Schulz
Gelber Zwiebelkäfer / Yellow Onion Beetle, 2015
Tinte, Bleistift und Buntstift auf Papier /
Ink, pencil, and colored pencil on paper
30 × 42 cm

CRISTINA GASCO-MARTIN

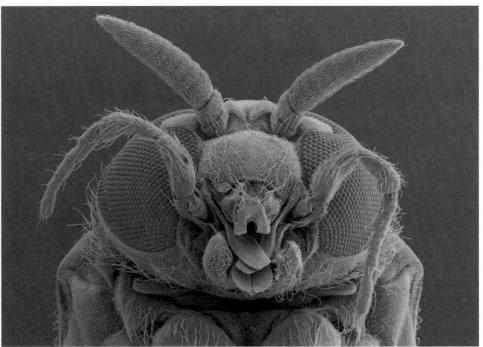

100 μm	WD = 11.5 mm	EHT = 10.00 kV	Signal A = SE1
	Mag = 225 X	I Probe = 150 pA	System Vacuum = 3.20e-006 mbar

SMNS

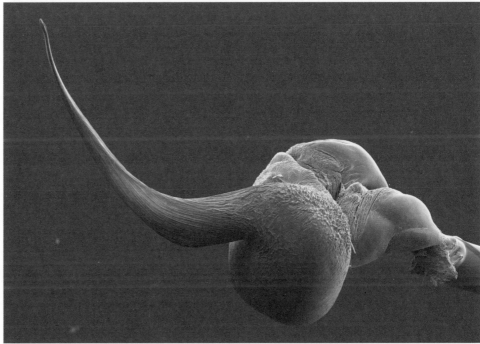

100 μm	WD = 6.5 mm	EHT = 10.00 kV	Signal A = SE1
	Mag = 130 X	I Probe = 150 pA	System Vacuum = 5.13e-006 mbar

SMNS

Christina Gasco-Martín
Kriebelmücke / Blackfly, 2019
Elektromikroskopische Aufnahme, Vergrößerung: 225-fach /
Electron-microscopic image, magnification: 225-fold
Naturkundemuseum Stuttgart

Christina Gasco-Martín
Pedipalpus Ischnocolus spec., 2019
Elektromikroskopische Aufnahme, Vergrößerung: 130-fach /
Electron-microscopic image, magnification: 130-fold
Naturkundemuseum Stuttgart

CHRISTINE LEINS

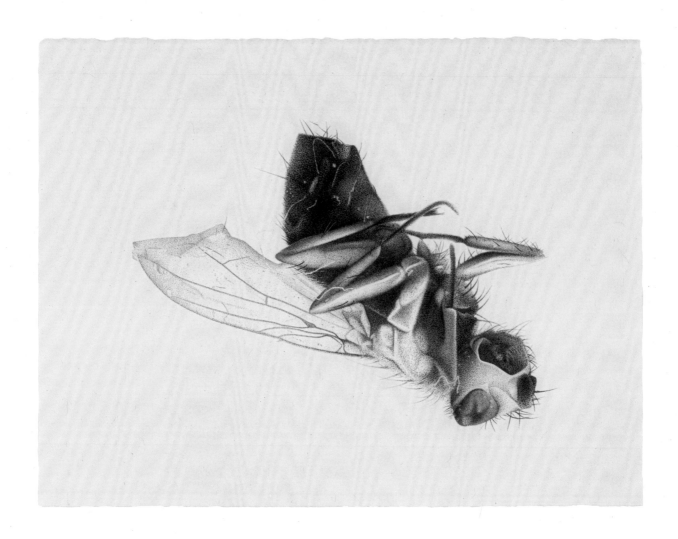

Christine Leins
Fliege / Fly, 1995
Bleistift und Buntstift auf Papier /
Pencil and colored pencil on paper
28,6 × 38,1 cm
Kunsthalle Mannheim

ARMIN CORAY

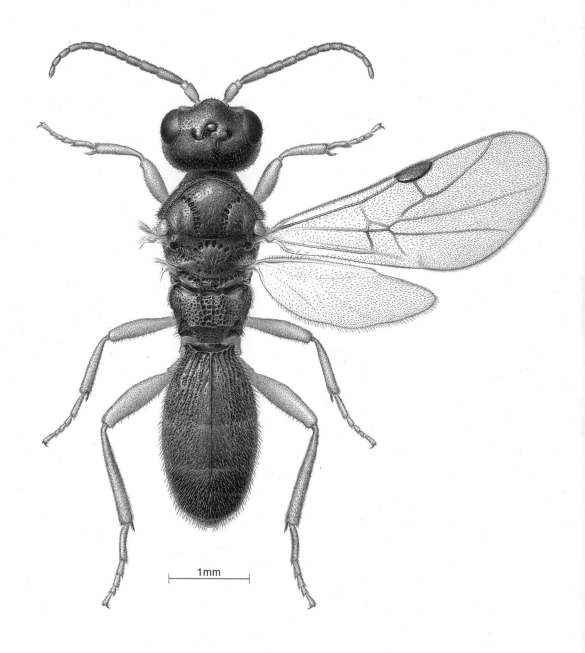

1mm

Armin Coray
Parasitoide Zehrwespe – Vanhornia leileri (Hedquist, 1976), Weibchen /
Parasitoid Wasp – Vanhornia leileri (Hedquist, 1976), female, 2003/04
Tusche auf Papier / Ink on paper
ca. 25 × 18 cm
Naturhistorisches Museum Bern

1,5 Grad

7

Im Freien /
In the Open

Im Freien

Sebastian Schneider

Die Ausstellung *1,5 Grad* erstreckt sich von der Kunsthalle Mannheim bis auf das Gelände der Bundesgartenschau Mannheim 2023, die zeitgleich in der Stadt stattfindet. Ihr Veranstaltungsort ist das Spinelli-Gelände, ein einst vom US-Militär genutztes Areal, das immer noch dessen Spuren trägt. Hier möchte die BUGA 23 zum Nachdenken über aktuelle Herausforderungen in Bezug auf Klima, Umwelt und nachhaltige Nahrungsmittelsicherung anregen. Die Werke von Olaf Holzapfel und Fabian Knecht, die auf Initiative der Kunsthalle für die BUGA 23 entstanden, fügen einer solchen Auseinandersetzung künstlerische Impulse hinzu. Sie inspirieren dazu, kritisch zu überdenken, wie sich der Mensch zu der ihn umgebenden Natur ins Verhältnis setzt. Die in der Kunsthalle begonnene Beschäftigung mit Mensch-Umwelt-Beziehungen wird aus dem Museum in die Natur selbst gebracht und ermöglicht dort eine unmittelbare Erfahrung klimarelevanter Themen.

Fabian Knechts Beitrag *Isolation (Brache)* besteht aus einem Kubus, der an einem zentralen Platz auf dem Gartenschaugelände steht. Von außen betrachtet wirkt er unspektakulär, sein Inneres enthüllt jedoch eine Überraschung: Eine Wiese erstreckt sich über die gesamte Bodenfläche des Raumes. Es scheint, als habe der Künstler ein ganzes Ökosystem in das Innere des Kubus verfrachtet. Wer genau hinsieht, entdeckt sogar Insekten. Tatsächlich handelt es sich aber schlicht um die Wiese, die sich auch sonst an dieser Stelle befindet – der Künstler hat auf ihr einen Raum errichtet und dabei die Bodenfläche ausgespart.

Die Grünfläche erscheint nun vor weißen, fensterlosen Wänden und im Licht von Leuchtstoffröhren. Diese Verschränkung des Außen- und Innenraums ruft einen eigentümlichen Effekt hervor: Die Wiese wirkt so greifbar wie entrückt, so natürlich wie künstlich. Mit seinem Eingriff erzeugt Knecht eine Rahmung, die sinnbildlich für den domestizierenden Umgang steht, den der Mensch mit der Umwelt pflegt. Die Natur wird als etwas Wildes und Unkontrolliertes begriffen, das es zu hegen gilt. Durch diese regulierenden Eingriffe etabliert der Mensch die Trennung der Sphären Kultur und Natur. In Knechts Werk treffen diese beiden Begriffe aufeinander, repräsentiert durch

einen minimalistischen, aseptischen Raum, der an das Innere eines Museums erinnert, und ein wucherndes Ökosystem. Der Künstler verweist auf die Vorstellung von Natur als etwas Unberührtem, enttarnt dieses Konzept aber durch sein Spiel mit Fragmentierung und Dekontextualisierung als bloße Idealisierung. Gleichzeitig zitiert Knecht mit *Isolation (Brache)* die Ästhetik des White Cube, also jener weitverbreiteten Konvention, Museums- und Galerieräume durch Verzicht auf Fenster, Tageslicht oder Lärm möglichst hermetisch von der (sozialen) Realität der äußeren Welt abzuschirmen. In einem solchen Setting wird unweigerlich alles, was in ihm ausgestellt wird, zu Kunst. Knecht verkehrt diese Logik durch seinen ungewöhnlichen Eingriff, das Museum zur Natur zu bringen. So macht er die Wiese zum Ausstellungstück und lenkt unseren Blick auf etwas, das wir häufig als selbstverständlich oder randständig betrachten.

Auch Olaf Holzapfel beschäftigt sich mit Fragestellungen des Zusammenhangs von Natur und Kultur. Auf dem Gelände der BUGA 23 hat er einen geschwungenen Durchgang konstruiert, der über eine Fläche mit besonderer Biodiversität verläuft. Er ist teilweise mit einem Flechtwerk aus Stroh und Weide ummantelt, das wiederum von einem Unterbau aus Holz gestützt wird. Dessen Konstruktion basiert auf der Technik der Fachwerkbauweise. Den Künstler fasziniert, dass Techniken wie diese zutiefst mit ihrem Baumaterial und deren lokaler Verfügbarkeit verknüpft sind: Im Falle des Fachwerks ist es die Höhe der Baumstämme, die vorgibt, wie hoch die Räume sein können, die aus ihnen errichtet werden.

Wenn man davon ausgeht, dass die Räume, die wir bewohnen, beeinflussen, wie wir denken, leben und handeln, vollzieht sich hier eine Durchdringung von Kultur und Natur. Dies zu realisieren bedeutet, »eine gegenseitige Bedingtheit einzusehen«, wie Holzapfel konstatiert. Dadurch eröffne sich die Möglichkeit, anders über spirituelle Fragen nachzudenken. Es handelt sich um ein ganzheitliches Prinzip, das weltweit in unterschiedlichen Formen zutage tritt. In seiner Arbeit erforscht Holzapfel in geografisch so weit entfernten Kulturen wie den Sorben in Brandenburg oder den Wichí, einer indigenen Gruppe in Argentinien, in welchen Formen sich diese Bedingtheit von Natur und Kultur manifestiert.

Holzapfels Installation *sie werden dorthin zurückkehren* auf dem Gelände der BUGA 23 setzt diese Arbeit nicht nur durch den Einsatz von Fachwerktechnik, sondern auch von Flechtwerk fort. Sie lädt dazu ein, den eigenen Körper, seine Verortung im Raum, aber auch die ihn umgebende Umwelt neu wahrzunehmen. Beim Gang durch die Passage kommen die geflochtenen Wandelemente dem eigenen

Körper unterschiedlich nahe, sodass eine sinnliche Erfahrung mit den pflanzlichen Materialien spürbar wird. Gleichzeitig gibt das Geflecht neue Perspektiven auf die Grünfläche frei, auf der sich die Installation befindet: ein Habitat für Insekten, Eidechsen und zahlreiche Pflanzen. Holzapfels Werk regt dazu an, die eigene Verankerung im Lokalen neu zu bewerten und dabei die Potenziale von regionalem Wissen und Traditionen einzubeziehen. Die Installation versetzt uns an einen Ort des Dazwischen, in dem das Spannungsverhältnis erlebbar wird, in dem Mensch und Natur stehen.

In the Open

Sebastian Schneider

The exhibition *1.5 Degrees* extends from Kunsthalle Mannheim to the grounds of The German National Garden Show Mannheim 2023 (BUGA 23), which is taking place in the city at the same time. The location for the event is the Spinelli site, which was once used by the US military and continues to bear its traces.

Here, the Bundesgartenschau would like to stimulate contemplation of current challenges connected with the climate, the environment, and ensuring a sustainable food supply. The works by Olaf Holzapfel and Fabian Knecht, which were created for the BUGA 23 based on a suggestion by the Kunsthalle, supplement this examination with artistic impulses. They encourage us to think critically about how people relate to the nature around them. The occupation with relationships between human beings and the environment that began at the Kunsthalle is taken out of the museum and into nature itself, and facilitates a direct experience with climate-relevant topics there.

Fabian Knecht's contribution, *Isolation (Brache)*, consists of a cube that stands at a central location on the grounds of the garden show. When viewed from the outside, it seems unspectacular, but its interior reveals a surprise: a meadow extending over the entire ground area of the space. It seems as if the artist has brought an entire ecosystem into the interior of the cube. People who take a closer look even discover insects. But it is actually simply a meadow that is otherwise found at this location, on which the artist erected a room, but dispensed with a floor.

The grassy area now appears in front of windowless walls and in the light of fluorescent

tubes. This interleaving of outdoor and indoor space gives rise to a peculiar effect: the meadow is both tangible and enraptured, both natural and artificial, to an equal extent. With his intervention, Knecht produces a framing that stands symbolically for the domesticating approach with which human beings cultivate the environment. Nature is comprehended as something wild and uncontrolled that needs to be fostered. Through this regulating effect, humans have established a separation between the spheres of culture and nature. These two concepts come together in Knecht's work, represented by a minimalistic, aseptic space that calls to mind the interior of a museum as well as an exuberantly growing ecosystem. The artist points to the notion of nature as something pristine, but exposes this concept as mere idealization through his play with fragmentation and decontextualization. With *Isolation (Brache)*, Knecht simultaneously cites the aesthetic of the white cube, hence that widespread convention of shielding museum and gallery spaces from the (social) reality of the outside world as hermetically as possible by eliminating windows, daylight, and noise. In such a setting, everything that is exhibited in it inevitably becomes art. Knecht reverses this logic by means of his unusual intervention, which brings the museum to nature. He thus makes the meadow into an exhibit and guides our gaze to something that we frequently consider to be self-explanatory or peripheral.

Olaf Holzapfel also occupies himself with questions regarding the connection between nature and culture. On the grounds of the BUGA 23, he constructed a curved passageway that transverses an area with particular biodiversity. It is partially clad with straw and willow basketry, which is supported in turn by a substructure of wood. Its construction is based on the technique of half-timbered construction. The artist is fascinated by the fact that techniques like this are closely intertwined with their building materials and their local availability: in the case of half-timbered construction, it is the height of the tree trunks that stipulates how high the rooms erected using them can be.

If we assume that the spaces in which we live influence how we think, live, and act, what takes place here is an interpenetration of culture and nature. To realize this means "recognizing a mutual conditionality," as Holzapfel states, and based on this the possibility of thinking differently about spiritual questions opens up. It is a holistic principle that appears around the world in various forms. In his work, Holzapfel examines the forms in which this conditionality of nature and culture is manifested in such geographically distant cultures as the Sorbs in Brandenburg or the Wichí, an Indigenous group in Argentina.

Holzapfel's installation *sie werden dorthin zurückkehren* (you will return there) on the grounds of the BUGA 23 continues this work by making use not only of the half-timbered construction technique, but also of basketry. It invites visitors to perceive their own body, their location in space, and also the environment surrounding them anew. When walking through the passageway, the woven wall elements come close to one's own body to varying extents, thus making a sensual experience with the plant material palpable. The basketry simultaneously opens up new perspectives on the grassy area on which this installation is situated: a habitat for insects, lizards, and numerous plants. Holzapfel's work prompts visitors to reassess their own anchoring in the local and hence incorporate the potential of regional knowledge and traditions. The installation transports us to a place of the in-between, where it becomes possible to experience the relationship of tension between human beings and nature.

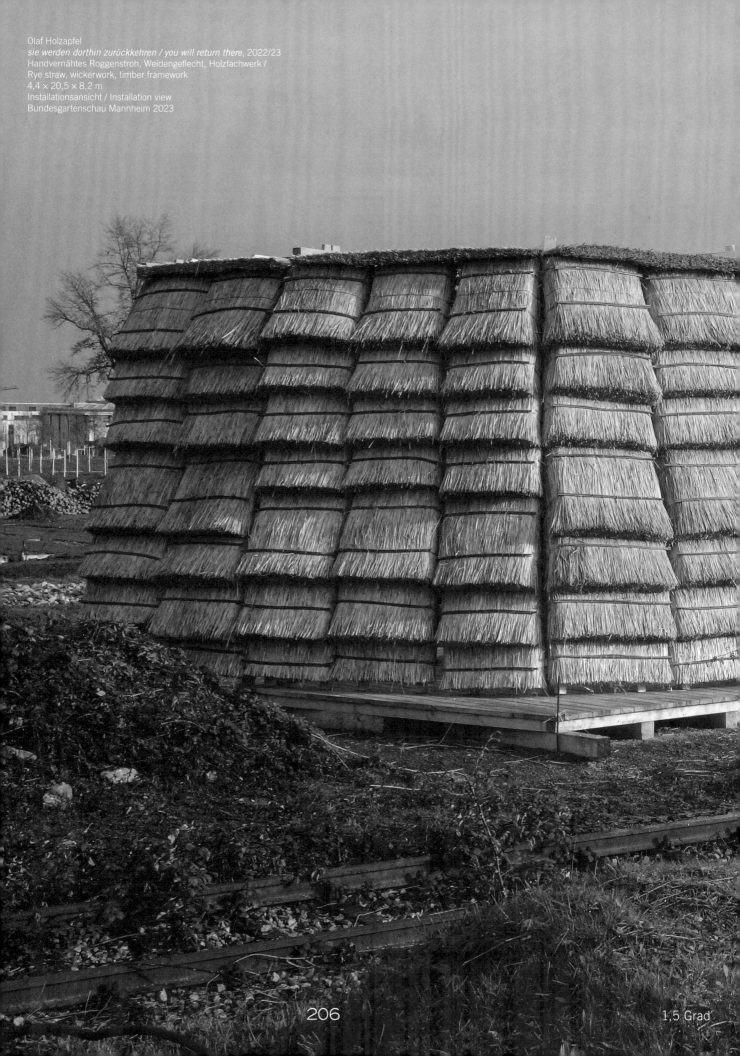

Olaf Holzapfel
sie werden dorthin zurückkehren / you will return there, 2022/23
Handvernähtes Roggenstroh, Weidengeflecht, Holzfachwerk /
Rye straw, wickerwork, timber framework
4,4 × 20,5 × 8,2 m
Installationsansicht / Installation view
Bundesgartenschau Mannheim 2023

1,5 Grad

OLAF HOLZAPFEL

Olaf Holzapfel,
sie werden dorthin zurückkehren / you will return there, 2022/23,
Handvernähtes Roggenstroh, Weidengeflecht, Holzfachwerk /
Rye straw, wickerwork, timber framework
4,4 × 20,5 × 8,2 m
Details

Olaf Holzapfel
sie werden dorthin zurückkehren / you will return there, 2022/23
Handvernähtes Roggenstroh, Weidengeflecht, Holzfachwerk /
Rye straw, wickerwork, timber framework
4,4 × 20,5 × 8,2 m
Animation von / by Tommaso Petrucci

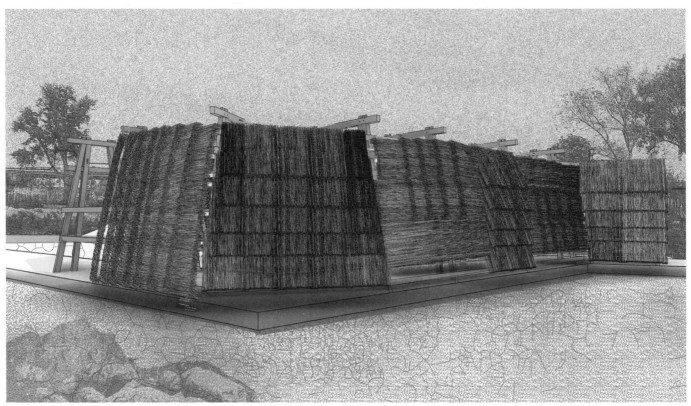

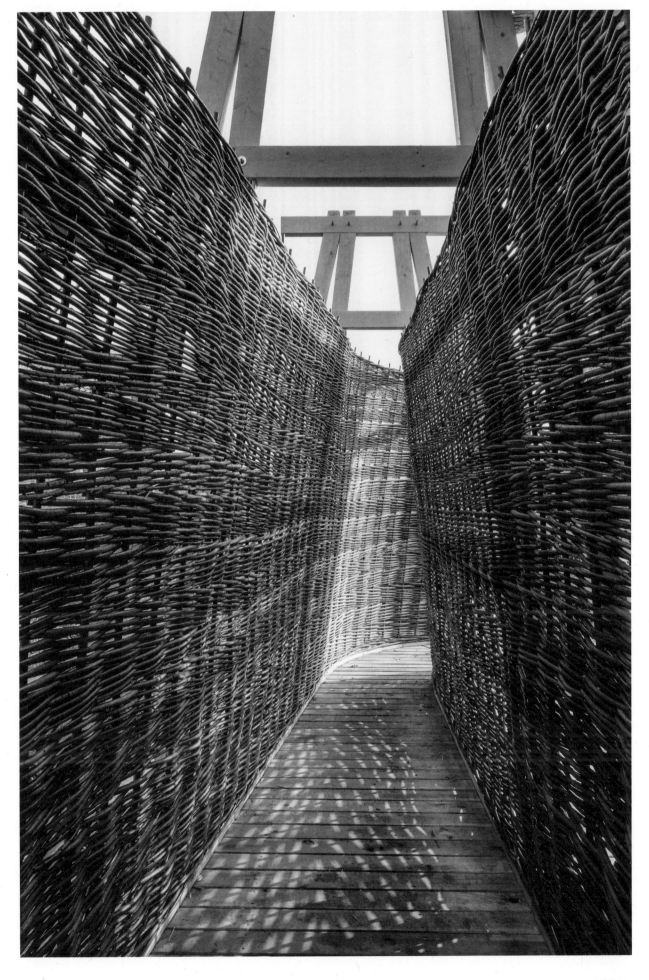

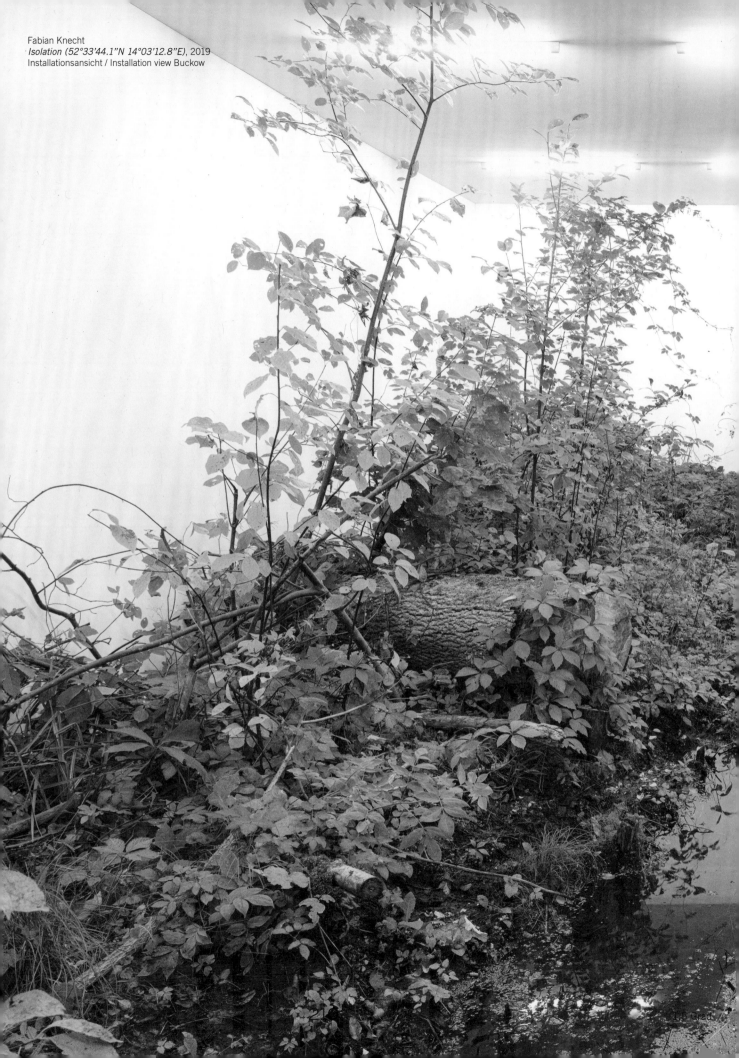

Fabian Knecht
Isolation (52°33'44.1"N 14°03'12.8"E), 2019
Installationsansicht / Installation view Buckow

FABIAN KNECHT

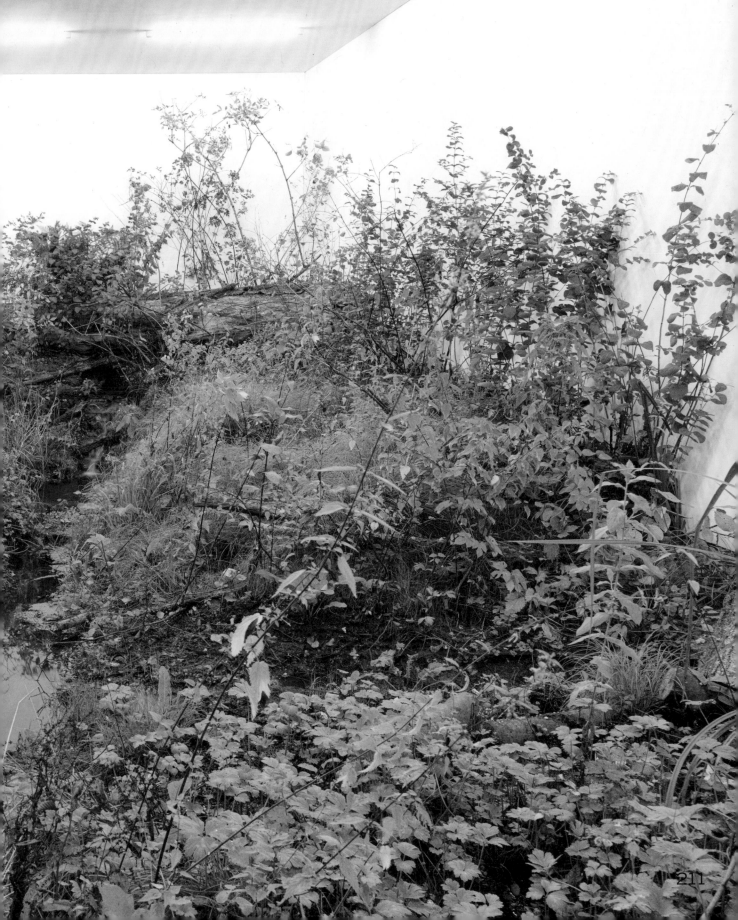

Fabian Knecht
Isolation (52°33'44.1"N 14°03'12.8"E), 2019
Installationsansicht / Installation view Buckow

Fabian Knecht
Isolation (Stamm), 2018
Installationsansicht / Installation view Baden-Baden

Fabian Knecht
Isolation (Stamm), 2018
Installationsansicht / Installation view Baden-Baden

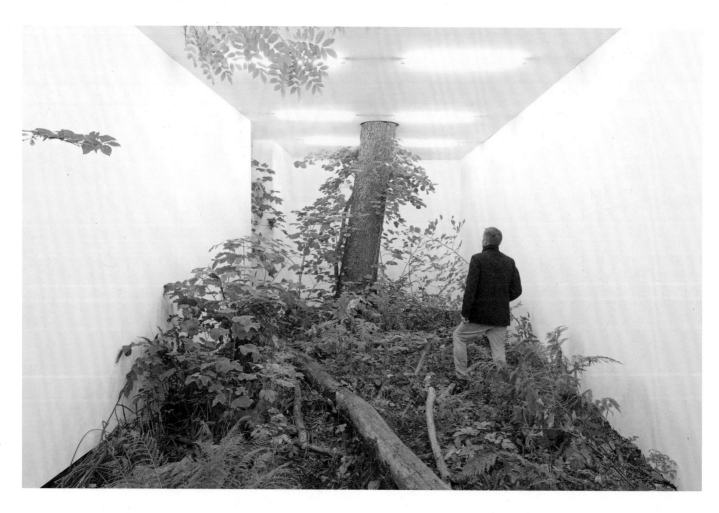

Fabian Knecht
Isolation (52°33'44.1"N 14°03'12.8"E), 2019
Installationsansicht / Installation view Buckow

Fabian Knecht
Isolation (Stamm), 2018
Installationsansicht / Installation view Baden-Baden

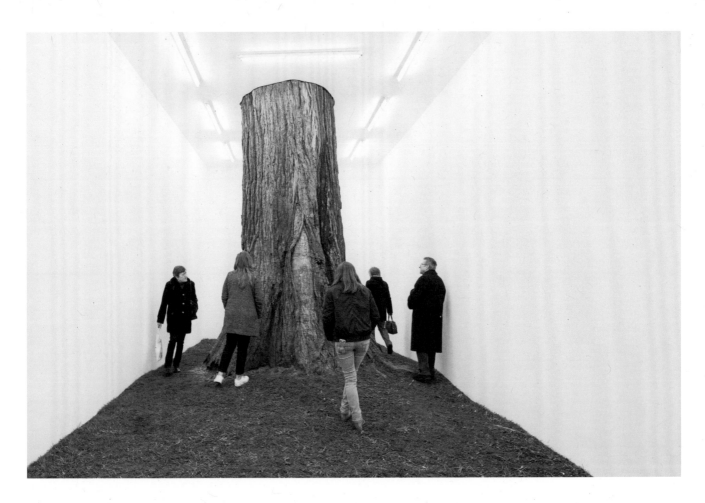

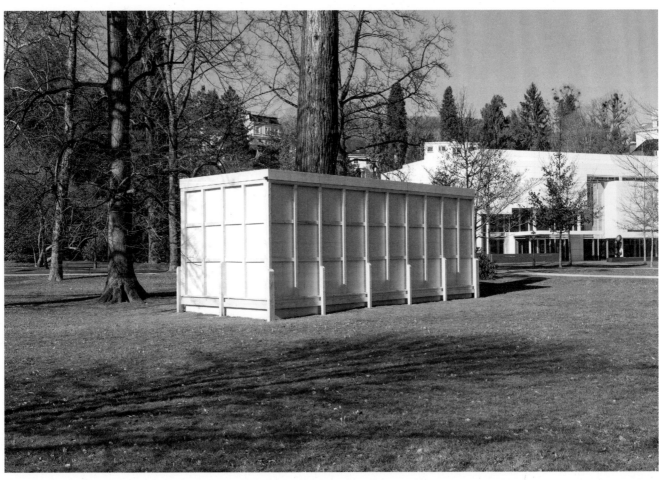

Bildnachweis / Photo Credits

Dank / Acknowledgments

13: bpk / Staatliche Kunstsammlungen Dresden / Jürgen Karpinski; 14: Courtesy Edward Burtynsky / Galerie Springer, Berlin / Nicholas Metivier Gallery, Toronto; 18: Courtesy Tomás Saraceno / Tanya Bonakdar Gallery, New York / Andersen's, Copenhagen / Pinksummer Contemporary Art, Genoa / neugerriemschneider, Berlin / Photo: Studio Tomás Saraceno; 31: Staatliche Museen zu Berlin, Gemäldegalerie / Christoph Schmidt, Public Domain Mark 1.0; 32: bpk / Musée du Louvre, Dist. RMN – Grand Palais / Angèle Dequier; 33: Royal Collection Trust / © His Majesty King Charles III 2022; 35: bpk / The Art Institute of Chicago / Art Resource, NY; 36: Courtesy Maja Smrekar / Photo: Manuel Vason; 60: Courtesy Emerson Pontes / Photo: Matheus Belém; 60: Courtesy Emerson Pontes / Photo: Lisa Hermes; 61: Courtesy Emerson Pontes / Photo: Lúcio Silva; 61: Courtesy Emerson Pontes / Photo: Keila Serruya; 62/63: Courtesy melanie bonajo / AKINCI, Amsterdam; 64/65: Baden-Baden Satellite Reef at Museum Frieder Burda – from the Crochet Coral Reef project by Margaret and Christine Wertheim / Photo: Museum Frieder Burda, Baden-Baden / Nickolay Kazakov; 68/69: Courtesy Tita Salina / Photo: Alfredo Rubio; 70/71: Courtesy Ernesto Neto / Fortes D'Aloia & Gabriel, São Paulo/Rio de Janeiro / Photo: Eduardo Ortega; 72/73: Courtesy Studio Fabian Knecht / alexander levy, Berlin; 82/83: Courtesy Lee Bae / Perrotin; 86–87: Courtesy Peter Fend / Ocean Earth & Eve Vaterlaus / Galerie Barbara Weiss, Berlin; 88/89: Courtesy Romuald Hazoumè / October Gallery, London / Photo: Jonathan Greet; 91: Kunsthalle Mannheim; 92–93: Courtesy Studio Olaf Holzapfel / Photo: Jens Ziehe; 94–95: Courtesy Bahzad Sulaiman / Photo: Daniel Hausig; 104/105: Courtesy Studio Daniel Canogar; 108/109: Courtesy Andreas Greiner / Dittrich & Schlechtriem, Berlin / Photo: Jens Ziehe; 110: Courtesy Tomas Kleiner / Photo: Kai Werner Schmidt; 112/113: Courtesy Trevor Paglen / Pace Gallery / Photo: Annik Wetter; 116/117: Courtesy Susanne M. Winterling / Photo: Marc Doradzillo; 126/127: Courtesy Archiv René Block; 129: Kunsthalle Mannheim / Cem Yücetas; 134/135: Kunsthalle Mannheim / Rainer Diehl; 137: Kunsthalle Mannheim / Cem Yücetas; 140/141: Courtesy Marianna Simnett / Société, Berlin / Photo: Henning Krause; 153: Courtesy Atelier Anselm Kiefer / Photo: Charles Duprat; 154/155: Courtesy Otobong Nkanga / Kunsthaus Bregenz / Photo: Markus Tretter; 164–165: Kunsthalle Mannheim / Cem Yücetas; 166–167: Kunsthalle Mannheim; 168–170: Kunsthalle Mannheim / Cem Yücetas; 171: Kunsthalle Mannheim / Kathrin Schwab; 172: Courtesy Wolfgang Laib / Buchmann Galerie, Berlin / Photo: Roman März; 173: Kunsthalle Mannheim / Lukac Diehl; 177: bpk / Staatliche Museen zu Berlin, Kupferstichkabinett / Jörg P. Anders; 178: bpk / Hermann Buresch; 189: bpk / Herzog Anton Ulrich-Museum, Braunschweig; 190: bpk / Staatliche Museen zu Berlin, Kupferstichkabinett / Volker-H. Schneider; 191: bpk / Städel Museum, Frankfurt am Main; 192: Horst-Janssen-Museum, Oldenburg; 197: Naturkundemuseum Stuttgart / Photo: Cristina Gasco-Martin; 206–209: Courtesy Studio Olaf Holzapfel; 208: Courtesy Studio Olaf Holzapfel / Tommaso Petrucci; 210–213: Courtesy Studio Fabian Knecht / alexander levy, Berlin

Das Projektteam und die Kunsthalle Mannheim bedanken sich herzlich bei allen Künstler*innen und deren Studios, die ihre Werke für diese Ausstellungen zur Verfügung gestellt haben. / The project team and Kunsthalle Mannheim express their heartfelt thanks to all the artists, along with their studios, who made works available for these exhibitions.

Lee Bae, melanie bonajo, Daniel Canogar, Julian Charrière, Oliver Coleman, Armin Coray, Sinje Dillenkofer, Peter Fend, Lili Fischer, Johannes Frisch, Eva Gentner, Kyriaki Goni, Andreas Greiner, Romuald Hazoumè, Olaf Holzapfel, Anne Duk Hee Jordan & Pauline Doutreluingne, Tomas Kleiner, Fabian Knecht, Wolfgang Laib, Christine Leins, Thomas Löhning, M+M (Martin De Mattia & Marc Weis), Marian Merl & Fabian, Guadalupe Miles, Ernesto Neto, Otobong Nkanga, Trevor Paglen, Laure Prouvost, Emerson Pontes / Uýra Sodoma, Anke Röhrscheid, Tita Salina, Nana Schulz, Günther & Loredana Selichar, Marianna Simnett, Bahzad Sulaiman, SUPERFLEX, Margaret & Christine Wertheim, Eva-Maria Winter, Susanne M. Winterling

Ebenso großer Dank gilt den zahlreichen Leihgeber*innen aus dem In- und Ausland. / Great gratitude also goes to the numerous lenders in Germany and abroad.

AKINCI / Buchmann Galerie, Berlin / Deutsches Literaturarchiv Marbach / Dittrich & Schlechtriem, Berlin / Galerie Barbara Weiss / Herzog Anton Ulrich-Museum, Braunschweig / Horst-Janssen-Museum Oldenburg / Mönchehaus Museum Goslar / Museum Frieder Burda, Baden-Baden / Naturkundemuseum Stuttgart / October Gallery, London / Pace Gallery / Perrotin / Sammlung 888 / Sammlung Stephan Meeder / Société, Berlin / Staatliche Museen zu Berlin, Kupferstichkabinett / Staatliche Museen zu Berlin, Sammlung Scharf-Gerstenberg / Städel Museum, Frankfurt am Main

Der BUGA 23 mit Michael Schnellbach als Geschäftsführer und Fabian Burstein als Verantwortlichem für das Kultur- und Veranstaltungsprogramm sowie allen an dem Kooperationsprojekt beteiligten Mitarbeiter*innen dankt die Kunsthalle Mannheim für die erfolgreiche Zusammenarbeit. / The Kunsthalle Mannheim is also grateful to the BUGA 23 with Michael Schnellbach as executive director and Fabian Burstein as the head of culture and events, as well as all the employees involved in the cooperation project, for the successful collaboration.